The Holden Arboretum

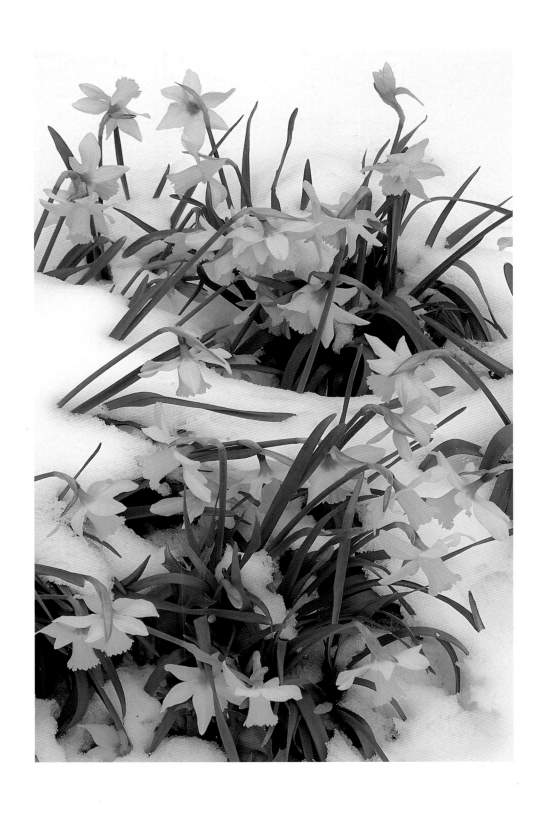

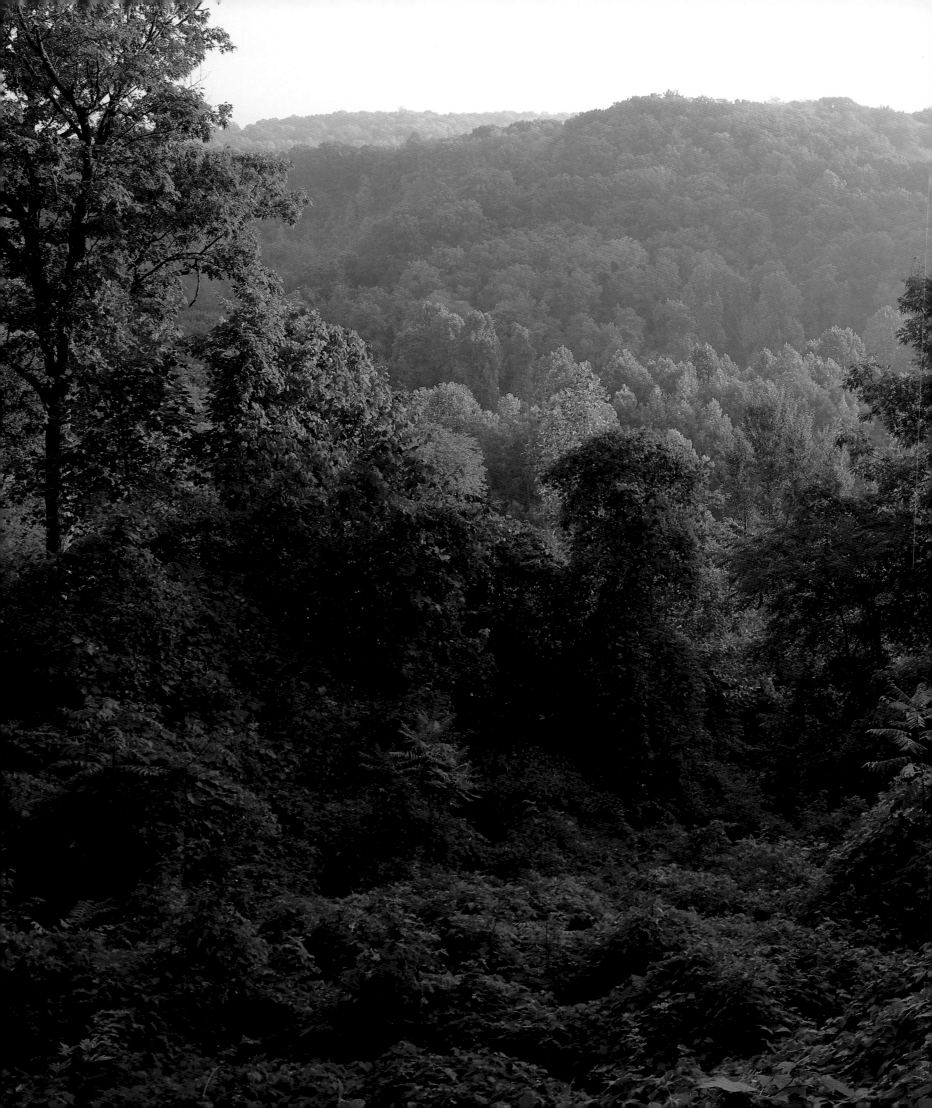

The Holden Arboretum

Photographs by Ian Adams

Text by Steve Love

THE UNIVERSITY OF AKRON PRESS

Akron, Ohio

All inquiries and permissions requests should be
addressed to the publisher, The University of Akron
Press, Akron, OH 44325-1703

Library of Congress Cataloging-in-Publication Data
Adams, Ian, 1946–
 The Holden arboretum / photographs by Ian
Adams ; text by Steve Love.
 p. cm. — (Series on Ohio history and
culture)
 ISBN 1-884836-86-0 (cloth : alk. paper)—
ISBN 1-884836-87-9 (pbk. : alk. paper)
 1. Holden Arboretum. 2. Holden Arbore-
tum—Pictorial works. I. Love, Steve, 1946–
II. Title. III. Series.

QK480.U52 H6425 2002
580'.7'377131—dc21
 2002020288

Printed in Korea.

The paper used in this publication meets the minimum
requirements of American National Standard for Informa-
tion Sciences—Permanence of Paper for Printed Library
Materials, ansi z39.48-1984. ∞

Contents

Acknowledgments

THE HISTORY OF THE HOLDEN ARBORETUM is a rich and complex story of remarkable, generous, and determined individuals. The Holden Arboretum is grateful to all the people who helped to bring its story and its beauty to the page, especially Steve Love and Ian Adams. Steve interviewed scores of people, read hundreds of pages of historical information, listened to oral histories of the key players in Holden's history, and hiked Holden's trails. Ian has been capturing Holden's extraordinary beauty for many years. Ian's technical genius is matched by his love of Holden. We are also grateful to the University of Akron Press for the opportunity to publish this book, which we believe will become a cherished keepsake. This book is a reality due to the determination of former executive director Richard Munson.

We extend special thanks to the individuals who shared their family histories, personal recollections, and insights with author Steve Love: Connie Norweb Abbey, Alison "Sunny" Corning Jones, Dixon Long, Elizabeth "Libby" Norweb, as well as Dick Munson, Miriam "Mimi" Gale, and C. W. Eliot Paine. Steve gathered information and stories from current and former Holden staff members and volunteers who are acknowledged in the list of sources at the end of the book.

We have made every effort to ensure the accuracy of the information contained in this book. We regret any errors of omission or fact that escaped our careful review.

The Holden Arboretum

C. W. Eliot Paine and Paul Spector provided initial encouragement for the book, and Richard Munson commissioned the project in March 2001. Susan Murray served as Holden's project coordinator for the book, and helped to steer and focus the book's development. Brian Parsons and Tom Yates shared their encyclopedic knowledge of Holden's natural areas. Ethan Johnson, Bill Isner, and Bruce Cubberley guided me unerringly through Holden's vast plant collections. Elaine Price generously approved the funding for a helicopter flight to obtain aerial photographs of the arboretum. Holden trustee Mimi Gale was a constant source of enthusiasm and encouragement for the project, and my good friend, the late Judie Gause, provided parking permits, access keys, and was a frequent hiking companion on my Holden explorations.

Many other Holden staff provided help and encouragement, including Jean Albertone, Dave Allen, Nadia Aufderheide, Peter Bristol, Dawn Gerlica, Roger Gettig, Sharon Graper, Dave Gressley, Stanley Johnston, Kelley Kornell, Steve Krebs, Jim Mack, Kathy Mahovlic, Bob Marquard, Carol Morrison, Doris Myers, Carl Reinemann, Denise Sacchini, Matt Tarajcak, Cathee Thomas, Don Whitney, and volunteer Ted Yocom.

Finally, I wish to thank Michael Carley and Amy Petersen of the University of Akron Press for their support, encouragement, and constant vigilance with respect to editorial deadlines, and Kachergis Book Design for their expertise in laying out the book.

Ian Adams

A Word from the Photographer

FOR MORE THAN A DECADE it has been my privilege and delight to explore, photograph, and conduct photography seminars and workshops at the Holden Arboretum. Participants in these workshops often ask me to recall my favorite places and experiences at Holden. In truth, there have been so many it is hard to select specifics, but I would like to share a few of my special memories of this very special place.

In midwinter each year I join a group of intrepid photography enthusiasts for an exciting hike into the icy depths of Holden's Stebbins Gulch to capture on film the spectacular frozen waterfalls and icicles in the rocky heart of the gulch. More than once, a sudden rise in temperature has converted the frozen stream into a flash flood, making the trek out of the gulch a challenging wade through freezing water. The pictures, though, are invariably worth the wet feet.

During January 2001 I visited Holden's Holly Collection and observed an unusual bird feeding on winterberries. A trip to the Warren G. Corning Visitor Center to consult a field guide revealed the bird to be a Townsend's Solitaire, a western thrush which had only been seen four times before in Ohio. The Solitaire remained in the Holly Collection for six weeks, and birders traveled to Holden from as far away as Minnesota to view this rare avian visitor.

Spring arrives in mid-April most years at Holden, and the sight of the first hepatica, spring beauty, and bloodroot blossoms along Pierson Creek and in the Myrtle S. Holden Wildflower Garden feeds my creative urge to photograph nature's rebirth at the arboretum. In late May and early June Holden's floral display is at its showiest, and I'm entranced by the extravagant blooms of rhododendron, azalea, lilac, and viburnum at Lantern Court, the Helen Layer Rhododendron Garden, and the Leach Research Station in Madison. Bluebirds and tree swallows compete for the nesting boxes around Corning Lake, and dozens of Red Admiral and Mourning Cloak butterflies take nectar from the weeping cherry tree at Lantern Court.

Early summer demands a wade into the squishy heart of Brainard Bog to photograph the rare showy lady's slipper orchids that grow there. Later, Holden's Prairie Garden and the Arlene and Arthur S. Holden Butterfly Garden attract a host of gossamer-winged butterflies and dragonflies, a challenge to identify and photograph. In July 2001, I joined Holden staff and friends from the Ohio Chapter of the

North American Butterfly Association for a butterfly/dragonfly count at the arboretum. Wielding nets, close-focusing binoculars, and field guides, we tallied more than 30 species of butterflies and almost as many species of dragonflies and damselflies.

In good years, Holden can provide a display of fall color equal to anywhere in the Midwest. In October 2000 I hiked with Holden's Visitor Center Manager Judie Gause before sunrise to an overlook near Carver's Pond, perhaps my favorite place in the arboretum. As the sun rose, turning the hillside gold, a mature bald eagle, resplendent with white head and tail, rose from its roost in a dead tree and flew *below our feet* around a bend of the East Branch of the Chagrin River. This was a few months before Judie's death after a valiant, unrelenting seven-year fight with cancer. In October 2001 I saw another bald eagle, perhaps the same bird, as I walked to the Bole Overlook on Sperry Road to complete a four-season set of photographs for this book.

Each season at Holden brings its special pleasures to the visitor, and I hope that the photographs in this book will help to foster a greater awareness of the myriad opportunities for nature study, hiking, horticulture education, and personal reflection, renewal, and growth at this Northeast Ohio treasure.

Cast of Principal Characters

Albert "Bert" Fairchild Holden (1866–1913)—Mining engineer and Cleveland businessman who provided for the establishment of the Holden Arboretum with interest from the Holden Trust. The funds were to be made available only after the deaths of his two daughters, Emery May Holden Norweb and Katharine Holden Thayer.

Roberta Holden Bole (1876–1950)—Bert Holden's sister who seized the initiative and made the Holden Arboretum a reality decades before the Holden Trust money became available. She and her husband, Benjamin P. Bole Sr., donated the first hundred acres of arboretum land.

Emery May Holden Norweb (1896–1984)—Daughter of Bert and Katharine Davis Holden. She was a principal supporter of the arboretum throughout her life. Her son, R. Henry Norweb Jr., became the first executive director of the arboretum.

Katharine Holden Thayer (1898–1985)—Daughter of Bert and Katharine Davis Holden. She also supported the arboretum, donating the Thayer Building, which was Holden's first center for visitors.

Benjamin P. "Pat" Bole Jr. (1908–1980)—Son of Roberta and Benjamin P. Bole Sr. An ecologist, he was one of the first leaders of the arboretum as a member of the Cleveland Museum of Natural History staff. He launched the arboretum's careful mapping of its land and recording of plants and was famous for his entertaining birdwatching walks.

Warren Corning (1902–1975)—Cleveland businessman who built Lantern Court on the cusp of the arboretum and became involved in guiding Holden and helping it grow through the timely purchases of land that he leased or gave to the arboretum. He convinced others to do the same with their land.

Lewis Lipp—Hired as propagator in 1954 and horticulturist in 1958. Lipp spent eighteen years at the arboretum (until 1972) adding to his reputation as one of the great plantsmen in the world. Warren Corning recruited Lipp from the Arnold Arboretum at Harvard University, alma mater of Bert Holden. He lives in retirement in Wiscasset, Maine.

R. Henry Norweb Jr. (1918–1995)—Son of Emery May Norweb and grandson of Bert Holden, Henry Norweb became Warren Corning's protégé and the arboretum's first paid executive director in 1959. With his businessman's acumen and love for his grandfather's legacy, Norweb led Holden through the challenging times before interest from the Holden Trust became available to support its operation.

C. W. Eliot Paine—Executive director emeritus and member of the Holden Board of Trustees, Paine succeeded Norweb in 1983 and served until 1995. He led the arboretum's development during periods both before and after the Holden Trust monies became available in December 1988.

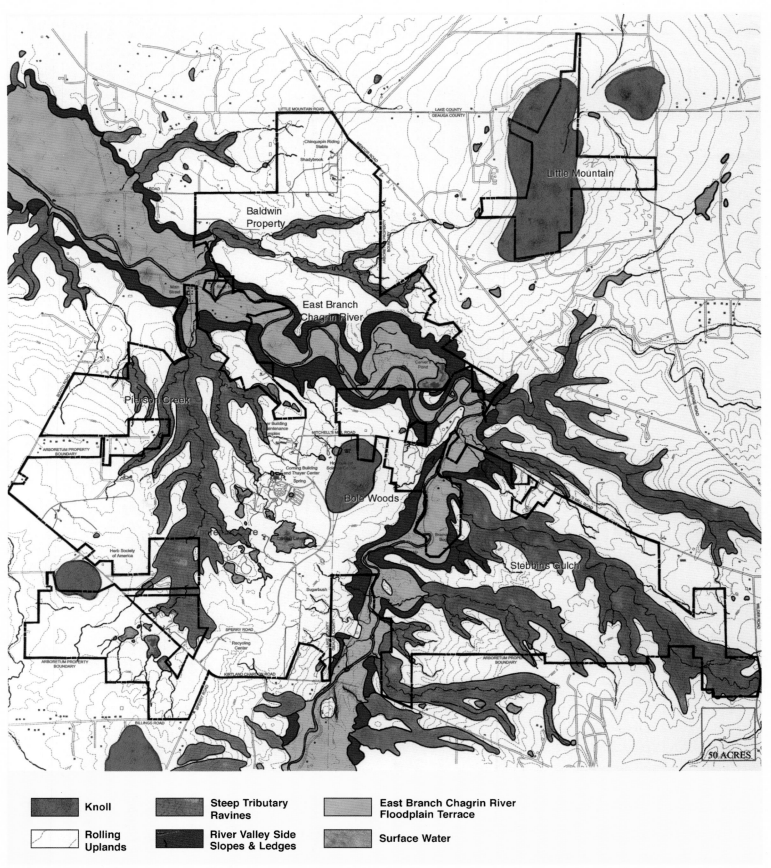

Legend:

Knoll	Steep Tributary Ravines
Rolling Uplands	River Valley Side Slopes & Ledges
	East Branch Chagrin River Floodplain Terrace
	Surface Water

Site Physiography Map of the Holden Arboretum, November 2000

Source: Knight and Stolar, Inc. and Andropogon Associated, Ltd.

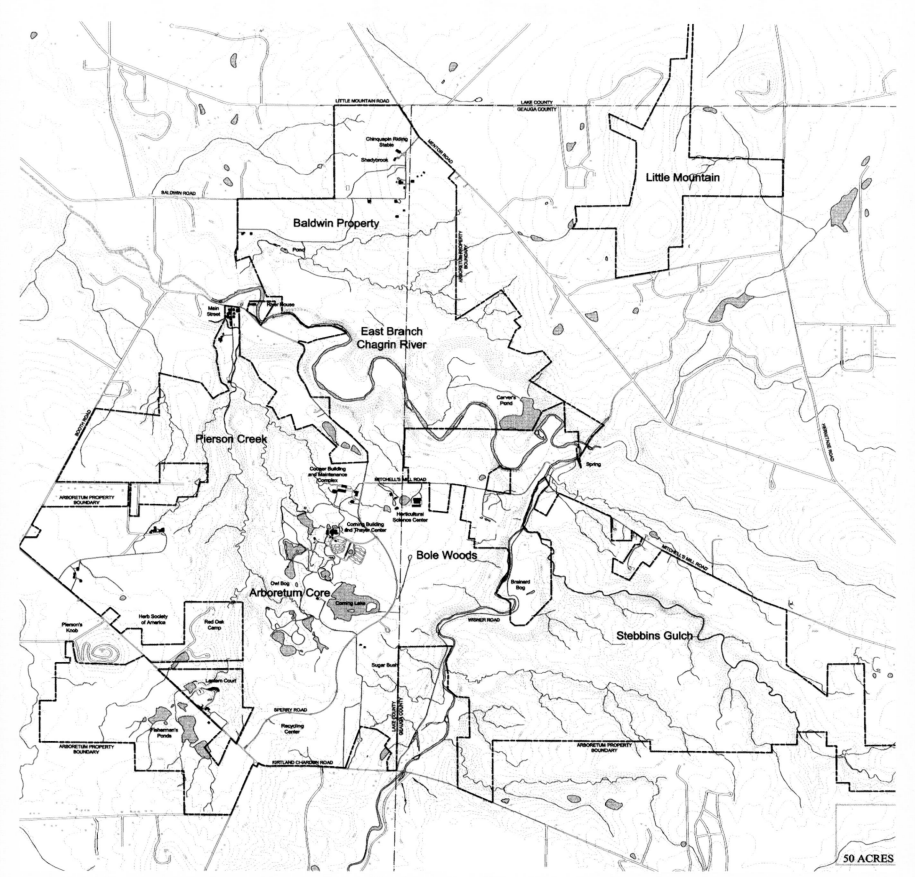

50 ACRES

The Holden Arboretum, Lake County-Geauga County, Ohio, August 2000

Source: Knight and Stolar, Inc.

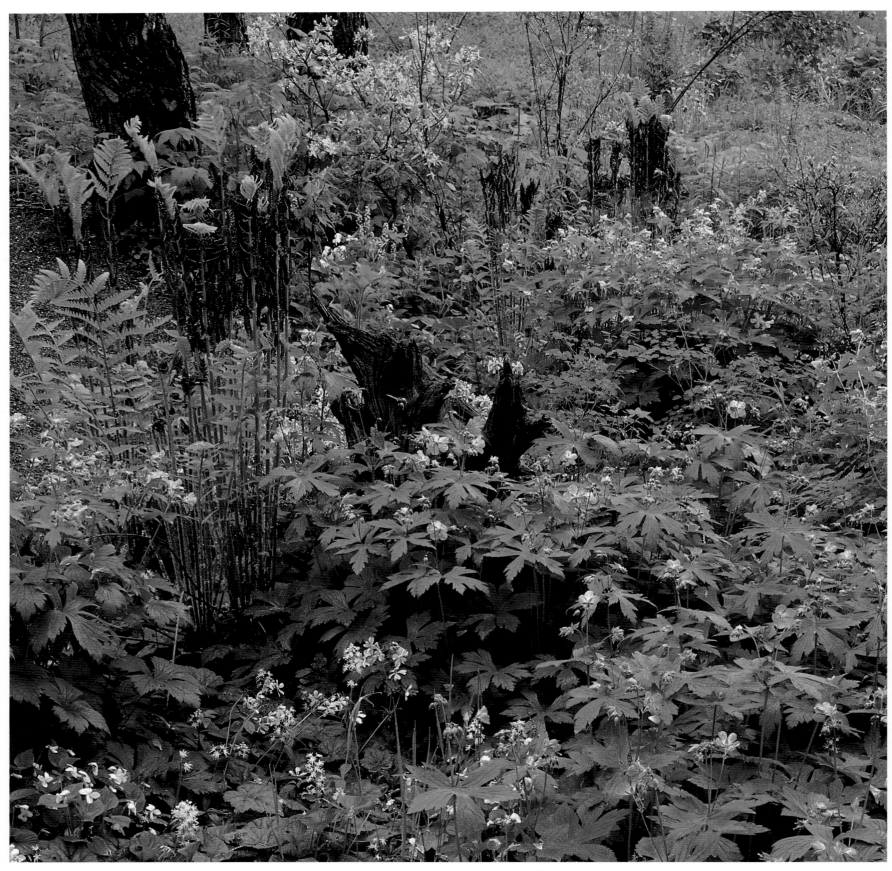

Spring Wildflowers, Myrtle S. Holden
Wildflower Garden

The Holden Arboretum

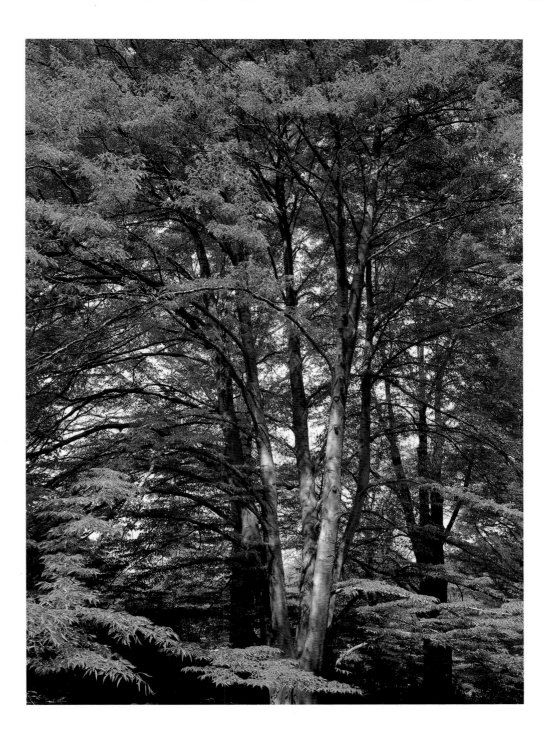

The History of the Holden Arboretum

ALBERT "BERT" FAIRCHILD HOLDEN died young of cancer in May 1913. Three months later almost to the day, his father, Liberty Emery Holden, the family patriarch, also died. It was a hard, dark time for the Holdens, a time softened only by the insight of certain family members, friends, and even strangers who went about the creation of Bert Holden's greatest legacy, the Holden Arboretum. To understand Bert Holden's splendid gift to Northeast Ohio is to know those who gave birth to it, those who nurtured it through its infancy, and those who continue to care for it today.

The land—now more than 3,400 diverse acres—makes Holden one of the larger arboreta in the world. Yet as large as the arboretum has become, it cannot be separated from and is not larger than the vision of the people who have contributed to it, who have pieced it together, one piece of property at a time, who have loved every inch of this land and worked to preserve it as if it were their own.

Not the least of these people is Bert Holden himself. He never knew the site, spread over the unique topography of two counties in which three distinct forest types converge. When Holden died at the age of forty-six on May 18, 1913, he believed that one day his fortune would create a small arboretum of perhaps seventy-five acres within the strikingly beautiful and peaceful Lake View Cemetery on the edge of Cleveland, industrial powerhouse of the early twentieth century.

Holden, a mining engineer and business executive, had become familiar with arboreta—in particular, the Royal Botanic Gardens at Kew in England and the Arnold Arboretum at Harvard University. As a Harvard undergraduate, the field Holden had been most noted for cultivating was the one on which the Crimson played football. Though a big, powerful man by nineteenth-century standards, Bert Holden had been nonetheless swift afoot—and, more important, a natural leader. In the 1888 Harvard team photo, Holden stands squarely at the center, cradling a fatter, more rounded football than today's model in his right arm. Twice chosen Harvard team captain, Holden scored the two touchdowns that won the 1887 Harvard-Yale game—the only game that really matters for Harvard. He left a lasting impression.

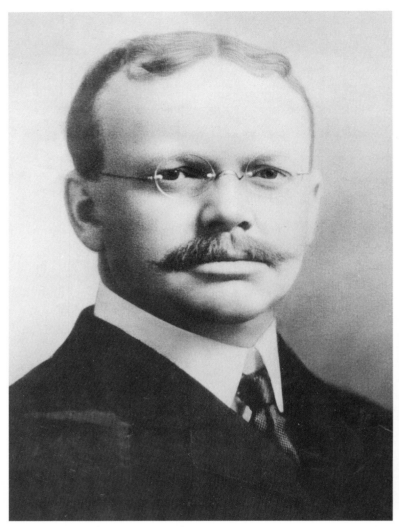

Albert Fairchild Holden. The founder and benefactor of the Holden Arboretum. Liberty Emery Holden, Albert's Father

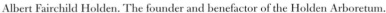

Years after Holden's glory days, Harvard's Dean Briggs had not forgotten Bert Holden. As he addressed the American Collegiate Athletic Association in 1914, Briggs could still see Holden's grace, power, and courage during a period when the game of football was what Briggs called "years of barbarity and rancor and low cunning." Despite this, there were men who had "that wonderful capacity for standing fire. Such was the late Bert Holden, whom I can see at this moment dashing down the field with the brilliancy of a cavalry officer. . . . In him, sincerity was an overmastering force."

By the last weeks of his life in 1913, that Holden fire had been smothered by cancer. Bert Holden was weak, hardly a flicker of the robust, more-than-two-hundred-pound man who had run through those Yale defenders. And yet he still thought of his legacy.

To someone who had known him only as a big mine operator who had extracted millions of dollars' worth of silver from the land in Utah at the turn of the century, Bert Holden's interest in preserving

the natural world might have come as a surprise. Like other mine operators of his day, Bert Holden had been the target of criticism concerning not only his mining practices but also the way his companies treated employees. In the *History of Utah,* Holden was judged a hard-nosed industrialist who had little sympathy for the workers' plight, much less their rights. Others, however, viewed Holden as nothing worse than a sharp, if tough, businessman, one of the better ones during an era in which the Cleveland-Detroit-Akron industrial axis was dominated by the Rockefellers, Fords, and Firestones.

Business, like football, could be a brutal game. Bert Holden played both to win. Between 1876 and 1912, he and his father refined and shipped minerals—primarily silver, gold, and lead—worth millions. That was only a part of Bert Holden's holdings (among other enterprises, he was also involved in publishing, as owner of the *Cleveland Plain Dealer,* and in real estate and hotels).

For all the money that Bert Holden made from mining, his interest in minerals had a softer side as well. He admired the beauty of rare gems and built a valuable collection that he left to Harvard University. His interest in the natural world led him first to consider providing money to supplement the work of the Arnold Arboretum at Harvard. He loved the land and the science of land, learning what grew on it and the birds that found shelter and food on it. He hiked and hunted and was a crack shot. He wanted to leave behind something that would allow others to gain an appreciation of the natural world. Because he arrived at this decision after his illness had drained his strength, Bert Holden required help to implement it. He received that help from Roberta Holden Bole, his favorite sister, who became the first of the family's guiding lights in creating and nurturing the arboretum that would bear the Holden name, and honor his daughter Elizabeth who had died of scarlet fever in 1908 at the age of twelve.

Roberta Holden Bole (1876–1950) shared her brother's love of the outdoors. They were serious amateur horticulturists. Just as today's arboretum staff shares its horticultural knowledge, so did Bert Holden. He treated each tree on the Holdens' Bratenahl property east of Cleveland as "an individual living thing, almost with a personality of its own." One day each year, his daughter Emery May would recall years later, father and daughter would survey the many trees on the Bratenahl estate, Katewood. Emery May would measure the girth of each tree and the length of its shadow in order to calculate its height. Bert Holden would dutifully record the figures in notebooks and on charts that revealed the growth of each tree, some of which Holden had named to reflect their personalities.

When Bert Holden broached the idea of endowing his alma mater's arboretum, the Arnold, Roberta Holden Bole had another suggestion: Why not create an arboretum for Cleveland, a place where students and adults with a serious interest in horticulture could learn the basics of horticulture and expand their knowledge?

Upon reflection, it seemed to Holden that the family compound in Bratenahl offered a small but perfect setting for an arboretum. He was willing to donate his estate, which, if combined with his father's estate, Loch Hame, could be used to create an almost fifty-acre arboretum. But his father demurred. He faced financial demands, and his wife wanted to keep her portion of the land—seventeen acres—in her

Roberta Holden Bole. Her importance in the history of the founding and growth of the Holden Arboretum was set forth in the tribute to her at her death by her niece, Emery May Norweb. "Had it not been for Mrs. Bole, the Holden Arboretum would still be a paper item on the books of the Cleveland Trust Company."

family. As an alternative, Bert Holden agreed to move the proposed site to Lake View Cemetery, where the arboretum was envisioned as an "outdoor Westminster Abbey." This resulted in provisions in Holden's will which stipulated that the interest from a Holden Trust Fund would become available to Lake View for an arboretum following the deaths of the Holden daughters.

Once again, as with the Arnold Arboretum idea, his sister Roberta Bole had her doubts. She believed that Lake View offered too little property. Potentially more detrimental, pollution generated by the expanding industrial city of Cleveland could threaten the success of an arboretum within the cemetery. Although Roberta Bole would be proved correct concerning the level of pollutants at Lake View (at least as compared with sites more distant from the city), the cemetery has become a natural spot of national repute. While Lake View is renowned for some of those buried there (President James A. Garfield, John D. Rockefeller, and many of the Holdens), as important as who lies at Lake View is what grows there—a diverse collection of trees and plants, many of them labeled, to study and enjoy. Lake View is as much a place of life as of death.

When Bert Holden died in 1913, his daughters, Emery May (1896–1984) and Katharine (1898–1985), were only sixteen and fourteen years old, respectively. Throughout their teenage years and beyond, their aunt, Roberta Bole, and their guardian, Fred Goff, influenced their lives in significant ways. Aunt Roberta was, in fact, too much of an influence, or so Emery May thought when she was young. In addition, she resented Goff's influence on her father and the Holden Trust that Goff managed as president of the Cleveland Trust Company.

"Uncle Fred," as Emery May and Katharine referred to Goff, would ultimately leave his own money to charity and had urged Bert Holden to do the same. Instead, Holden decided to endow the arboretum but with the provision that the interest from the trust would become available only at the end of Emery May and Katharine's lives. While the arrangement provided generously for the Holden daughters, it did not give the young women control of the estate. That created some resentment. "I went through many bitter years feeling that if Aunt Robbie and Uncle Fred had not gotten at him, he would not have done what he did," Emery May would concede fifty years after her father's death.

Emery May's feelings would change as she became personally involved in the arboretum and even more so when her son, R. Henry Norweb Jr. (1918–1995), became the arboretum's first executive director in 1959. Without Bratenahl as a possible site, there seemed to be no alternative to the agreement with Lake View Cemetery. Yet always during the period from Bert Holden's death in 1913 to 1927, Roberta Bole knew her brother had "died feeling that I would see his plan through somehow." Aunt Roberta acted decisively when she learned in 1927 from conversations with Harold T. Clark, a Cleveland attorney who had helped to start and grow a number of Cleveland charitable organizations, that the Lake View agreement, in which the city of Cleveland had a stake, might indeed be altered.

Clark approached the Lake View Cemetery Association Board of Trustees. He proposed that the arboretum be located elsewhere, with Lake View receiving compensation. Since the trust fund's interest would not become available until the deaths of Emery May and Katharine, the Lake View board was inclined to delay a decision until that time. This created two problems for Roberta Bole: A more appropriate location could not be sought for the arboretum, and the project could not begin immediately with whatever funds she and others might generate. Roberta Bole knew that no one felt as strongly as she about seeing her brother's legacy take root. If she did not act, the potential of an arboretum as grand as her brother might die with her. So she wrote the document that is arguably the most important not only in establishing the Holden Arboretum, but also in giving the arboretum the head start that has allowed it to achieve maturity in the first years of the twenty-first century.

In a December 13, 1927, letter, Roberta Bole appealed to the Lake View Cemetery Association Board of Trustees through its president, Francis F. Prentiss. She was eloquent and honest, revealing the family conflict over the Bratenahl arboretum proposal and stating that she was "aghast" at the prospect of a "scientific experimental station" in a cemetery. Roberta Bole thought the fifty acres that might be allotted for the arboretum were too few and the location too near Cleveland's steel mills and other factories that spewed pollutants.

Sensing his sister's disappointment, Bert Holden had promised to change his decision "if I live long enough and see anything else to do . . ." This did not happen. All he was able to do was to modify

Emery May Norweb. Guardian of the concept of an arboretum, guide for its planning and execution, donor of unlimited time and funds to her father's dream from 1937 until her death in 1984.

Richard H. Munson,
Executive Director
(1995–2000)

his will to allow flexibility in how daughter Elizabeth's memorial and his natural-world legacy might be created if, after his death, Roberta Bole were able to persuade their mother to change her mind about a Bratenahl arboretum. Roberta failed.

In the dozen years after Bert Holden's death in 1913, no one thought about "a third alternative, that of establishing the arboretum on some property still to be chosen . . ." Roberta Bole faulted herself for this oversight and for not trying to persuade her sisters or her surviving brother to give up the proceeds from the sale of the Bratenahl property of Liberty Holden after his death on August 20, 1913. "For several years I could not bring myself to speak of it," Robert Bole later wrote, "as I felt I had betrayed [my brother's] confidence." With her letter to Lake View in December 1927, Roberta Bole sought to correct those mistakes.

"That letter," Harold Clark said, "is one of the most important contributions that will ever be made to the Holden Arboretum."

If anything, Clark understated the impact of Roberta Bole's letter. It changed the Holden Arboretum's destiny.

Whether viewed in the immediacy of Clark's recognition or from the more distant perspective of Richard Munson, who directed the arboretum from 1995 to 2000, the importance of Roberta Bole's determination cannot be overemphasized.

"I try to envision what the Holden would be like if everyone had sat back and waited for the money from the trust before the arboretum was established," Munson said. "First of all, the arboretum would not be at its current location. This land would all be built up. Lord knows where the arboretum would be."

In the beginning, there were one hundred acres off Sperry Road near Kirtland, Ohio. That the arboretum was established at this site, with its potential for growth and unmatched geographic diversity, was largely Roberta Bole's doing.

Even before Lake View trustees, Cleveland city officials, and the Cuyahoga County courts accepted in December 1930 that the agreement between Bert Holden and Lake View Cemetery should be altered, Roberta Bole had commissioned Gordon C. Cooper, a Cleveland landscape architect, to study sites more distant from Cleveland. Cooper examined an area bounded by Lake Erie on the north, by

Painesville, Chardon, and Ravenna on the east, by Akron and Medina on the south, and by Grafton, Elyria, and Lorain on the west.

Cooper's investigation was meticulous and detailed. To substantiate his site recommendation, he conducted tests to determine how much soot fell at each location. Rainfall and snowfall statistics were documented, with an emphasis on the growing season. Cooper reported that the "primary consideration in location [had included] atmospheric conditions, qualities and conditions of soil, topography and accessibility." Cooper had a broad vision. Though he adhered to the strict definition of an arboretum as a "living collection of trees and other woody plants," he recognized the validity of what horticulturists from arboreta such as the Arnold advised: There should be a place for display gardens of herbaceous plants to attract the support of the public and, if possible, a diversity of topography that, in Holden's case, has become its hallmark. To grow more than five thousand species of trees, shrubs, vines, and small plants and provide for roads, paths, the necessary nursery, facilities sites, and contingencies, Cooper recommended in 1928 an arboretum of at least 350 to 400 acres.

"He developed the facts as to why this would be a good site," said C. W. Eliot Paine, director emeritus and a member of the Holden Board of Trustees, of Cooper's methodology. "Of course, his client *was* Mrs. Bole. I think he worked hard, probably, to develop it that way."

Without money from the Holden Trust, the seed acres would have to be donated if the arboretum were to have the developmental head start Roberta Bole desired. Cooper's choice of a site near the Bole property assured that the acres would be made available. If the outcome was predetermined, it also received the affirmation and blessing of some impartial observers, including Ernest H. Wilson and Dr. Edward B. Merrill of the Arnold Arboretum and Dr. John Wister, a professor at Swarthmore College. Bole invited them, separately, to visit each of three possible sites and offer their opinions as to which was best suited for an arboretum. After their visits, each man responded in writing. All came to the same conclusion. Because of its topographic diversity, variety of indigenous plants, varying soil types, swamps, gorges, and meadows, the Sperry Road site was not only the best immediate choice but also one with boundless potential.

"You will some day have the greatest arboretum in the world," Ernest Wilson told Roberta Bole. The Holden Arboretum has been trying to live up to that prediction ever since, growing, evolving, rethinking how it uses its many resources.

In December 1930, Roberta and Ben Bole and their son, Benjamin P. "Pat" Bole Jr. (1908–1980), created the core of the arboretum by donating one hundred acres of the Bole Farm, with the promise of more land. The potential of the arboretum clearly matched Cooper's estimations of what was required. The arboretum land and that around it—from Little Mountain to Stebbins Gulch—could hardly have provided a more perfect convergence of vegetation common to Northeast Ohio. Three forest types meet here: the beech, maple, and hemlock forest of the northern Alleghenies; the oak and hickory forest of Midwestern states; and the chestnut, oak, and yellow poplar forest of the southern Allegheny foothills.

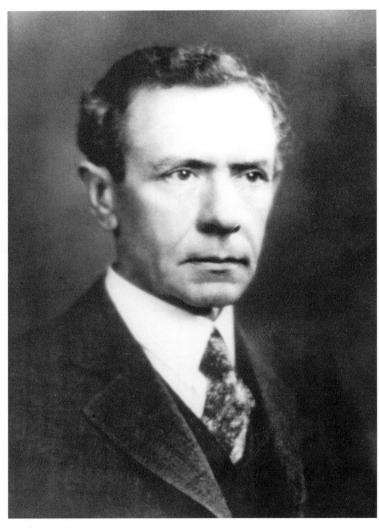

Benjamin Patterson Bole: Lawyer, Husband of Roberta Holden Bole, and Father of Pat Bole. Mr. Bole was Albert Holden's lawyer, who drew his will and codicils, which formed the trust that led to the creation of the Holden Arboretum.

As Dean Halliday explained to Cleveland Museum of Natural History members in a 1931 pamphlet titled "Significance of The Holden Arboretum," the land already included or had the potential for "upland swamps, hemlock-covered gorge walls, streamsides, lakes, lowland meadows, evergreen forests, wild gardens and heaths."

As much as great land was necessary to build and cultivate the arboretum, someone also had to supply start-up money and find people with the knowledge and energy to use it well. Again, the Boles provided the impetus, and at a time when the country was in the grip of the Great Depression. Equally important, the operation of the arboretum was placed in the hands of the Cleveland Museum of Natural History, which Roberta's husband Ben had helped to found and where son Pat worked as an assistant in charge of the Department of Mammalogy. Museum staff members became a working board: they not only guided the arboretum during its earliest days but also got their hands dirty performing the physical labor required. In addition to Pat Bole, the board included Dr. Arthur B. Williams, museum naturalist and ecologist, who oversaw some thirty acres of deciduous forest; Dr. John W. Aldrich, assistant in ornithology, who concentrated on swamps and planted the area around Buttonbush Bog; and Arthur B. Fuller, who was to become head of the museum's education department and at Holden oversaw the shrubs and flowering trees.

When he was preparing his report for Roberta Bole, Gordon Cooper emphasized the need for a broad-based source of support—and not just financial—if an arboretum were to succeed over the long haul and have the continuity required to flourish. "The lesson taught by early arboreta of this country—and for that matter of every other country," Cooper advised Holden, "is the futility of establishing them as private hobbies or ventures. The span of human life is too short and the continuity of purpose it affords is not sufficiently long. It is necessary, if arboreta are to accomplish the work it is intended they should, that they be attached to permanent institutions—colleges, foundations or governments."

The Cleveland Museum of Natural History was such an institution. The museum also presented the advantage of the Boles' direct involvement, thus assuring that Roberta Bole's promise to her brother would be in the hands of another Bole promise-keeper. In the working board's initial division of labor during the 1930s, Roberta's son, Pat Bole, not only took responsibility for the conifer plantings but also

drew plans for nine planting areas, concentrating on an overall effect. Limitations cut hard into wild dreams. Without water, equipment, or labor other than their own, the efforts had to be reasonable and well considered. In a word: limited. What these scientists could and did do, however, was follow Pat Bole's suggestion to divide the property into one-hundred-foot sectors to record existing vegetation and new plantings. Arthur B. Williams recorded everything two inches or higher. That was the beginning of the detailed plant records that are kept today and that are the scientific and educational lifeblood of an arboretum.

Such records separate a botanical garden or arboretum from a park, and that difference was important to Bert Holden. Just as the Cleveland Museum of Art records each of its works of art and knows where each is located, so too does the arboretum track each of its living pieces of art. "We curate our collections," said Holden's plant recorder. "You can't have works of art that aren't interpreted and researched. Just as an art museum would make a concerted effort to verify that a painting is a Rembrandt, we do the same with a tree that is a Rembrandt."

The arboretum has its share of woody Rembrandts, not the least of which is the nearly three-hundred-year-old oak that has been struggling through its final years in the Helen S. Layer Rhododendron Garden. When Gordon Cooper scouted the area in the late 1920s and early 1930s looking for reasons to locate the arboretum along the old Sperry Road axis, the ancient oak must have been among the inviting beacons that caught Cooper's eye. Likewise, the arboretum's plant documentation ledger offers a history—a story, as it were—of what has been added since 1931—and, sometimes, lost.

Emery May Holden Norweb, who married R. Henry Norweb in Paris in October 1917, planted the arboretum's first tree, a Washington Elm. It arrived at Holden rooted in the apocryphal tale that George Washington had stood beneath the limbs of the parent tree on Cambridge Commons to assume command of the Continental Army. The true story is still worth telling: General Washington's headquarters were located in the future house of poet Henry Wadsworth Longfellow in Cambridge, Massachusetts, and while he may not have taken command under the ancestor of the arboretum's tree, the Washington Elm stood in the vicinity—close enough for a good story. Like so many of the arboretum's elms, however, the great Washington Elm succumbed to disease, probably in the 1940s though no precise date is known. Now, only its history remains.

By the time she planted the Washington Elm, Emery May Norweb's resentment of her father's estate-planning and of the administration of the living trusts he had left his daughters had dissipated. She became as ardent about the arboretum as her father might have been had he lived, as ardent as her son would be during his tenure as Holden's first full-time executive director. This was a woman who had literally learned about the natural world at her father's side, a woman who could be as fearless in her pursuit of excellence as her demanding father had been and had required her to be.

Even when she was only seven years old, Emery May was allowed no more than two weeks of

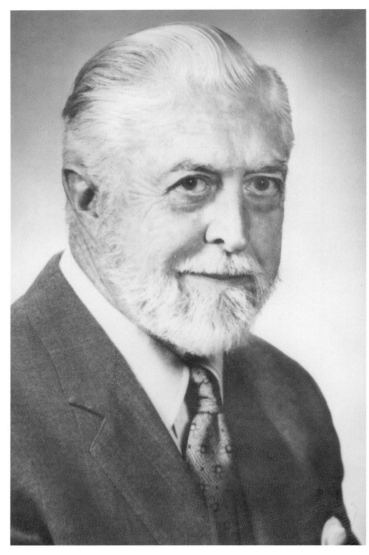

The Hon. R. Henry Norweb, 1975: Husband of Emery May Holden Norweb and Father of R. Henry Norweb Jr.

summer vacation as most children knew it. The rest of the time, her father told her, "you work." That meant tutors and study. She learned five languages (helpful, given her future husband's distinguished career in the foreign service). In 1908 when she was twelve, Emery May was placed in charge of her father's renowned mineral collection, which would be bequeathed to Harvard. Her experience went beyond the academic. Bert Holden took his daughter into the Utah mines to learn. She also traveled with him to the Alaskan frontier, where Holden had gold mines.

"I was delighted," Emery May would recall of the Alaska trip, "until I found I was supposed to be a useful person. In the morning, when they started out, they left me wherever we were and I had to catch fish for dinner." Bert Holden had given his daughter a man's name (Emery, for his father) softened by a middle name on which his wife, Katharine, insisted. After the death of both his wife in 1900 and eldest daughter Elizabeth in 1908, Bert Holden took such a fancy to Emery May (she always felt that she had a kinship with her father that exceeded blood) that he invited her hunting with him in Alaska. Emery May had her own .22-caliber rifle. "My father never let me have a heavy gun," Emery May said. "He didn't believe in it for women." She was carrying the small-caliber rifle along a narrow Alaskan trail one day—when she stepped around a large boulder and was confronted by a grizzly bear. The animal, standing on its hind legs, loomed over Emery May at its full height, which dwarfed hers. Emery May fired her .22. Her father, who was a step behind her, fired his larger-caliber weapon at almost the same time. The grizzly fell—on top of Emery May.

"Did I hit him?" Emery May asked her father when the bear had been dragged off her.

"Yes, dear," Bert Holden told her. "You gave him a very bad toothache." That's all her modest .22-caliber rifle would have done, but it had been enough to reveal even to the most demanding father the exceptional courage of his daughter.

Such childhood experiences grounded Emery May solidly in the natural world. Likewise, Emery May's Aunt Roberta influenced the woman she would become. After Emery May's father died in 1913 and Roberta Bole became one of her guardians, Emery May admitted: "I did not like her much but I toadied to her as much as I could, because she had a great deal of power." It was up to Roberta Bole, for

instance, to decide whether her niece could go to France in 1917 following her graduation from Westover School. Emery May wanted to accept a position driving an ambulance with the French Red Cross. Accompanied by a chaperone, she was attached to a hospital providing care for World War I casualties. Emery May's war effort was not entirely altruistic. She had secretly become engaged to R. Henry Norweb, whom she had met when she was at Westover and he at Harvard. Henry was serving on the staff of the American Embassy in Paris in 1917. Emery May failed to mention this to her aunt.

"I knew if I asked to go over and get married, I wouldn't be allowed to," Emery May said. "So I enlisted." Though she had no medical training, Emery May proved an asset to her ambulance unit because she was fluent in French (all those summers of study had paid off). While she served at the hospital, Emery May did not see Henry Norweb. But after Emery May had completed her contract, she and R. Henry Norweb were wed on October 18, 1917, in Paris. Roberta Bole had given her blessing.

"When one is young," Emery May said, "one's mind is small. And the things that [Aunt Robbie] did, I resented because I was young." As she matured, Emery May, who spent much of three decades (1917 to 1949) traveling to foreign-service assignments with her husband, became her aunt's staunchest ally in support of the arboretum, two strong wills supplementing what Bert Holden had willed into existence.

At almost the same time the arboretum was being established on the Boles' first hundred acres in 1931, successful Cleveland businessman Warren Corning was building his American country house estate, Lantern Court, on nearby land overlooking the lovely and precious Pierson Creek. Always interested in the natural world, Corning was captivated not only by the arboretum's potential but also by his neighbor Roberta Bole's enthusiasm for and dedication to establishing her brother's legacy. These very personal influences on the land and its fate were critical to the arboretum in the 1930s and remain so today.

Corning joined the arboretum board in 1937 and went to work. He oversaw the Lilac and Heath collections, becoming for years a day-in, day-out presence because of the proximity of his home and the depth of his interest. Ultimately, he became the arboretum's first unpaid administrator. His daughters, Alison "Sunny" Corning Jones and the late Ellen Corning Long, remember their father rising "at the crack of dawn" so he could visit the arboretum and talk with workers about the projects that needed to be accomplished that day.

The land drew Warren Corning to it. Through it, he made the most significant of his many important contributions to the arboretum. An inspired amateur horticulturist, he was always pinching off a sprig of some plant wherever he went in the world and bringing it to the arboretum's professionals to see if they could make it grow. Corning took an interest in everything in the natural world: birds, insects, plants, butterflies. In the master bedroom of Lantern Court, the proof of the quality and range of Warren Corning's butterfly collecting remains today in a coffeetable display created by his wife Maud. Maud

Warren G. Corning.
Surveying a wooded
area of the arboretum
on a wintry day in
1948.

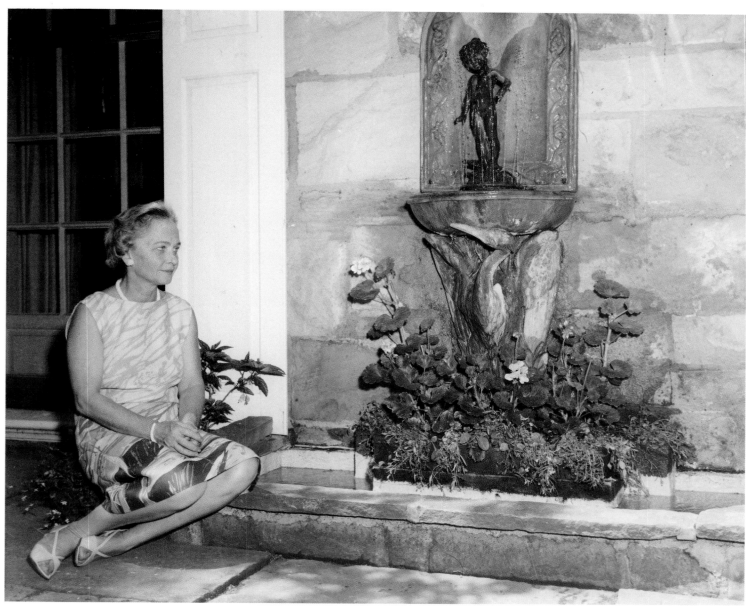

Maud Corning. Enjoying the fountain on Lantern Court's side patio.

Corning made important contributions of her own to the arboretum and was her husband's "sounding board," a member of a true family team, according to the late Ellen Corning Long.

The conversation at the Corning dining table invariably focused on the arboretum. "There was actually a point in our early teens," Ellen Long recalled, "where we children said: 'Ah, can't we talk about something else besides the arboretum?'" She knew the answer. The arboretum was figuratively and literally all about the Cornings. It was more than an institution of beauty and learning. "The arboretum," Ellen Long said, "is almost a spirit."

That the arboretum is a spirit that continues to grow stronger and affect Northeast Ohioans can be attributed not only to the Holden family and its descendants but also to Warren Corning and his.

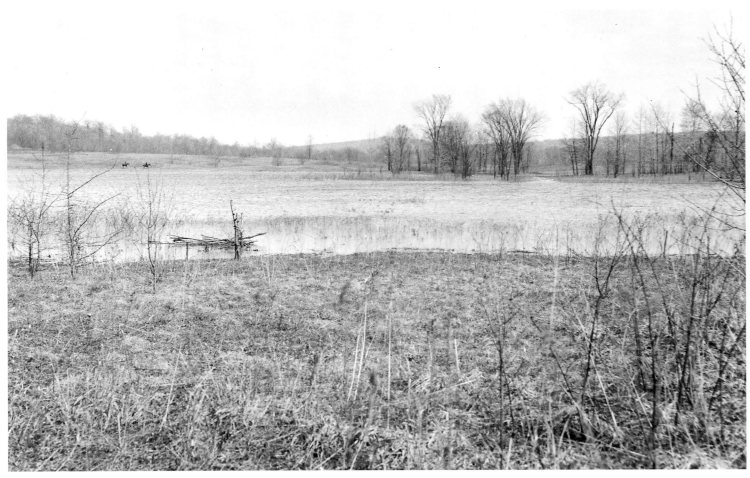

A View of Corning
Lake, May 21, 1939

Beyond Corning's everyday engagement and the immediate influence it had, his foresight and involvement in acquiring property for the arboretum has helped to make Holden the complex institution it has become, one with options and a diversity of influences. Size matters, and Holden has it. Its size allows for diversity and balance that is being sought between the educational possibilities of display gardens and the wild, natural opportunities at Little Mountain, Stebbins Gulch, or Carver's Pond.

Corning and other benefactors found themselves able to accumulate large land holdings. More than a hundred years ago, much of the arboretum land was owned as small parcels. Farmers eked out equally small livings. Orchards and vineyards dotted the terrain. Over the years, the wealthy purchased much of the land, consolidating it in fewer hands. The new landowners, many of them from Cleveland, bought property for weekend retreats. They were not the full-time residents that the Cornings became. They built stables. Resorts cropped up on Little Mountain. When their days had passed, a number of their descendants passed the land on to the public through the arboretum.

Corning's vision and inspiration outstripped that of others. When Interstate 90 was built east from Cleveland in the early 1960s, Corning recognized the pressure it would place on the land in the area

of the arboretum. He knew this land would be coveted by commuters with money. If the arboretum did not purchase it, or at least make arrangements to purchase it later when the income from the trust fund became available, the land could be lost forever, leaving the arboretum unable to grow or even to protect the land it had.

Corning preserved the land, which is what the arboretum continues to try to do today. Working with landowners, the arboretum receives conservation easements, whereby landowners agree to restrict future development of their land. Such restrictions are important as current patterns of suburban growth degrade ecosystems. The land often is subdivided into fragments. Even if a fragment is not built on, it no longer functions as part of a system. Landowners are motivated to give the arboretum a conservation easement because they love their land and wish to preserve it. They also may gain certain tax advantages for doing so. Preservation of adjacent or nearby lands is critical to the continued protection of the arboretum's natural resources.

Corning took it upon himself to convince his neighbors and others near the arboretum that they should either leave their land to the arboretum—and thus to the public—or allow the arboretum to purchase it. In the early days of the arboretum, it had no money for such purchases. Corning recognized that though one day the arboretum would have the interest from the Holden Trust—an endowment worth millions when the arboretum gained access to it in 1988—the timing of its availability would not prevent 1960s developers from grabbing the land first.

Over cocktails and dinners at Lantern Court, Warren Corning and his wife Maud talked to friends and neighbors about the arboretum and about what Henry Norweb Jr. described as Corning's "endless vision" for it, a vision which came to be shared by many others.

"My parents would not want to be singled out as too important," Sunny Corning Jones said. "They did so much with other people. I think that relationship of working with other people was my father's strength. Though he often had these ideas and wanted to grow the ideas, he would do so with a lot of counsel and good advice from other people."

Because of Warren Corning's example, others responded to the goal of making the arboretum a large outdoor museum with its now unsurpassed collections of woody plants and natural areas where people can learn about the natural world. Corning did more than talk. Alert to property for sale, Corning bought it and either leased it to the arboretum for a dollar a year or established an option for the arboretum to purchase the land at the turn of the century, after the Holden Trust endowment would be available.

Corning's personal investment gave him credibility. He suggested nothing to others that he himself was not doing. He began in 1937 by giving the arboretum almost forty-eight acres on which is located Corning Lake and followed that with an adjacent tract of nearly ten acres two years later. Corning's were the first land gifts after the Boles' original hundred acres. Corning created a vision and impetus that have done as much to define the arboretum as Roberta Bole's decision to write to the Lake View Ceme-

T. Dixon Long (right). A son-in-law of Warren Corning, succeeded to his seat on the Board in 1971, became President of the Board in 1982, and served as President until 1991, stepping down shortly after the death of his wife Ellen Corning Long. Dixon led the board through its most turbulent years from 1982 to the maturation of the Holden Trust in 1988. He calmed the waters and threw bread upon them by way of frequent contributions from the family trust. He played a large part in establishing the Corning Center (and later the Horticultural Science Center).

tery Association Board of Trustees to propose that the arboretum be located elsewhere.

"Without the land, you cannot do anything," said Richard Munson, former arboretum executive director.

The emphasis being placed on the educational and research possibilities of the natural areas today would not be possible but for the foresight of Warren Corning and the contributions of many others.

"No one at the time had the notion that large acreage should be used in a way that could track environment degradation," said Dixon Long, the late Ellen Corning Long's husband and member of the arboretum's board of trustees. "But the notion is emerging that in addition to a major set of educational and demonstration programs on the cultivated part of the arboretum, there would be a natural areas focus, a study of what is going on on the noncultivated part."

Warren Corning did so much for the arboretum on so many fronts that at times it seemed to the other member of the Corning team, his wife Maud, as if he did not receive the recognition he deserved. When Emery May Norweb's son Henry Norweb Jr. directed the arboretum from 1959 to 1983, this put him uncomfortably in the middle of the Cornings, who were unknowingly at cross-purposes. Norweb found his mentor "oddly enough, an unassuming person for being as arrogant as he seemed to be to people. He didn't want kudos. If he wanted to give you a desperately needed $10,000, if he could possibly wrap it [around] a brick and throw it at your head, this would be the way he would like to do it." Corning was a complex man, one with a genius for doing the right thing at the right time but, sometimes, in a mysterious way.

Corning would suggest to Norweb that he give an award to someone who had done something for the arboretum or who was particularly interested in it. Corning's hope was that the recognition would prime the pump for even greater involvement. This occurred on two or three occasions.

Even with people such as Warren Corning involved, the evolution of the arboretum from 100 to more than 3,400 acres, and from an emphasis on ecological plantings—native plants in natural settings—to a recognition of the need for systematic plantings of showy ornamentals was often difficult. Natural

and manmade disasters alike deterred progress and created daunting setbacks.

With funds scarce and full-time employees scarcer still during much of the 1930s, development of the first hundred acres proceeded slowly. (Roberta Bole did allow her employees, including Tom Eville, to do work at the arboretum on her time and money; Eville went on to become the important first superintendent.) Using stakes made from American chestnut trees killed by disease, the arboretum committee of the Cleveland Museum of Natural History, led by Pat Bole, staked out in 1934 the first hundred acres in units measuring 100 feet on a side. Land was cleared. Wetlands were nurtured and bogs planted.

By 1937, as the Great Depression relaxed its grip, if only slightly, and as Warren Corning joined Roberta Bole and Emery May Norweb in providing funds, the arboretum hired Eville and Harry Phillips as its first full-time employees, supported them with additional part-time help, and provided equipment and materials for plantings and for improving the physical facilities. The result was a locked entrance gate off Sperry Road, a service building, a dam on Lotus Pond, cinder service roads, seed beds, and other accomplishments.

Even at this early stage of development, a debate sprouted that continues today. The debate concerned the best way to allow the public as much access as possible to the arboretum without endangering the flora and fauna. The arboretum, after all, was supposed to be an outdoor classroom. Neighbors and others took an interest in the arboretum's development. The area, however, was closed to automobiles. In fact, by 1937 the public had not been invited to the arboretum at all and, apparently, would not be until the young trees that had been planted were larger and more established. Even Cleveland Museum of Natural History members had to obtain a permit to visit. In the beginning, the arboretum resembled a select club, and Emery May Norweb wanted that to change. She argued with Corning and Pat Bole about opening the arboretum to a broader audience, an argument for which she had support long before she won out and Holden was opened in 1947.

Shortly after he had addressed the Cleveland Museum of Natural History's annual dinner in December 1938, Dr. E. D. Merrill,

R. Henry Norweb Jr., 1983: First Director of the Holden Arboretum 1959–1983, Trustee 1957–1995, Grandson of Albert F. Holden, Son of Emery May Norweb and Hon. R. Henry Norweb. He saw the Holden Arboretum through its most difficult years into the beginning of its golden era.

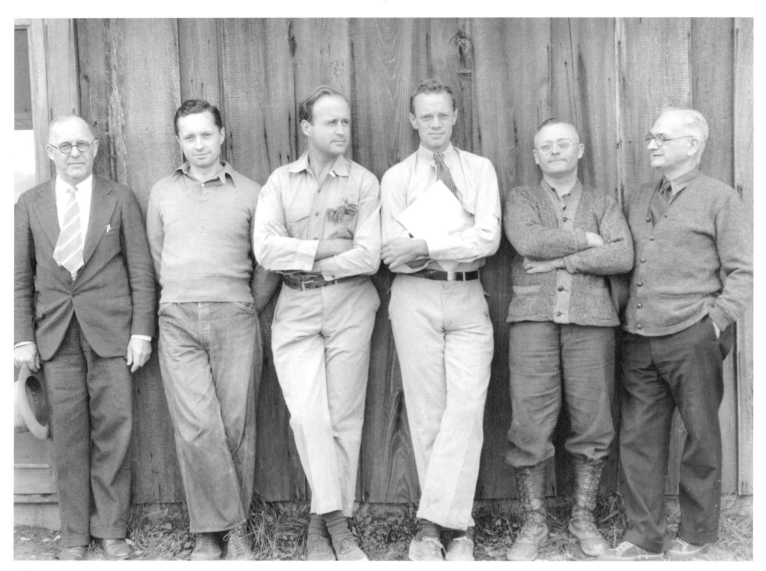

"The Committee,"
September 10, 1938.
Left to right: H. L.
Madison, J. W. Aldrich,
Warren Corning, Benjamin Patterson Bole
Jr., Arthur B. Fuller,
and Arthur B. Williams.
These men planned
and largely did the
physical work on the
Holden Arboretum
during the 1930s.

director of the Arnold Arboretum, suggested to Corning in correspondence that to generate interest, the arboretum needed showy plantings comparable to Arnold's lilacs. To educate people, arboreta first have to attract them. The following year, lilacs in nearly 150 varieties were planted at Holden. They were paid for by a Corning (Mrs. Henry W., Warren's mother), and the planting was designed by a Corning (Warren), with an assist from Gordon Cooper, the arboretum's consulting landscape architect and a continuing influence on Holden. More important, a plan for ornamental collections was generated, and finally there was the comfort of knowing that even a severe drought, such as the arboretum endured in 1939, would not prevent watering: Corning Lake, on the property donated by Warren Corning, had filled to overflowing, its nineteen acres becoming a navigational point of reference for pilots (not to mention migrating birds), as the largest body of water for miles.

Since the arboretum's earliest days, disagreements have occurred among the leadership and staff

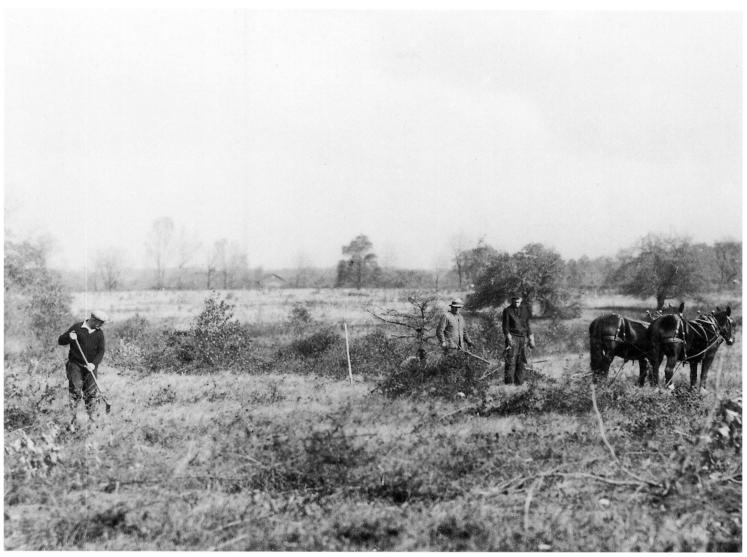

Clearing Brush from European Deciduous Unit—"First 100 Acres," October 1936

concerning not only how best to use the arboretum's resources but also which of those resources should be emphasized. Pat Bole, for instance, preferred native plantings to display gardens. Even in his 1928 report that guided the first years of the arboretum in the 1930s, Gordon Cooper addressed this issue, if only tangentially. He concluded that no matter how large an arboretum might be, there will be limitations, necessarily, on what it should try to grow, even if the climate is conducive to more varieties of plants than the arboretum possesses. The issue involves more than money—though money is important. (Cooper's criterion was that an arboretum would need a million dollars for every 125 acres planted with trees and shrubs. That was over and above the cost of the land.) The issue is what can be done well, what can be sustained—the continuity necessary in the building of a great place of woody plants and educational opportunities in nature.

A View of The Lilac
Planting, March 23,
1939

Holden was and is today many arboreta in one because of its land acquisitions and an emphasis on providing a diverse natural experience. As the plantings competed in open fields with grasses and weeds, winning their place in the landscape, people such as Pat Bole could hear on Yellowpine Hill "the wind whistling through the stiff-needled pines, just as it does along the north rim of the Grand Canyon." To others, the lilacs and the flowering crabapples spoke.

When the Museum of Natural History's Arboretum Board found its own voice in the late 1930s, what it had to say would have come to nothing had it not been for Tom Eville and Harry Phillips, who turned talk into action. Eville was only twenty-seven when he was hired as superintendent in 1937, but he was already an expert in the germination of conifer seeds and the care of young seedlings and nursery specimens. In the next three years, he became a builder of roads and ponds, knowledgeable about machinery and whether the use of it would save the arboretum money, and an expert on cataloging plantings—creating his own system. Eville, who died at thirty of complications from a tonsillectomy, left behind not only physical monuments but, as Pat Bole suggested, "a moving spirit" as an "intelligent

executor." Over the seasons, the arboretum has been fortunate to have a succession of such superintendents, including Paul Martin, Eville's immediate successor.

The loss of Eville in 1940 could not have come at a worse time. Options on adjacent land would increase Holden's holdings to more than two hundred acres. The Arboretum Board, with Gordon Cooper's counsel, had created a master plan for future plantings, both ecological and ornamental. No one thought this was the master plan to end all master plans, yet neither could Pat Bole, the chairman of the board, know how wrong he was when he reported that the arboretum now knew, more or less, how big it would be. No one, in fact, had any idea of the size Holden would attain.

Eville and Phillips had planted virtually every plant between 1937 and 1940. As Paul Martin took over and tried to maintain this momentum, he faced impossible odds. He had been Eville's friend, a Kirtland man whose qualifications to succeed Eville were "considerably the best of those who applied" (and there had been a number of applicants). Martin was not to have the benefit of Phillips's counsel or work, because he had long been suffering from leukemia. In the year after Eville's death, the disease had rendered Phillips too weak to work, except for brief periods. Phillips had been the chief planter of the arboretum's earliest forests, of its bog and, eventually, of everything that came out of the nursery. As far as Pat Bole was concerned, Phillips was "the best planter the arboretum has ever had"—and in that assessment Bole included himself.

Paul Martin, 1958: Superintendent 1941–1973. He carried the burden of maintenance, sometimes single-handedly, from the Depression through WWII and into the 70s, overcoming great odds.

To compound the loss of Phillips, John W. Aldrich, the board member responsible for planning the arboretum bogs, left in February 1941 for a position with the Fish and Wildlife Service in Washington, D.C. Aldrich did, however, leave behind a detailed plan for the bogs and the pine barrens that Bole would oversee and that Martin and his staff would execute.

As Gordon Cooper turned the Master Plan into an actual blueprint to follow, the resources to accomplish the plans were becoming increasingly scarce, from leadership to working staff to money. With the onset of World War II, the arboretum shared the problems and made the sacrifices of other American institutions.

In 1943, Roberta Bole was forced to step in and take over the agricultural and Victory Garden projects. The arboretum turned its cleared acres into fields of potatoes, corn, field beans, soybeans, oats, and hay. By 1944 all of the men who had been working on the food project were off to war or to better-paying jobs necessary to the war effort. The women had to take charge.

In addition to the war demands sapping the arboretum's manpower, natural disasters struck. The great flood of 1942 damaged arboretum property and, to some minds, its reputation. A sixteen-foot wall of water had swept down Pierson Creek and damaged properties in Kirtland Hills and Waite Hill. Though the flooding resulted from five inches of rain in less than two hours and not from changes arboretum personnel had made to the terrain, some people in the neighborhood had their doubts. The flood diverted Holden workers from normal property maintenance to the repair of lost ponds and broken dams.

At the outset of this difficult time, Emery May Norweb had been forced by changes in the tax code and increased financial responsibilities elsewhere to reduce her support of the arboretum. She provided $6,000 in June 1941, with the restriction that no more than $1,500 be used in any one year. This financial cutback immediately curtailed the arboretum's work agenda for 1942, shifting emphasis to the Victory Gardens.

In 1945, Warren Corning came home from the war, and with him returned the promise that had previously begun to blossom at the arboretum. Another later homecoming also had an abiding impact on the future of the arboretum. Emery May Norweb came home to Cleveland in 1949 after years of living abroad with her husband R. Henry Norweb Sr., who obtained the foreign service's highest rank when he was named ambassador to Cuba in 1945 by President Roosevelt. Upon her return to Cleveland, she joined the Arboretum Board of Control executive committee.

As the arboretum was run out of the Cleveland Museum of Natural History, which devoted the most personnel, the arboretum's management also had become exclusive, something of an old boys' club, its number small, male, and self-perpetuating. The men who did the early work also made the decisions. Holden seemed like their personal garden. Roberta Bole and Emery May Norweb objected. Together with Corning, they wanted broader representation and more independence, using as a model the museum's relationship with the Cleveland Zoo. The zoo was run by a board of control that included not only museum personnel but also interested community members.

Following the zoo model, the Cleveland Museum of Natural History in January 1947 approved a twenty-six-member board of control nominated by the arboretum. As the controlling board was expanding in membership and ideas, the arboretum was growing in size. In addition to another forty-acre gift from Roberta Bole, Eleanor P. Strong contributed an adjoining 151 acres. Additional amenities included the Albert Fairchild Holden Shelter. Katharine Holden Thayer funded construction of the shelter so that something tangible on the arboretum would be identified specifically with her father.

With the enlarged board of control providing broader, if at times unwieldy, management of the arboretum, Emery May Norweb's idea of opening to the public won approval. In May 1947, more than a

thousand people visited, paying twenty-five cents apiece for admission on Wednesdays, Fridays, Saturdays, and Sundays and entering without charge on Tuesdays and Thursdays (the arboretum closed on Mondays, as it does today). The gates had been opened.

During 1949 and 1950, the relationship between the arboretum and the Cleveland Museum of Natural History came under further scrutiny. Reports were written. Behind the scenes, talks occurred about the arboretum's future. Roberta Bole's death on October 28, 1950, crystallized how far the arboretum had come since her brother's death more than thirty-seven years earlier and how important she had been to the arboretum's progress. The arboretum was as much Roberta Bole's legacy as her brother's. Aggressive, visionary leadership would be needed to continue what she had started.

Emery May Norweb eulogized her aunt at a meeting of the board of control. She reminded everyone that "had it not been for Mrs. Bole, the Holden Arboretum would still be a paper item on the books of the Cleveland Trust Company instead of a living, vital entity in the civic life of Cleveland." If anyone in the family could carry on Roberta Bole's work, it was Emery May Norweb. The two women possessed similar wills of steel.

When the key meeting regarding the future of the arboretum arrived on January 25, 1951, Emery May Norweb applied one of the business lessons she had learned from her father. For more than a year the museum and the arboretum, in separate meetings and each in its distinct way, had been reconsidering how the arboretum should be governed. Emery May had her own ideas.

A report written in 1950 by a committee consisting of both Museum and Arboretum Board of Control members concluded that the large, unwieldy board of control should be reduced from thirty-two to nine members, with an advisory committee created to involve others. No action was taken on the report. During this period, Emery May Norweb had lunch with Harold Clark, one of the museum founders. He told her that the museum wanted to sever its relationship with the arboretum. Clark never offered a definitive reason for the proposed separation. Emery May's assumption was that it had to do with museum economies and a concern that the arboretum might overshadow the museum or—and this seems more likely—distract from the museum's broader purpose. In any case, leaders on both sides of the relationship wanted to sever it.

Initially, Emery May Norweb opposed the separation. But the more she thought about it, the more Emery May came to believe that the arboretum had reached a stage at which it should guide its own destiny. She did not, however, want this to appear to be the arboretum's idea. That might appear thankless. The museum, and particularly the dedicated circle of supporters to whom the arboretum had been more than just a part of their jobs, had been so important in the arboretum's early days. Emery May preferred that the museum appear to push the arboretum out of the nest.

Emery May Norweb maneuvered toward that outcome in a way that would have made her father proud. Because she had a conflicting obligation with the Cleveland Museum of Art Board of Trustees, Emery May had not planned to attend the Museum of Natural History trustees meeting on Jan-

uary 25, 1951. The more she thought about that meeting, though, the more Emery May became convinced that this would be the decisive moment: "I'll bet you," she told herself, "this is about the arboretum."

So she skipped the art museum meeting and instead showed up at the Union Club in downtown Cleveland. As Emery May walked in on the Museum of Natural History trustees, people stirred in their seats. Maynard Murch, the museum's president, stopped what he was doing.

"But you weren't coming," Murch said to Emery May.

"I changed my mind," she explained.

Then Emery May sat down and remained perfectly quiet. As she had anticipated, the subject turned to separating the arboretum from the museum. Emery May listened intently. The language of this action would matter. So would the actual execution. It would create the first impression of a stand-alone arboretum. An arboretum that seemed secure in itself, yet not so arrogant as to demand independence, might expect to find in the community the support that would be necessary, before and after the Holden Trust funds became available.

When Maynard suggested the museum board take a vote on separation, Emery May Norweb asked that, because of the vote's significance, the board be polled. No anonymity allowed. This jury would be held accountable. In particular, Adrian Joyce, chairman of the board of trustees, wanted Emery May to share her thoughts with the group. He wanted her on the record. Emery May, her father's daughter through and through, was circumspect, choosing her words as carefully as she had been listening to the words chosen by others.

Emery May Norweb conceded that the arboretum board members had met to discuss the advantages and disadvantages of separating from the museum. And, she told the museum board, those leading the arboretum "felt they could manage it." Not that they wanted to do this or demanded it. But they *could* manage it. The key contributors to the arboretum's success, however, were not unanimous. Warren Corning, longtime museum board member, opposed the separation, and abstained from voting.

As important as the unanimous separation vote was (excluding Corning's abstention), Emery May went away even more satisfied that Murch had made it clear the separation was the museum's idea. She never did find out exactly why Murch and others wanted the separation (she continued to believe it was both for economic reasons and so that there would be no chance that a piece of the museum would one day overshadow the whole).

Though there would be challenges and difficult days ahead for the arboretum, Emery May Norweb would be among those who saw to it that independence would further her father's dream, one that she, her sister, her Aunt Roberta, Pat Bole, Warren Corning, and many others had made come true.

Late in 1953, the year after the Cleveland Trust Company and a Cuyahoga County court approved the separation (it was a legal arrangement), Warren Corning suggested to the new, independent govern-

ing board that the arboretum hire a plant propagator. Corning wanted someone to bring to the propagation of plants the passion that he had demonstrated for accumulating land, a passion that he would continue to exhibit and would pass on to R. Henry Norweb Jr., his handpicked successor.

When propagator Lewis Lipp joined the arboretum in 1954, he already had the reputation for being a proficient plant propagator. Lipp's career at the Arnold Arboretum had been facilitated by and closely tied to Dr. Karl Sax, the Harvard geneticist who was Arnold's director. When Sax retired at the end of 1953, Warren Corning seized the opportunity to try to lure Lipp to Holden. Lipp did not need Holden nearly as much as Holden needed him. He held the prestigious position of chief propagator at the Arnold Arboretum, early on Holden's main source of advice and inspiration. What could Holden, the upstart, have to offer? Acres and acres of opportunity.

Though comparatively young and struggling, the Holden Arboretum, thanks to the foresight of Warren Corning and his colleagues, presented Lipp with a large, blank canvas compared with the Arnold Arboretum. Arnold required only a finishing brush stroke here and there. Holden was land on which a propagator, especially one as single-minded as Lipp, could leave a mark.

Lewis Lipp: First Horticulturist at the Holden Arboretum 1954–1972. Shown in the greenhouse, January 15, 1966.

Lipp's strength as a grower of plants was born of a frailty: childhood polio that left his legs weak and motivated his father to seek ways to strengthen them. He hit on sending his son to agricultural school because of its outdoor emphasis and physical demands. Lipp did not come away with a college degree, but he fell in love with plants—with growing them, with reproducing them, and, ultimately, with sharing his results and his knowledge with others. Some plantsmen have green thumbs, but when it comes to teaching others, their thumbs look more as if they have been hit with a hammer. Warren Corning was like that. He knew plants. He loved them, as Lipp did. He just did not have the knack for sharing that knowledge. Even Corning's children recognized this.

"Dad wasn't a great teacher," the late Ellen Corning Long said. "Lew Lipp was the teacher. He taught us what was what and why certain procedures were done. I'd ask Dad: What's this we're taking cuttings of? And he'd say: 'Oh, it's a viburnum.' Well, there are hundreds of viburnum. Lew would tell

me the genus, species, variety, source, etc." Lipp could sugarcoat all this knowledge with a sense of humor that made his enthusiasm contagious.

It was a fortunate combination for the arboretum. People around the world who loved plants loved Lew Lipp. When he asked them if they would share cuttings or seeds, they did so eagerly. "We never had a person who did better public relations work for us, particularly in a period of struggling," Henry Norweb said. "He could sell himself." And that meant Lipp was also selling the arboretum.

This was particularly important during Lipp's eighteen years with the arboretum, when there was no money for the international expeditions that Peter Bristol, a later director of horticulture, and others would take. Those trips to Korea, China, and elsewhere yielded not only knowledge for arboretum horticulturists but also plant material. By comparison, the accessions in the 1950s and 1960s resulted from seed exchanges with other institutions. What Lipp accomplished with the seeds and cuttings he collected was remarkable.

Lipp taught two Holden directors much of what they knew about plants: Henry Norweb, who was a historian, not a horticulturist; and C. W. Eliot

Lew Lipp Inspecting Propagating Area with Corporate Board Members, May 14, 1971

Paine, who first came under Lipp's spell as a teenager in Boston in 1952. Both men, the historian and the young man who would become the first Holden executive director to have earned a degree in horticulture (Cornell, 1958), came to the same conclusion about their mentor: Lipp was the best plantsman they ever saw or heard of.

"He could root anything," Paine said. "He was probably the best propagator of woody plants in the country."

Lipp's personality complemented perfectly the expanding landscape that was his canvas. "He worked from dawn until dark, seven days a week," said Paine. "That was his one and only hobby. He played no sports. He was only interested in plants. So he collected this vast amount of material. The greenhouse was just bulging with plants."

Despite how hard Lipp worked, it was luck that had led to his discovery of a propagation tech-

nique that made him famous. In a way, though, even his luck fused with his work ethic: Expecting visitors at the Arnold Arboretum greenhouse, Lipp wanted everything to be in its place and nothing to distract from the plants. While he was cleaning, Lipp removed a piece of plastic from view by tossing it under a bench and on top of a flat of cuttings. Afterward, he forgot about it. A couple of weeks passed. Lipp, spying the plastic, removed it from the flat and discovered plants that were well rooted and flourishing. Lipp's accident became known as plastic-tent propagation, a horticulture industry standard ever since.

Given the caliber of Lewis Lipp's horticultural reputation, recognized even outside the industry in 1953 in such magazines as *Newsweek,* only the convergence of Lipp's predilection for the budding possibilities of Holden and the changing circumstances at the Arnold Arboretum made it possible for Holden to attract someone of his renown.

The Lipp-Corning connection became even more established and better known in the community when Lew Lipp joined Warren Corning's wife Maud in 1955 to create a Horticultural Therapy program at Holden, one of the first such programs in the country. Using plants as a means to improving the health of people—physical and psychological—may date back to the ancient Egyptians. Lipp's first experience with the concept occurred during his service in World War II as a navy corpsman. His patients responded to planting and caring for plants, a program Lipp continued and refined at the Arnold Arboretum.

Since the 1950s, the horticultural therapy program has evolved to include a full-time horticultural therapist conducting programs and providing consultation with healthcare professionals. The horticultural therapist travels to healthcare facilities to conduct therapy sessions in which people coping with diseases, injuries, disabilities, or simply the aging process learn that working with plants can provide insights into their own situations and opportunities to improve physical and mental health.

Metaphors are often used. Pruning, for instance. People learn the value of pruning plants—that cutting a plant back will allow it to flourish again. Such principles can apply in everyday life: that reducing stress, for example, may allow a person to maintain a better overall level of health. In the process, participants also have the opportunity to contribute to a plant's health. Caring for plants is a role reversal for individuals who have been receiving care.

Today, Holden most often takes horticultural therapy to the person. In the 1950s, Maud Corning would climb into her station wagon and drive to Cleveland to pick up a group of residents from the Golden Age Center. She would drive them back to the Cornings' family home, Lantern Court, on the edge of the arboretum. There, Lipp would meet the group and talk about plants, explaining how to start and grow them and giving his students a feel for how important the care they provide a plant could be. The senior plantsmen and -women would also visit the greenhouse and the arboretum collections, including the beginnings of the Conifer Collection, one that, Paine believes, is Lipp's greatest legacy.

As soon as he arrived at Holden in 1954, Lipp began acquiring the conifers that comprise Hold-

en's more than 450 species on forty acres. The now majestic spruces, pines, firs, and a few deciduous conifers greet visitors entering the arboretum at Kirtland-Chardon and Sperry roads, their wide limbs like the open arms of an evergreen welcoming committee.

Planting began in 1959. By the beginning of the twenty-first century, a Norway spruce that is nearly fifty years old had grown to more than sixty feet. Lipp conceived the collection not only for its intrinsic beauty but also to demonstrate that the main genera in the pine family are suitable for landscaping in Northeast Ohio. Planted east of old Sperry Road, most of the collection lies west of new Sperry Road, extending north to Hourglass Pond.

Beginning with the early days in the 1930s, when Pat Bole sketched a plan for the original hundred acres, there have been a number of studies of the arboretum and master plans created for it, the latest being formulated by Andropogon Associates in 2000–2001. Among the tasks assigned Andropogon, a landscape architecture and ecological planning and design firm from Philadelphia, has been to identify the best way to improve access to collections, such as the conifers, that are comparatively remote from the Warren G. Corning Visitor Center.

In the 1960s, the arboretum's trustees briefly considered a plan that would have altered the arboretum irreparably. Clark and Rapuano, planners from New York, envisioned engineering greater accessibility. The plan would have involved significant road building and the spanning of Pierson Creek with a suspension bridge. Rather than creating access to the land, this smacked of abuse of the land, particularly of natural areas such as Pierson Creek, in Corning's opinion. He urged the trustees to visit the Morton Arboretum near Chicago. There they could glimpse Holden's future if such a plan were adopted.

On beautiful spring weekends, vehicles clog Morton's roads. Its parking lots became packed to overflowing. Visitors see nature through the windshields and side windows of their cars. Corning refused to let this happen to Holden, even if it meant living with difficult access to certain collections. The trip to Morton convinced the trustees to abandon thoughts of building a spider's web of roads. Even so, Corning left nothing about the future to chance. He altered the specificatioins on the leases that the arboretum held on hundreds of acres of Corning land. The land would eventually be given to Holden or sold to the arboretum at a reasonable price. One new provision: no roads or bridges could be built on property acquired from the Cornings. Corning's restrictions irked some trustees, including Emery May Norweb, who had funded the Clark and Rapuano study.

Emery May Norweb did not like Morton's roads any more than Corning did. She thought they were too finished and distracted visitors from the natural beauty and learning opportunities around them. She did, however, want to assure people the means to get into collections such as the conifers, to listen to the songbirds that thrive on conifer seeds, to look for the small mammals that seek protection in the collection's tallgrass meadow, maybe even to a spot a great blue heron working in Hourglass Pond for fish.

Emery May thought that small satellite parking areas could be created off Sperry Road, opening

the Conifer Collection and other collections to more visitors. It is an issue to which her son, Henry, and his successors have sought solutions.

For those who love woody plants and glorious natural settings, the Conifer Collection should be seen as more than a reminder that it is Christmas every day at the arboretum. The conifers are the essence of the prospects Henry Norweb embraced as the first paid director of his grandfather's legacy.

"I think the reason I got excited about the arboretum," Henry Norweb said, "was the vision had been so great that the problems were really exciting. For this I always thank Warren Corning. He had acquired, in terms of all reasonableness, too much land. Lew Lipp, the propagator, had acquired, beyond all sense of reasonableness, too many plants. How do you let such a challenge go?"

Henry Norweb was born to the arboretum, though he grew up in faraway cities where his father's diplomatic career took the family. He actually had in mind a career path that led nowhere near the gardens or into the woods.

Norweb graduated in 1940 from Harvard, where he studied history. In the end, though, his family history would prove more compelling, his destiny unavoidable. But before he became the first paid executive director of the arboretum, Henry Norweb had enough of a taste of the world to know himself and what he did well.

People were his strength. He had a knack for making things work right. Norweb had planned to attend graduate school at Stanford University, perhaps following in his father's globetrotting, diplomatic footsteps. A summer of reporting for the *Cleveland Plain Dealer,* the newspaper his grandfather had published, convinced Norweb that he preferred being in the thick of things. He soon was.

Like so many young men who came of age in the 1940s, Henry Norweb wound up serving in World War II. He joined the Ohio National Guard and served in several other branches of the armed services, including the 107th Armored Cavalry Regiment, which needed radio operators. Henry passed himself off to a sergeant as a radio operator, even though Henry's previous experience with radio consisted of listening to one.

Henry Norweb was motivated by a desire to be helpful and a sincere faith in himself, the same faith that would permit him to plunge into the world of arboreta with little knowledge of plants. In the air force, Henry became an officer—he was discharged in 1946 with the rank of captain—and a radar expert. Through it all, from shortwave to radar and whatever else was asked of him, Henry Norweb saw himself as an administrator, a man who could figure out what a job required and work with others to get it done. That's what he was doing when he became director of the arboretum. He had returned to the *Plain Dealer* after the war, first taking on an assignment in engineering at the radio station owned by the newspaper and then moving into sales. In the 1950s, Norweb had become a vice president for a Cleveland manufacturing firm when circumstances presented the perfect opportunity for Warren Corning to approach the grandson of the arboretum's benefactor about becoming involved at Holden.

Henry Norweb had been running the manufacturing company in the absence of the president,

who had had a heart attack. When the president recovered, Norweb returned to his job as vice president of operations, but it no longer was a good fit.

"I had run the company for too long," Norweb said.

It took Henry Norweb a while to recognize that the arboretum was, on the other hand, the perfect fit. If it was not immediately obvious, he was led, systematically, to that inevitable conclusion by Warren Corning. Corning's fingerprints were all over the transfer of leadership to Norweb.

First, in 1957, Corning involved Norweb with the arboretum as volunteer assistant executive administrator. Then, when Henry's mother Emery May resigned from the Holden Board of Trustees later that year, Henry was named to replace her. In 1958, Corning relinquished the position of volunteer executive administrator, all the while introducing Norweb, his replacement, not only to the right people but also to the importance of acquiring land that Holden would need for diversity, growth, and self-protection. Norweb was perfect for the job. He had his father's diplomatic skills. His administrative abilities exceeded those of the visionary-but-sometimes-distracted Corning and meshed with Holden's need to put together the land and the plants that were proliferating under the green touch of Lew Lipp. The need, Norweb recognized, was to meet these difficult challenges with practicality rather than simply "vision and osmosis."

As volunteer administrator, one of Norweb's initial jobs was to find the right person to become the first salaried executive director. "So I spent about a year," Norweb said, "trying to find a practical manager and one day, somehow, going around a corner, I found myself." It was so obvious: Holden had all this marvelous land and all these glorious plants and no support system to make the best use of them. Creating such a stable system, given the arboretum's limited and uncertain resources of 1959, would require not only administrative acumen but also the kind of resolve and dedication often associated as much with love as with business.

Elizabeth Gardner Norweb, Henry's wife, whom everyone called Libby, had reservations about her husband taking the arboretum executive director's job, because horticulture was not his field. She had met Henry at a wedding during the war when the air force had sent Norweb back to Harvard to learn radar operations. A librarian, Libby Gardner was working at the Maine State Library. They were married in 1944, the year after they met, and if there is one thing that Libby Gardner knew from the beginning and never doubted through the years, it was: "Henry was not lacking in brains."

When Henry Norweb ran into himself looking for an executive director, he knew the arboretum lacked sufficient staff to care for the 1,400 acres to which it had grown by 1959. Besides Lipp, there were only Paul Martin, Holden's superintendent, and two workmen, Archie Alderman and Floyd Bell. Sometimes, the arboretum did not pay them on time. Warren Corning would leave his downtown Cleveland office with checks for the arboretum staff but forget to distribute them because, when he got to Holden, he became caught up in the horticultural business of the moment. Norweb sought to bring order to paydays. That could require ingenuity.

Dick Munson one day would join the line of executive directors of which Norweb stood at the head and for which he set the standard of concern. In the 1970s, during the first of Munson's two stints at Holden, he was not aware of a fact he would later learn as director: On Fridays, Norweb would sometimes be forced to scurry around to trustees to ask for funds to cover the payroll. Failing that, Norweb was known simply to dig into his own pocket for enough cash to deposit in the bank to allow him to issue checks to the employees.

"That's how tight it was," Munson said. "I was never aware. Henry did a masterful job of keeping this place going with no money."

Norweb could hardly do otherwise. The arboretum employees seemed less like staff and more like family. Longtime members of the family such as Bill Isner, supervisor of the Helen S. Layer Rhododendron Garden, lament the inevitable loss of that feeling as the size of the staff increased to about a hundred full-time and seasonal employees by 2001. Superintendent Paul Martin was personally on the grounds with his staff. Henry Norweb and his family also became figures familiar to every employee.

Elizabeth, "Libby," Gardner Norweb, 1963: Wife of R. Henry Norweb Jr. First librarian in the first library at the Holden Arboretum. She catalogued and arranged the early gifts from the Corning Horticulture Collection in addition to the growing library on botany and horticulture.

Before the Norwebs moved to the former Bicknell home adjacent to the arboretum, Henry Norweb drove from Shaker Heights to Kirtland each weekday and often on weekends. Connie Abbey, Norweb's youngest daughter and now a Holden trustee, looked forward to Sundays at the arboretum with her father, her brother Harry (Henry Norweb III), and sister Emery May Royall. They would rise before the sun, get to Holden by 6 A.M., and join the birdwatchers. Then Henry Norweb would take his daughter to Mentor for breakfast at Kenny King's. Afterward they would return to Holden and Connie would help Paul Martin's wife, Elizabeth, distribute to visitors "little A-B-C brochures about birds or insects or trees, just anything Dad could afford to have Xeroxed or printed." There was not yet a Warren G. Corning Visitor Center, only a small shack from which the volunteer members of the Holden family welcomed people to the arboretum. (As a reminder of that time, the shack still serves as a shelter and bird observation post at Corning Lake.)

Connie Abbey was not the only family member Henry Norweb persuaded to come to the aid of the

arboretum. Libby, with her education and experience as a librarian, possessed a skill that the arboretum required if it were to live up to the educational standards that Norweb's grandfather expected from it.

"Would you like to take care of the books?" Libby remembered Henry asking.

There was one problem.

"There weren't any books," Libby said.

That suited the circumstances. There was no library in which to put them. Libby Norweb set up shop on a card table in a corner of the administrative Cooper Building. Superintendent Paul Martin contributed the first books (there was, of course, no money to buy books). Martin's collection consisted primarily of books from his days as a student at Ohio State University. "Largely," Libby Norweb said, "they dealt with growing corn and potatoes."

Gradually, the collection grew to include books and periodicals more useful to those engaged in horticulture. Warren Corning proved particularly generous. Corning had built a collection of practical horticulture books and rare botanical books of inestimable value. He would show up at the Cooper Building and enigmatically drop off from three to fifteen books on Libby's desk (a step up from the card table). When Libby came in for her one day of volunteer library work each week, she could not be certain of Corning's intentions. He left no instructions. Did he intend for her to dust his books, care for them temporarily, or integrate them into the arboretum's growing permanent collection?

As with the land itself, Corning's contributions and influence were anything but short-term. He valued the books, as did Libby Norweb, not so much for their cost as for their content. During her years as the volunteer librarian, from 1963 to 1978, Libby Norweb increased the arboretum's collection from 300 books to between 4,000 and 5,000. They are now housed in the Corning Library.

Warren Corning approached the acquisition of his rare books systematically, recording in a series of little black notebooks the purchases he made during his world travels and those from dealers who were happy to send him items on approval. He would take his time deciding whether to make a purchase. He would negotiate, rejecting items he considered overpriced. Early on, he sought the advice of the library staff at the Garden Center of Greater Cleveland. In return, Corning, desiring the people of Cleveland to have a gardening resource, allowed his books to be housed at the Garden Center.

The facility, located near an underground creek, sometimes ended up with water in its basement when the creek flooded. Books had to be rescued. Corning drove into Cleveland and took back most of his books. It was these books that he eventually moved from Lantern Court to the Cooper Building library at Holden. Today, four-fifths of his collection is housed at Holden's Corning Library. The other fifth remain at the Cleveland Botanical Garden, successor to the Garden Center.

Because books are fragile, researchers and participants in supervised classes are the only library visitors allowed direct access to the rarest of Corning's collection, which is particularly rich in herbals and classic illustrations, the earliest from 1483. Holden's curator of rare books has made much of the information accessible through his book, *Cleveland's Treasures from the World of Botanical Literature,*

the result of the Cleveland Herbals Project, in which the arboretum participated with the Cleveland Botanical Garden and the Cleveland Medical Library Association. Examples from the rare book collection are on display.

That pride of association also led to another unusual contribution to Holden, its first reception center beyond that little hut from which Connie Abbey and her siblings distributed information. During the early years of Henry Norweb Jr.'s tenure as executive director, the arboretum remained, in essence, a private club. Because it lacked physical facilities other than the reception hut and outhouses, winter brought the limited activities for members (and the occasional opening to the general public) to a halt. On one occasion in the early 1960s, with the weather crossing fall's bridge from crisp mornings and comfortable afternoons to the all-day bite of early winter, Katharine Holden Thayer paid a visit to the arboretum. During the course of visiting an outhouse, it came to Mrs. Thayer's attention how off-putting Holden's facilities were.

"All I can imagine," Norweb said, "is there had been a very cold updraft."

Whatever the stimulus, Katharine Thayer was annoyed. At the conclusion of her visit, she steamed up to Henry Norweb, exasperated with the outhouses. She said that the arboretum must provide "proper washroom facilities." Norweb explained that the arboretum had neither running water nor electricity, both prerequisites.

Katharine Thayer said that the lack of utilities should not stop the arboretum, that she would fund the project, including such necessities as water pipelines and sewer plants. Plans were drawn. But when Norweb showed them to Thayer, she had developed a vision beyond the architectural renderings of all-weather washrooms.

"Henry," Katharine Thayer said, "I can't possibly have my name on washrooms. Put them in the basement and put something on top of them."

Twenty years later, the memory still made Henry Norweb laugh.

"So that," he said, "is how we got our first all-weather reception building."

The Thayer Center, for which Katharine Thayer contributed $55,000, changed Holden. It not only made available indoor facilities for the first time but it also made more accessible the Arboretum itself, in all its horticultural and natural glory. Since 1965, the arboretum has been open year-round. It shed some of its exclusiveness and sank its roots deeper into the Northeast Ohio community.

Warren Corning had introduced Henry Norweb to the community movers and shakers. They included both those who had dedicated themselves to furthering the arboretum's horticultural goals and those supportive nearby landowners whose outright gifts of land or willingness to sell it to the arboretum created a buffer to the Boles' first hundred acres and the rest of Holden's core holdings. These were the arboretum's friends. Others harbored resentment that the arboretum, a nonprofit organization, paid no taxes.

"There has always been some feeling, more in Kirtland than anywhere else," Norweb said, "that

Katharine Holden
Thayer, Emery May
Norweb, and architect
John Terrence Kelly at
1965 dedication of
Thayer Center

it is terrible to have all this land off the tax duplicate when it could be developed and taxes generated for schools and so on."

The fact that the arboretum crossed so many boundaries alleviated some but not all of the civic hostility and spread the loss of potential tax revenues over Lake and Geauga Counties, the city of Kirtland, Kirtland Hills Village, and Chardon and Concord Townships. It was incumbent on Norweb, and even more so on his successors, to build relationships with governmental leaders and to try to heighten their appreciation of the rare natural asset that the arboretum preserves for everyone.

C. W. Eliot Paine, who succeeded Norweb as executive director in 1983 and served until 1995, continues to serve on the board of trustees and returned for nine months as interim executive director in the latter part of 2000 and the first months of 2001. Paine seemed destined for a career at the arboretum. As a sixteen-year-old in the early 1950s, he had volunteered at the Arnold Arboretum in Boston and worked with Lewis Lipp, who was to end up at Holden and make a lasting impression. After Lipp had moved from Massachusetts to Kirtland in 1954, Paine, then a student at Cornell University, won a summer job at Holden in 1955, sleeping under canvas at neighboring Red Oak Camp before cabins were built there.

Following graduation in 1958 from Cornell University, graduate work at the University of California at Davis (M.S., 1960), and a stint in the navy, Paine found himself casting about for a job in 1964. Corning got word of it. He telephoned Paine in New York. The conversation was typical of the complex, generous Corning. Why use a hundred words when ten will do? The conversation went something like this:

Corning: Paine, we understand you are looking for a job.
Paine: Yes, sir, I am.
Corning: Well, you've got to come see us at the Holden Arboretum.

C. W. Eliot Paine could not get to Kirtland fast enough. When he arrived, events unfolded in a strange way (strange, that is, unless a person knew Corning). Paine interviewed with Norweb, the executive director, and was told that his interest in working at Holden was appreciated but that there was no job. Lew Lipp and his wife, Arlene, took Paine to lunch. Lipp knew something his boss did not: "Don't you worry," he told Paine. "Something will happen."

It did. Not until many years later—after Paine had gone on to become director of the Garden Center of Greater Cleveland in 1970 and then had returned to Holden as executive director in 1983—did Paine learn exactly what had happened. Warren Corning had provided the money to hire C. W. Eliot Paine as an assistant horticulturist. As Corning knew, people were as important as the acquisition of land to Holden's development.

When Paine took over from Henry Norweb in 1983, he set about improving what he found upon his return to Holden to be "some very nasty relationships," ones that had deteriorated into lawsuits and had even resulted in an illegal Kirtland admissions tax aimed solely at the arboretum. The road to better relations, oddly, was paved not only with good intentions on the part of Paine but also with asphalt. It was Sperry Road.

Paine, the plantsman who had grown up under the tutelage of Lew Lipp, had formalized and honed his people skills during thirteen years as director of the Garden Center of Cleveland (Cleveland

C. W. Eliot Paine: Second Director of the Holden Arboretum. Eliot started his career in plants under Lewis Lipp at the Arnold Arboretum. When Lipp moved to the Holden Arboretum, Eliot followed for a summer job again under Lipp. Following a horticultural education, he was employed again at Holden holding various jobs, but finally as a teacher and Education Director. In 1970, he left to assume the newly vacant position as Director of the Garden Center of Greater Cleveland. After 13 years of successful leadership there, he came back to the Holden Arboretum in 1983 as successor to Henry Norweb.

Botanical Garden), beginning in 1970. He had always had a knack for making people like him. Warren Corning discovered as much.

After arranging in May 1964 for Paine to be hired as assistant horticulturist, Corning had invited the young man to the Cornings' Fourth of July celebration. Paine was to spend the weekend in the cottage at Lantern Court. He stayed for six years.

"Mr. Corning always introduced me at parties and receptions as the house guest who didn't have enough sense to leave," Paine said. "We got along very well."

In return for his cottage, Paine cared for the Corning greenhouse—"That wasn't work. That was fun"—growing flowers that decorated the main house. As he had done throughout his relationship with the arboretum, Corning, by providing Paine's living quarters, was helping to defray an expense the arboretum otherwise would have assumed directly.

There was another fringe benefit for the arboretum. Paine had the opportunity to see the arboretum through the eyes of the man who had, arguably, cared more about it than anyone, building up its resources with a vision that Paine would need to develop if he were to untangle the web of conflict that had stalled the prospect of making Holden more accessible and visitor-friendly by constructing a new Sperry Road. No one had ever thought of the idea that Geoffrey Rausch of Environmental Planning and Design of Pittsburgh came up with in the 1980s.

Old Sperry Road cut arrow-straight through the heart of the arboretum, practically bumping into Hourglass, Heath, and Lotus Ponds on the west and Corning Lake on the east. The road belched dust in summer's dry season and swallowed vehicles up to their lugnuts in the mud season of March. Kirtland maintenance trucks dumped load after load of gravel onto the road. It all disappeared into old Sperry's gravel-eating maw.

After Environmental Planning and Design's initial idea of moving the Visitor Center to the top of old Sperry Road overlooking the Norweb home was rejected as an inappropriate setting, Rausch proposed moving Sperry Road.

"You can't do that," Paine told him. "You can't just take a municipal road and close it. That isn't going to work. It has been there for a hundred years."

Kirtland officials shared Paine's skepticism. Rausch stood his ground. He said relocating Sperry Road was the best way to provide the visitor with a beautiful view of the property and advance the concept of an arboretum-within-an-arboretum. So Paine launched a campaign to win over Kirtland Mayor Mario Marcopoli, the Planning and Zoning Commission, and the City Council.

Paine invited the public officials to the arboretum. He took each of them for a ride or walk on a pathway that had been mowed to follow the course of the proposed road. The plan required Kirtland to vacate the old road and give it to the arboretum. In return, Holden would build a new, paved road from Kirtland-Chardon Road to a point just south of Mitchells Mill Road. There, the new road would rejoin the existing Sperry Road. Holden would maintain the road. Kirtland would provide snowplowing and

policing. Though it would be a private road, it would be open to the public all but the one day a year necessary to validate that it is indeed a private road that belongs to the arboretum.

"The bottom line," Paine said, "is that it was such a good bargain for the city of Kirtland, that it couldn't turn it down."

No one opposed the plan. It proved that the arboretum and Kirtland (and the other governmental entities) could work together. Lawsuits were not the means to cooperation. Personal persuasion and mutually beneficial projects were. It convinced many in the Kirtland community that the arboretum was not the "elitist, closed club" that they had considered it. New Sperry Road opened on the weekend of November 2, 1991, and arboretum and community officials shared the moment.

As if Sperry Road was not enough of a challenge for Paine's negotiating skills, acquiring the David Leach Research Station in Madison provided another. Leach wrote the book on rhododendrons. His research station, which is located about forty-five minutes northeast of the arboretum near Lake Erie, presented both an opportunity and a conundrum for Paine, Dixon Long, and others on the Holden Board of Trustees.

"The board saw a chance," Long said, "to have a specialty area in research and propagation that was not being done to that degree anywhere else." The arboretum continues to seek ways to integrate what is being done at Madison more directly with what visitors to the arboretum see, to strengthen the connection between rhododendron research and home rhododendron gardens. Still, the long, hard negotiations already have yielded beautiful dividends.

Leach wanted to leave a legacy—on his terms. Over a three- or four-year period in the mid-1980s, he seemed on the verge of striking a deal with the arboretum that would assure continuation of his work. On each occasion, Leach backed out at the last minute and upped the ante. He wanted oversight. He had specific requirements. Other trustees shook their heads. They told Long and Paine that they would never close the deal. Long and Paine persevered.

With the clock ticking toward changes in the tax laws that would have adversely affected Leach, he, Long, and Paine sat in the Warren G. Corning Visitor Center on December 31, 1986, and arrived at an agreement.

The Leach Research Station, a rich asset, further diversified an already complex, multidimensional institution that was woefully underfunded given its size (Holden had grown to 3,100 acres by 1986). The Research Station added to the arboretum's costs, but Holden's financial circumstances were about to change as a result of the deaths of Bert Holden's daughters, Emery May Holden Norweb (March 27, 1984) and Katharine Holden Thayer (October 27, 1985). Both women—Emery May Norweb in particular—had provided monetary and emotional support that permitted the arboretum to take root long before it might have otherwise. They did this out of a shared respect for their father's vision, but the irony of the circumstances did not escape them. Bert Holden's daughters realized that their good

health and longevity ultimately delayed the arboretum's access to the resources that would allow it to become all that their father might have wanted.

When she addressed the Holden trustees, Emery May said she felt as if she should say: "I'm sorry, but I'm feeling very well." She and her sister lived "with the burden that when [we're dead], the arboretum will benefit greatly."

It would be wrong, however, to conclude that Bert Holden's daughters were worth more to the arboretum dead than alive. Emery May took satisfaction in this knowledge. Her greatest pleasure, in fact, was in helping the arboretum to reach a point that it could survive—thrive, even—with or without the trust funds that became available on December 27, 1988. Anticipating that day, Emery May had "almost shamefully come to feel [the trust fund] is a gift" that would lift the arboretum to new heights, but not one necessary to its survival.

When the courts released the trust from which the interest could be drawn for operating costs— to include buying the land that had been leased to Holden by such people as Warren Corning in anticipation of this day—a new financial problem arose. C. W. Eliot Paine faced it head on.

"The arboretum benefited in an interesting way by having no money for many years," Paine said. It learned to make its case to individuals, businesses, and foundations for what the arboretum offered to the Northeast Ohio community. It had preserved land of priceless natural beauty. It had created an outdoor classroom in which everyone from schoolchildren to home gardeners to academic researchers could learn. In what it shares with the community, the arboretum contributes something more precious than the tax dollars it does not pay as a not-for-profit organization.

Paine and others at the arboretum set out to remind those who had been contributing to Holden that their support was still necessary, that an endowment does not allow the recipient to spend the principal. Elaine Price, who became executive director in June 2001, has found herself and her staff continuing to explain the mathematics of the trust fund.

"Rich," Price has explained, "is when you have far more than you need. If we were small and had the same endowment, we'd be rich."

To gain a better understanding of Holden's financial needs, walk through the Myrtle S. Holden Wildflower Garden, take the stairway down into Pierson Creek Valley, or stroll in early May into the Crabapple Collection where there remains in bloom one of each variety of crabapples originally chosen by Warren Corning. Look beyond the beauty of the Myrtle S. Holden Wildflower Garden's prairie exhibit. See past the ferns—the Rattlesnake, the Goldie's Wood, the Broad Beech, and the many other varieties—of Pierson Creek Valley.

Ask: How many people are required to maintain such beauty? How much does such beauty cost? What is such beauty worth?

More than 60 percent of the arboretum's annual budget goes to pay the employees who build and maintain the trails, research the new cultivars that may find their way into the Holden collections, and

tend to those plants that do. The worth of what they do? Priceless, especially at a time when greenspaces are vanishing from the American landscape.

The arboretum devotes much of its resources to the "spit-and-polish" areas of the arboretum: to the Butterfly, the Rhododendron, and other display gardens; to the Crabapple and Conifer Collections; to all the areas people are most likely to see when they visit the "arboretum within the arboretum."

This mini-arboretum, some 200 acres, is small only in the image the name evokes and in comparison to Holden as a whole, with its more than 3,200 additional acres. It demands and devours staff hours. There is so much to do: mowing, weeding, mulching, deadheading (pinching dead flowers off their stems to facilitate new growth), fencing large areas and individual plants to protect them from deer (a greater scourge than disease), maintaining trails, identifying plants that have died and making sure that they can be removed from the arboretum's plant records, to be replaced by new plants and their history.

Elaine A Price,
Executive Director
(June, 2001–)

Today's staff work closely together, more so than during earlier days when propagator Lew Lipp and Superintendent Paul Martin clashed over Lipp's prolific planting. Lipp's pace made it impossible for Martin, who had too little help, to keep up with where Lipp was planting, much less protect what Lipp was planting. Arboretum staff and others travel throughout Ohio and to China, Korea, and other faraway lands to study plants and acquire those suitable for the arboretum, but their accessions have been systematic and carefully recorded.

Lipp's style served the arboretum well, his accessions coinciding with Warren Corning's grand vision for the acquisition of the land itself. The emphasis has shifted and continues to do so. For instance, whereas Lipp used to drive up to Baldwin Acres and plant whatever he had to plant without so much as telling Martin, Holden's research unit now uses some of the same land to plant witch hazel, which is one of the arboretum's research groups. The others are buckeyes and redbuds, and in each instance, Holden is trying to advance the knowledge of plants not heavily studied, to gain the sort of details that will make these plants less difficult for people to work with at home.

When Bert Holden thought about plants, whether on his Bratenahl property (remember the tree-measuring exercise with daughter Emery May) or in arboreta, he sought to connect the aesthetic and intellectual. As the arboretum enters the twenty-first century, its leaders have tried to extend the intentions of the arboretum founders—the Holdens and Boles—to contemporary circumstances. To this end, the arboretum's goal has become to help people connect with nature, learn about nature—for nature and through nature—in order to conserve natural resources.

Sally Gries, President
of the Board of Trustees
(May, 2001–)

Everyone at the arboretum—including the board of trustees led by president Sally Gries, Executive Director Elaine Price, and her staff members and the 350–400 volunteers who give more than 35 hours a year per person—will be making decisions with these three words—connect, learn, conserve—in mind. Agendas are converging. No longer is the right question whether to emphasize the display gardens and collections of the mini-arboretum or the natural areas. Rather, the question is how to connect the most people to as many areas of the arboretum as possible. These connections will lead to learning, including an understanding of the most environmentally sound practices, those that sustain nature rather than abuse it.

In his too-short life, Bert Holden experienced both the great vistas of the West, where his mines were located, and the different, more subtle beauty of Northeast Ohio, where his heart was. Connie Abbey has thought about her great-grandfather's vision, about the arboretum he foresaw on the family's Bratenahl compound, about how he taught Emery May, Connie's grandmother, so much about nature, about how much more he might have taught her had he lived.

By establishing the Holden Trust, Bert Holden did the only thing he could have done to continue educating Emery May about the natural world he loved and to educate future members of the Hold-

en family, which, because of the arboretum, has grown to include not only those who carry the Holden blood but also those who have the Holden spirit.

Bert Holden's arboretum was to have been beautiful but modest, dependent on his family's lands rather than on the hope that others would share so completely his vision of an arboretum's worth that they would make it their own cause and contribute to it.

Death, love, conflict, and life regenerated through the land—all of these are deeply rooted in the Holden Arboretum. Because of Bert Holden's death . . . because of Roberta Holden Bole's love of her brother . . . because of the family's disagreement over its Bratenahl property and Lake View Cemetery's insufficient acreage to accommodate a legacy as large as Bert Holden's should be . . . because of the help of Warren Corning and all who share a love for the land and its spirit . . . there is today a Holden Arboretum, guarantor of nature's tomorrows.

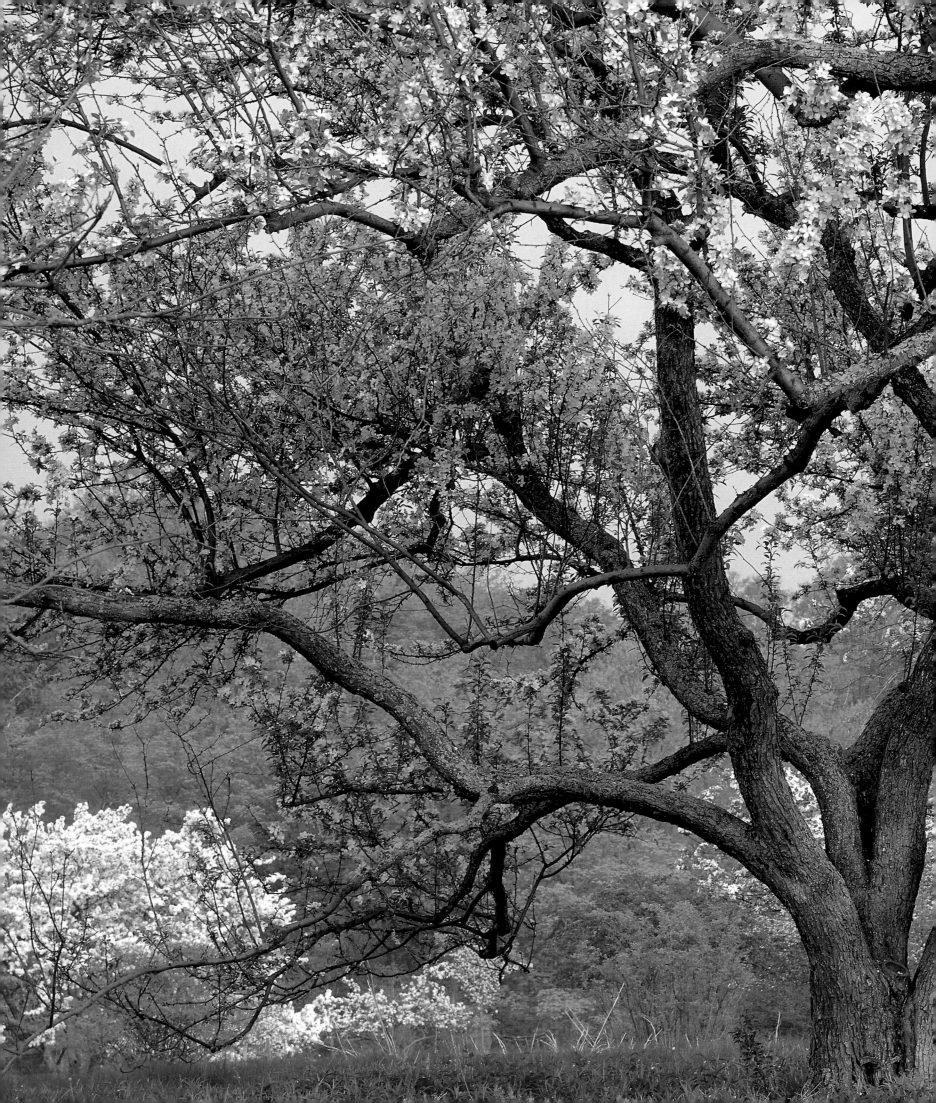

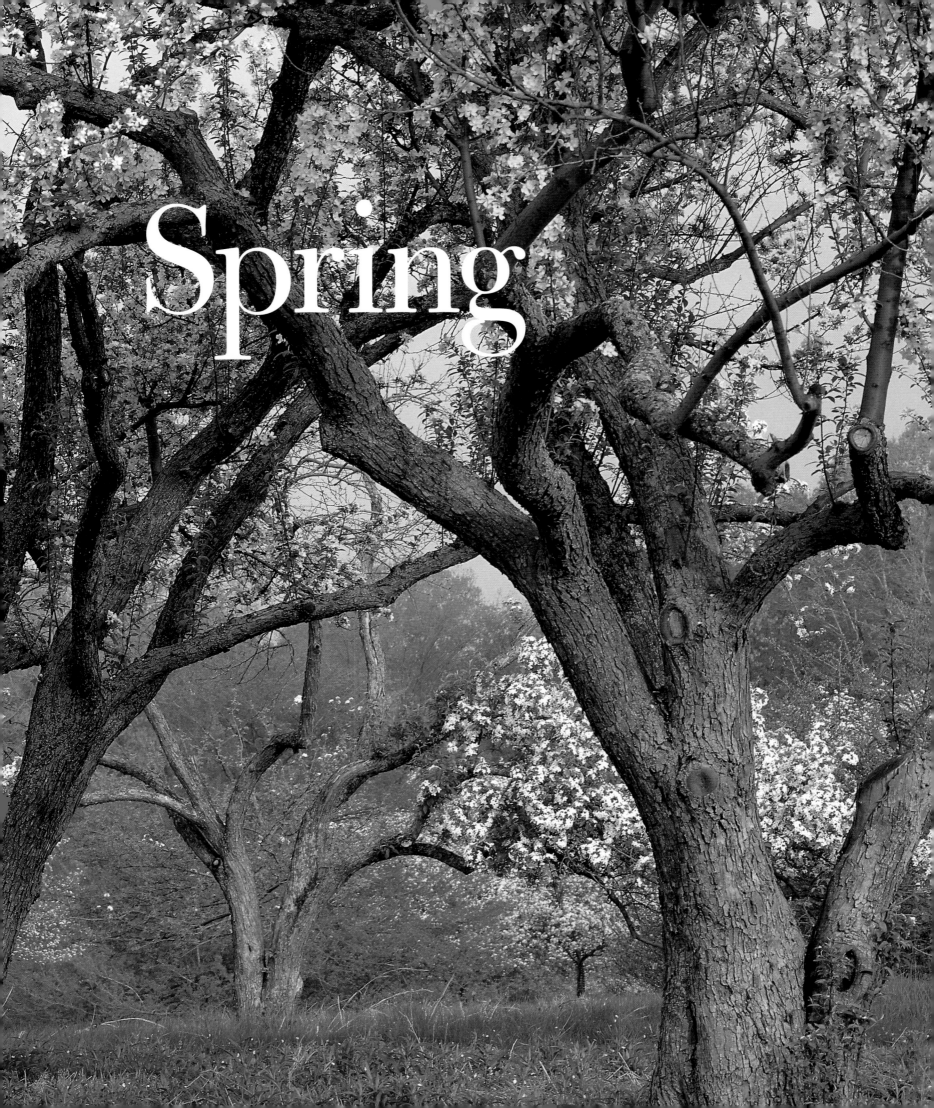

Spring

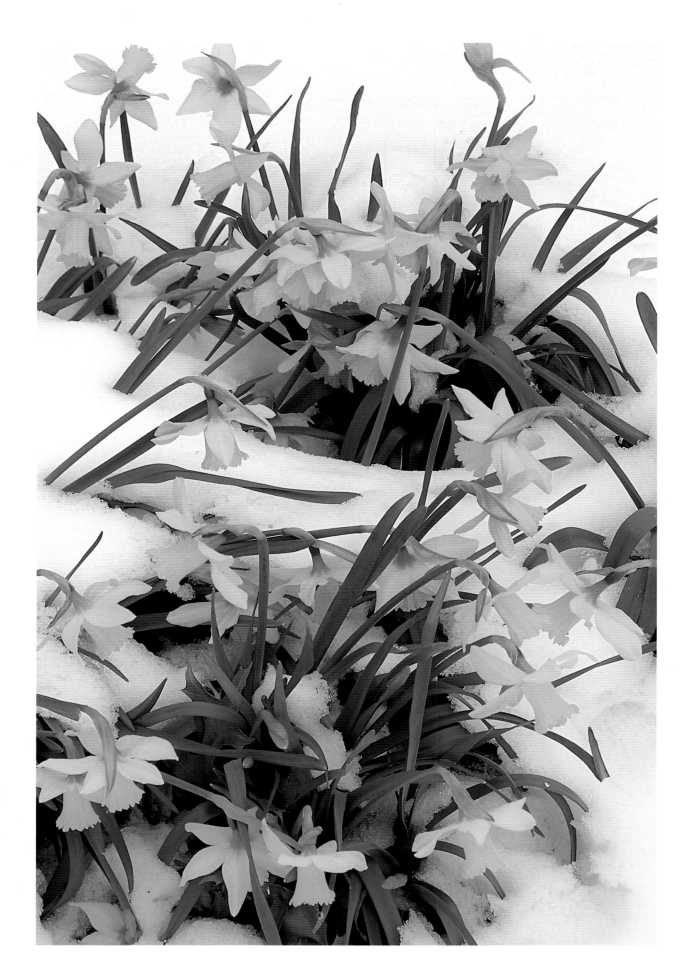

Previous pages:
Crabapples near
Warren G. Corning
Visitor Center

Daffodils, Lantern
Court

MAY COMES FRESH, bright, and hopeful to the Helen S. Layer Rhododendron Garden. There, in full flower, the yellows, oranges, whites, pinks, and reds stand at attention against a shimmering backdrop of blue water and green lily pads in Heath Pond.

In 1940 Warren Corning initiated what would later become known as the Layer Rhododendron Garden and would grow to twenty acres. It is arguably the Holden Arboretum's best-known public face, a place to which visitors return again and again in the late spring, as, more than sixty years ago, Dr. E. D. Merrill indirectly suggested they would. He influenced, again in a roundabout way, more than one garden at Holden.

Merrill, the director of Boston's prestigious Arnold Arboretum, spoke at the Cleveland Museum of Natural History annual dinner in December 1938, a time when the museum still oversaw the arboretum. More important, during Merrill's visit to Northeast Ohio, he reviewed Holden's progress and followed up with written recommendations to Corning. The essence of Merrill's message: Get flashier.

Scientific specimens (primarily in hues of green) dominate serious arboreta. What the Arnold had discovered was the value of color, in particular, that was provided by lilacs. So Corning added lilacs to Holden's display plantings, and when he made a subsequent visit to the Arnold, he also traveled to Sandwich, Massachusetts, to meet with Charles Dexter. Dexter owned a magnificent collection of rhododendrons and azaleas, and he offered Holden 250 of them. Corning eagerly accepted, and the Dexter rhododendrons formed the beginnings of and remain today in the garden. The Layer Rhododendron Garden offers the arboretum's most striking, sometimes overwhelming display of spring colors.

During the years that the arboretum was run out of the Cleveland Museum of Natural History, little emphasis had been placed on planning and developing ornamental collections such as the rhododendrons. That changed with Helen Layer, whose 1970 obituary in the newspaper requested that in lieu of flowers donations be made to the arboretum. The Layer family wanted her flowers to last for years, not days.

Curious about Helen Layer, Henry Norweb looked her up in Holden's records and found that she had a $25 family membership. She had made other donations as well, but nothing of such significance that the staff remembered her. The day after the obituary appeared, Norweb received a telephone call from Helen Layer's husband, Harold. He said he wanted to add a "substantial amount" to whatever others might donate in memory of his wife. He told Norweb that he would come to Holden to discuss how the money might be used.

Henry Norweb did not know how much "a substantial amount" might be, but Norweb had in

Over Three-Hundred-
Year-Old Red Oak,
Helen S. Layer Rhodo-
dendron Garden

mind a plan for landscape architects William Strong and Thomas Hill to supplement Corning's small start in rhododendrons with a fully designed garden. When Harold Layer came to visit, Norweb presented him with the idea of the Rhododendron Garden and tried, subtly, to find out how much of a donation Layer had in mind. After a verbal game of cat and mouse, Norweb learned that Layer was talking about $10,000.

That was enough to have Strong create a design that played to the strengths of the garden that Corning had started—the topography and the trees. Strong's design made it seem as if the garden were a part of the land, a part as natural as a 380-year-old white oak and a 270-year-old red oak that have become garden landmarks. Harold Layer liked the design.

"You know that $10,000 I was talking about, Henry," Layer told Norweb, "I just told you that to get you stirred up. I'll add a zero to it."

Two days later, Harold Layer showed up again at Henry Norweb's office. Norweb was down the hallway. Someone said she would get Norweb, that he would want to see and again thank such a generous benefactor. Layer said not to bother. He tossed the first of two checks for $50,000 on Norweb's desk and left. The other $50,000 arrived on schedule.

As important as funding was to the development of the Layer Rhododendron Garden, the task was anything but simple, and the garden that has produced hundreds of ribbons and honors was not turned as if by magic into an overnight award-winner.

Holden librarian Libby Norweb, wife of executive director Henry, gave the horticultural staff books about rhododendrons, including *Rhododendrons of the World* by David G. Leach. The staff did not realize at the time that the man who wrote *the* book on rhododendrons would become their friend and garden benefactor. Before that occurred, the staff learned the hard way about rhododendrons. The garden today gives no clues of how difficult it was and how badly the planting went in the beginning.

Staff would place plants in a bed and the next morning they would be gone, vanished, as if David Copperfield or some other magician had made a pass through the garden in the night. The ground did

not drain properly and the plants literally would sink into it. In the summer, when the heat hit, the soil would dry out and set up like concrete. Workers tried everything. One summer, a platoon of interns dug ditches into which they poured gravel in an attempt to improve the drainage. Nothing worked. The arboretum needed help.

Northeast Ohio had help, in spades, to offer. Tony Shammarello, a legendary rhododendron breeder and all-around expert on the plants who lived in South Euclid, was hired as a rhododendron consultant from 1976–78.

Beginning in 1980, the staff created two levels for the beds. Rhododendrons were planted in soil placed on top of the existing soil. Around them, more topsoil and wood chips were added. The plants could be plucked off the ground—ask thieves—like a cup off a saucer. The plants proved sturdy enough, however (sometimes reinforced with staking for the larger plants, which can reach a height of twenty feet), and the two-tier drainage system solved the sinking-when-wet and hardening-when-hot-and-dry problems.

A look at the labeling on the plants in the Layer Rhododendron Garden will tell a visitor that Tony Shammarello has left more than his knowledge. With many hybridizers creating new shades of old colors, Shammarello's 'Hino-Red' and 'Helen Curtis' (a white) still have an appeal that never goes out of fashion.

The Leach Research Station became affiliated with Holden at the end of 1986. The research staff has recognized that with some 25,000 registered hybrids produced since the mid–nineteenth century, improving ornamentation is perhaps less useful than improving other aspects important to rhododendrons—cold hardiness, heat tolerance, pest resistance. Plant breeding requires an investment not of weeks, months, or years but of decades, one generation of rhododendrons leading to another, improvements resulting when the plants are crossed correctly.

Holden has an elite germ-plasm pool of hybrids. They are largely very cold-hardy and contain a mixture of perhaps twenty to thirty species from around the world. This legacy would have meant nothing if Leach had not made sure that his life's work would be preserved.

Because of Leach's foresight, researchers at Leach Station have been working to extend and improve his breeding program. Their goal is to create rhododendrons that will be widely distributed and identified with Holden. As much cachet as the Leach name has—no one has done more to popularize rhododendrons—his plants have not been as well-received by nurserymen (and thus by home gardeners) as might be expected. Nurserymen are practical. They want to sell plants. As sophisticated and engaging as Leach's rhododendrons are, many of them also demand fussy caretakers. They can be difficult to grow. Nurserymen do not need challenges. They need customers. Customers gravitate to plants that live and flourish, without requiring extraordinary care. The goal is to make better, easier-to-grow rhododendrons through scientific research.

Visitors to the Layer Rhododendron Garden may not realize that to achieve award-winning beau-

ty, hybridizers such as Leach have invested lifetimes. Holden researchers want to reduce the investment that must be made and bring the results to fruition sooner. Holden has discovered the opportunity to apply science to this practical end.

Leach Station researchers are devising shortcuts that they hope will accelerate plant development by reordering the priorities long used by breeders, including Leach (although to a lesser extent than some breeders). Hybridizers most often choose which plants to select based on the plants' ornamental qualities, factoring in the flower size and color, the leaf structure, and the flowering period. The hybridizer picks the progeny that looks the best and then begins to evaluate, over many, many years, the resultant hybrid's other attributes. This is where Leach differed from some hybridizers. He emphasized cold hardiness and then ornamentation. The current researchers would push this altered emphasis to another level.

Leach Research Station, because of its location near Lake Erie, experiences somewhat warmer winters than does the arboretum. Rather than wait for the rare winter when the temperature drops to the test target of minus-15 degrees Fahrenheit or lower, Holden researchers are conducting controlled freezing experiments with plant tissue and even entire plants. They are also putting seedling populations through a controlled disease screening in order to select survivors resistent to a deadly soil fungus. The survivors are field planted and further selections are made based on their ornamental qualities. With more known from the outset about the ability of these plants to resist disease and withstand cold, they become better investments for the years required to further prove their worth and make them available commercially.

Step onto the Leach Research Station's twenty acres in late May and it is not the years of grower investment but the beauty of the results that overwhelms. Spread throughout the property are generations of Leach rhododendrons, a multicolored floral family album, a legacy on which David Leach was working practically to the day he died in 1994. Leach, like any dedicated hybridizer, was the ultimate optimist. When he was eighty-three years old, he continued to cross-pollinate magnolias (he created some of the first yellow-flowered varieties) although he knew it would require at least twelve to fifteen years to gain a feel for the quality of the plant that had resulted.

David Leach's personal history is planted on the landscape in the form of rhododendrons as high as fifteen feet and as old as fifty years. Some of them he transplanted from Brookville, Pennsylvania, after some of his rhododendrons and a marriage had gone up in flames and sent Leach in search of a new garden. The transplanting required four years of weekends after Leach found an abandoned farm that the owner was about to sell. Because he considered his gardens an outdoor laboratory, Leach did not open them to visitors, other than horticulturists and hybridizers, as is now being done on a controlled and limited basis each spring. Nor, for proprietary reasons, did Leach send rhododendrons for testing to other arboreta and educational institutions with which the arboretum has agreements.

A test plot in the Layer Rhododendron Garden, where it gets colder than at the research station, also furthered the relationship that Leach and others established. A number of Leach's rhododendrons are planted on Beech Knoll.

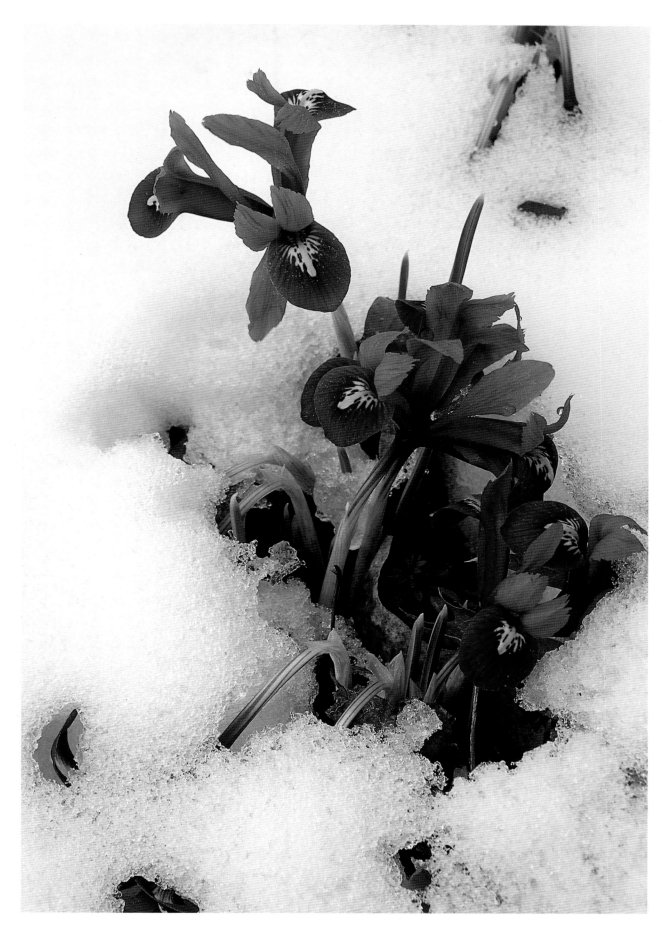

Reticulated Iris
Emerging from Snow,
Lantern Court

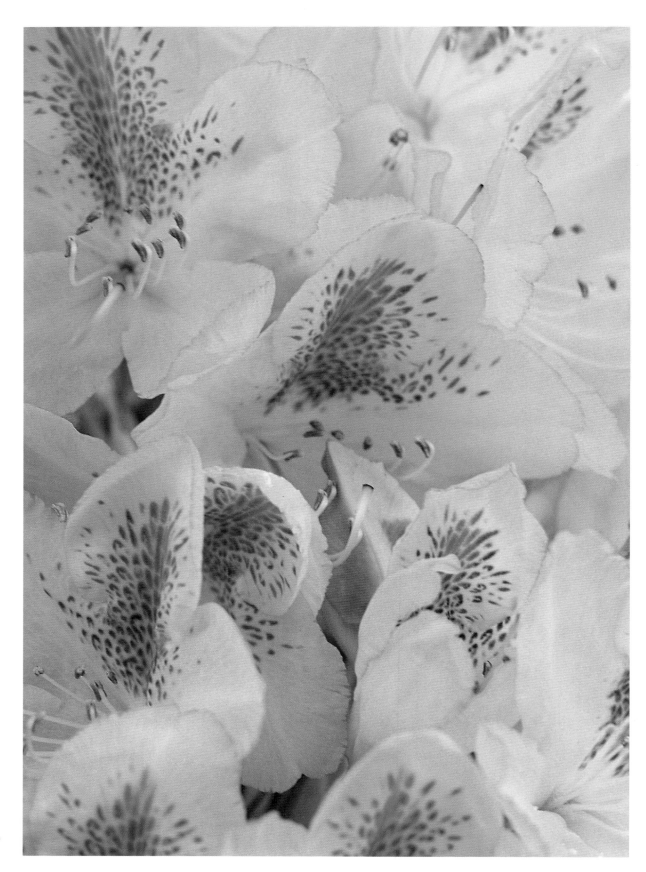

Rhododendron
'Swansdown,' Leach
Research Station

Facing page: Daffodils,
Lantern Court

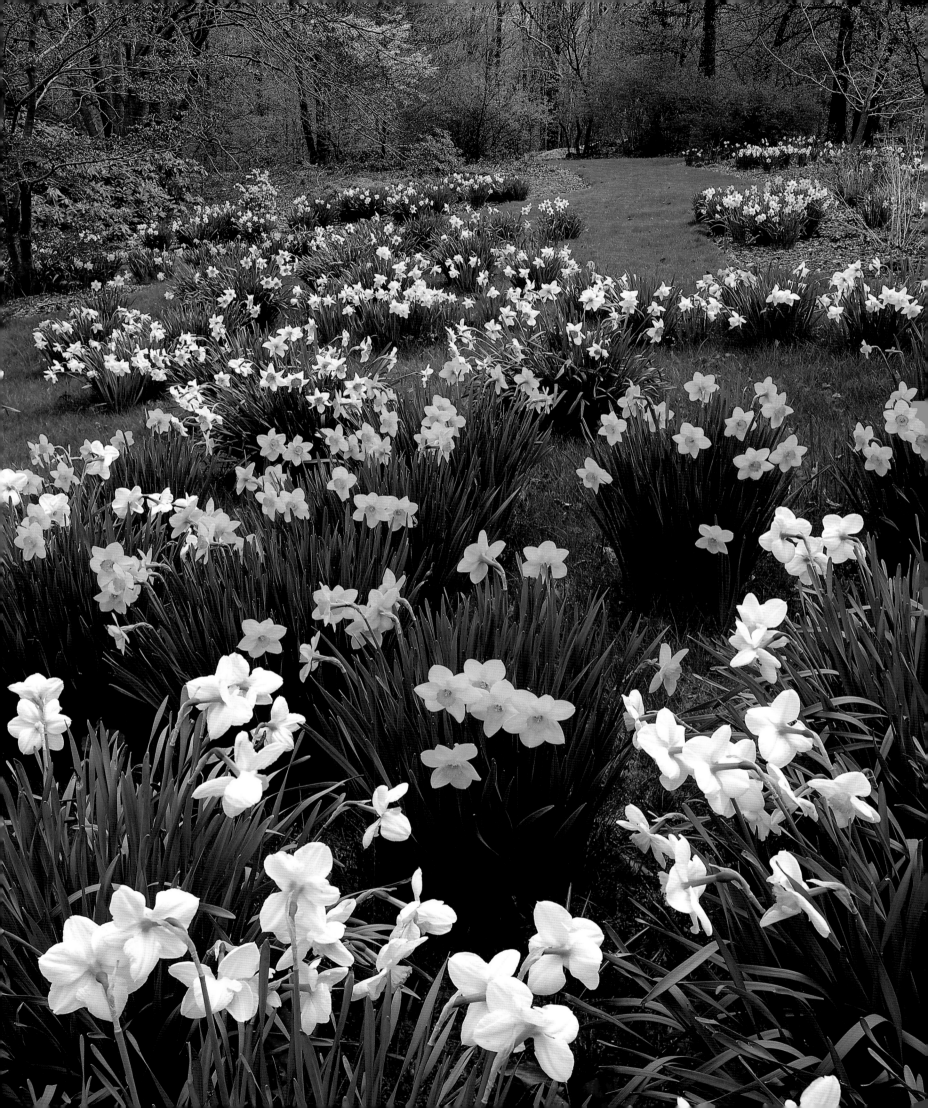

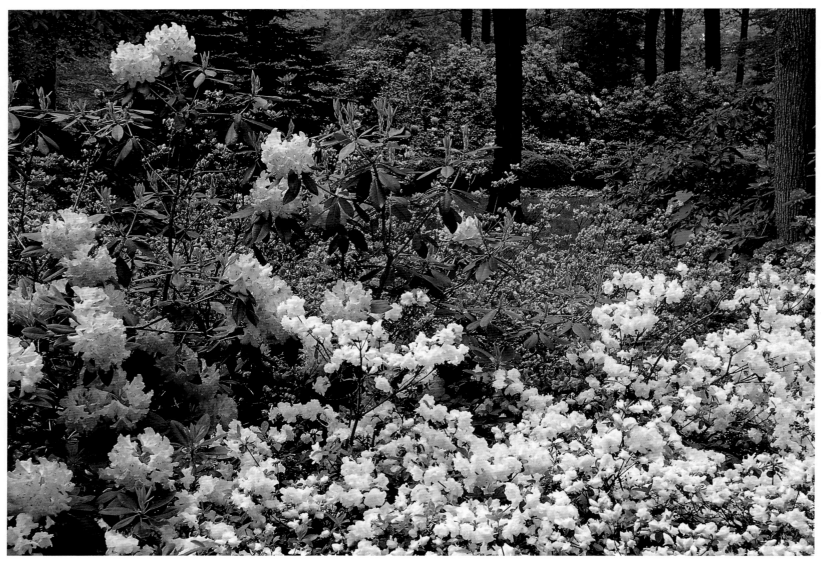

Helen S. Layer
Rhododendron
Garden

Mountain Laurel,
Helen S. Layer
Rhododendron
Garden

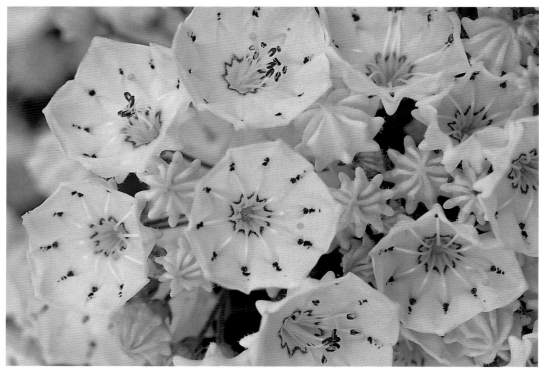

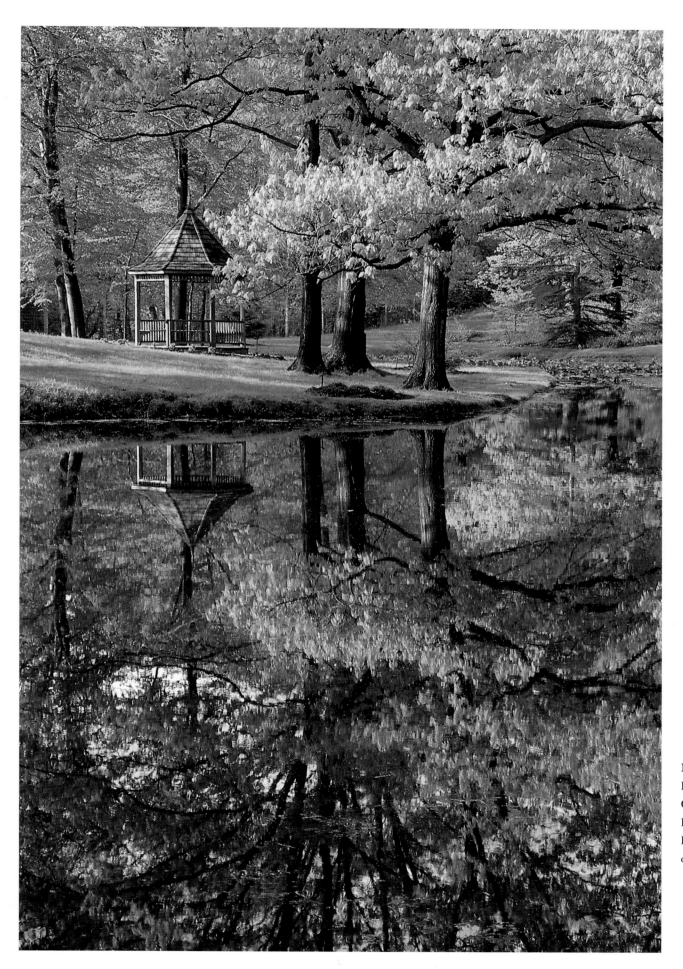

Nancy Adams
Bole Memorial
Gazebo, Heath
Pond, Helen S.
Layer Rhododen-
dron Garden

Redbud at Lantern Court

Greenhouse Area at Lantern Court

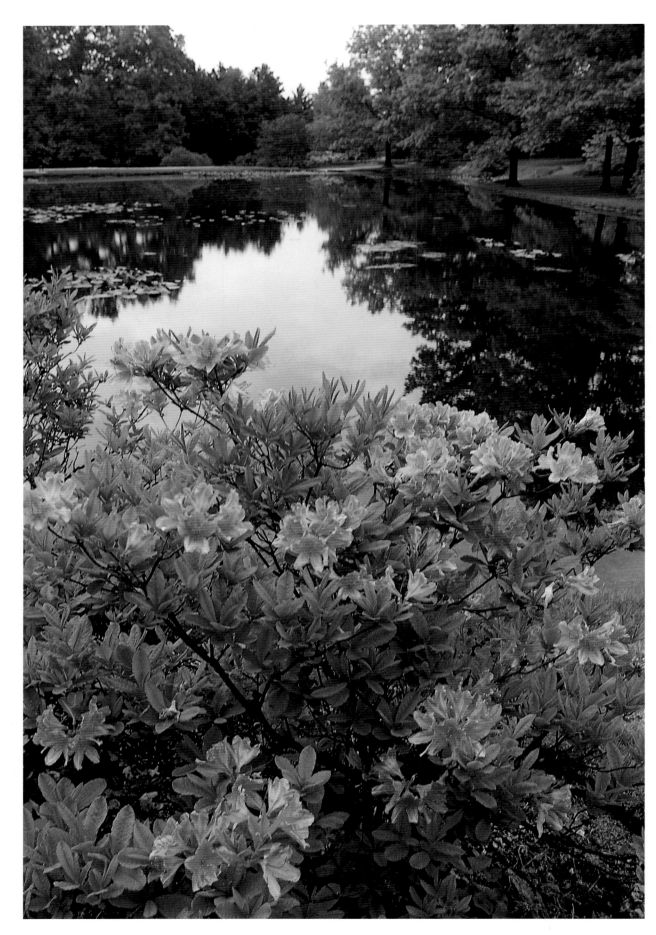

Azaleas near Heath
Pond, Helen S.
Layer Rhododen-
dron Garden

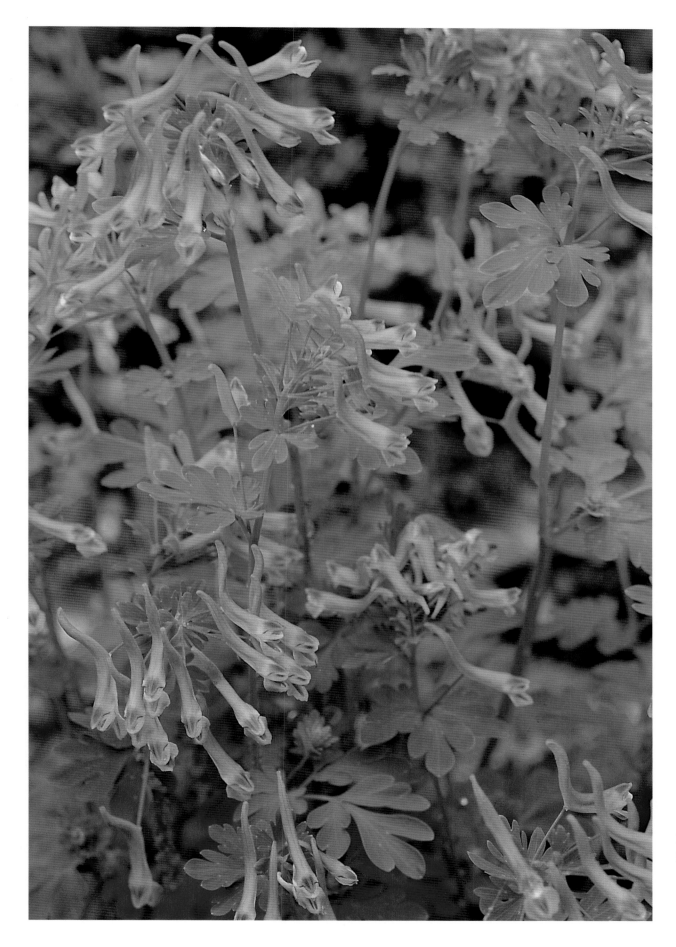

Himalayan Corydalis,
Lantern Court

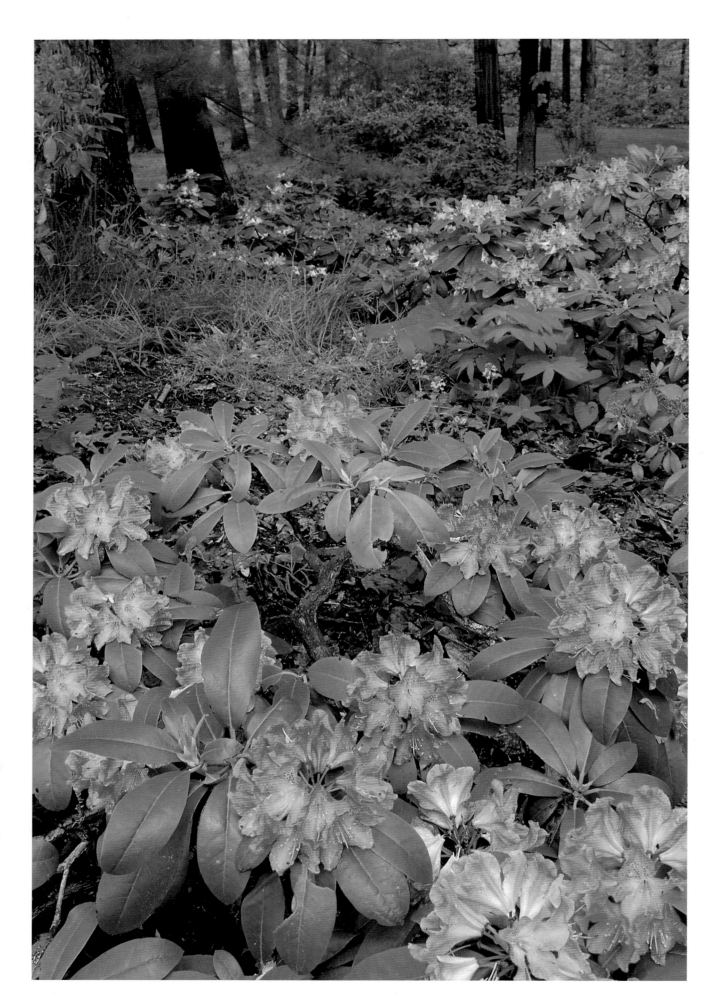

Rhododendron
'Holden,' Helen S.
Layer Rhododen-
dron Garden

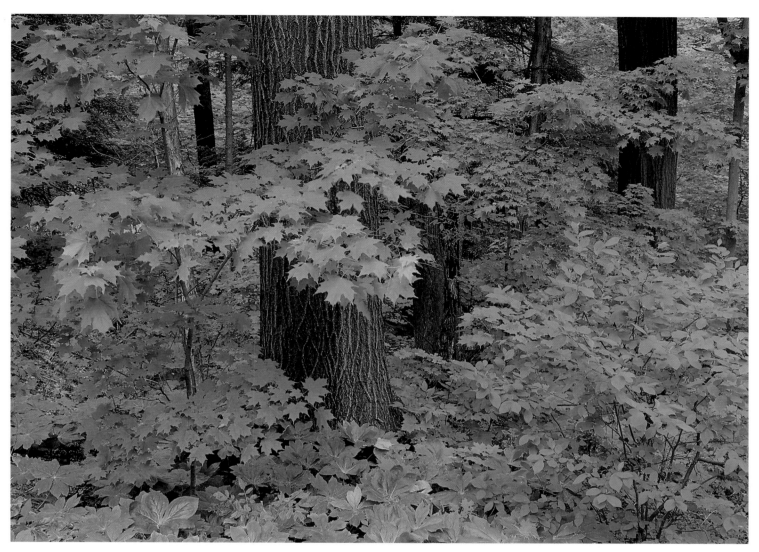

Spring Foliage, Lantern Court

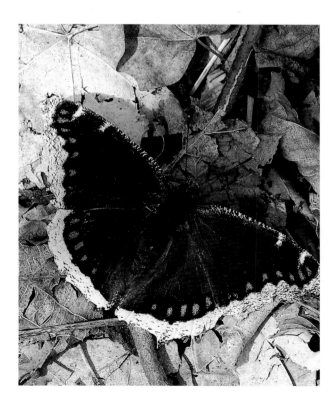

Mourning Cloak,
Helen S. Layer
Rhododendron
Garden

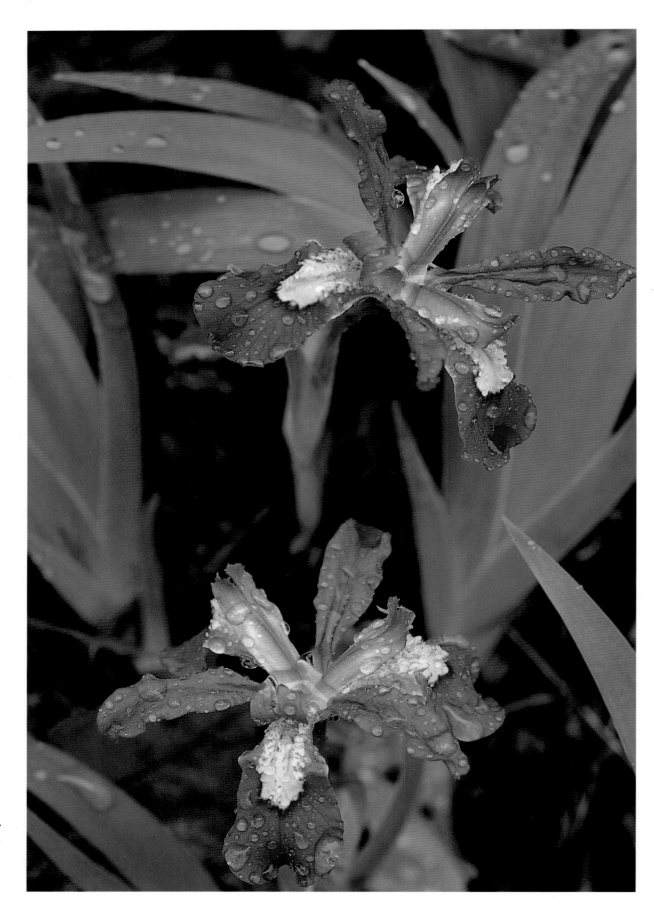

Crested Dwarf Iris,
Myrtle S. Holden
Wildflower Garden

Facing page: Rhodo-
dendrums in Helen S.
Layer Rhododendron
Garden

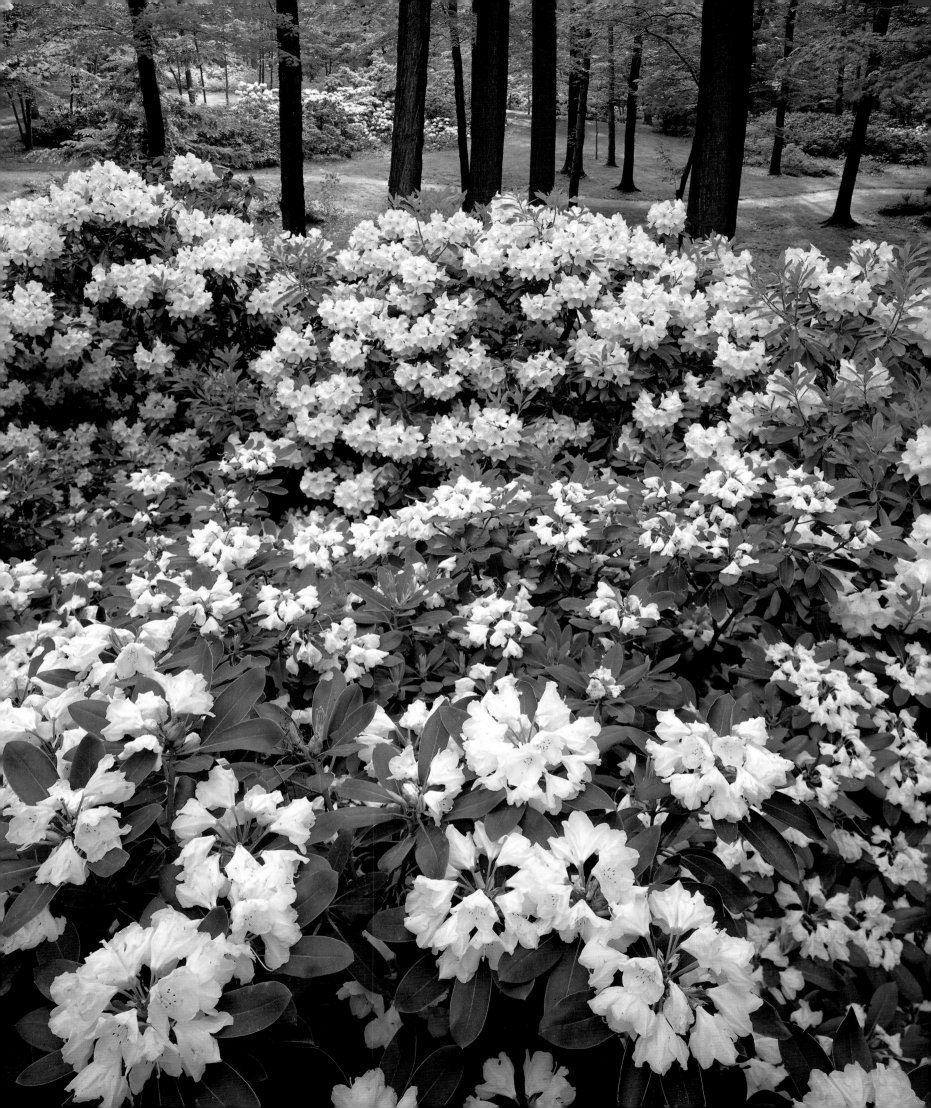

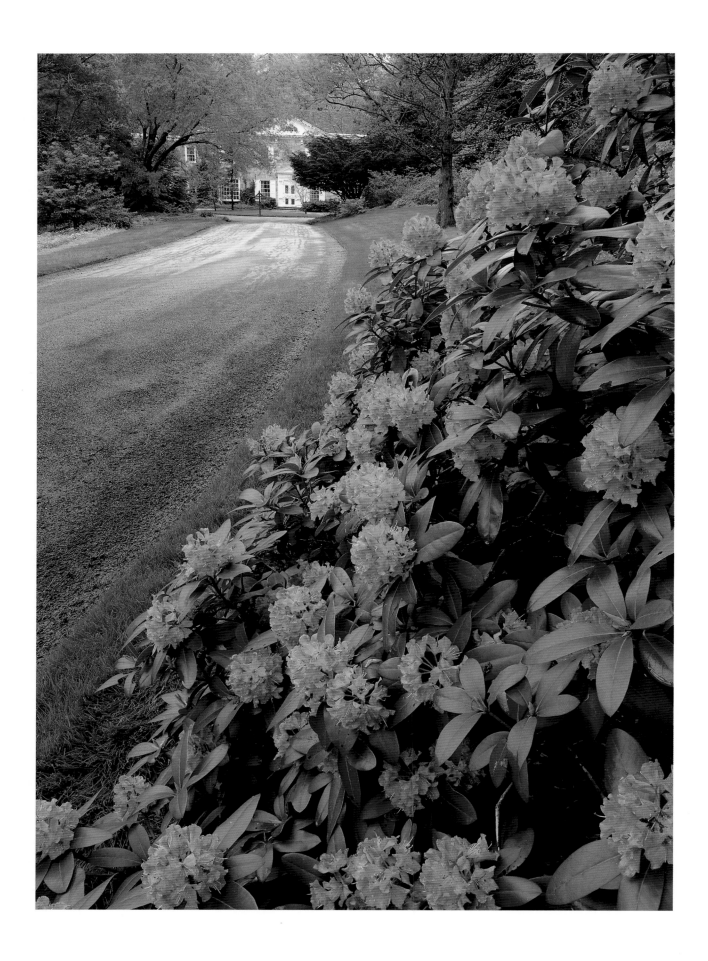

Rhododendrons,
Lantern Court

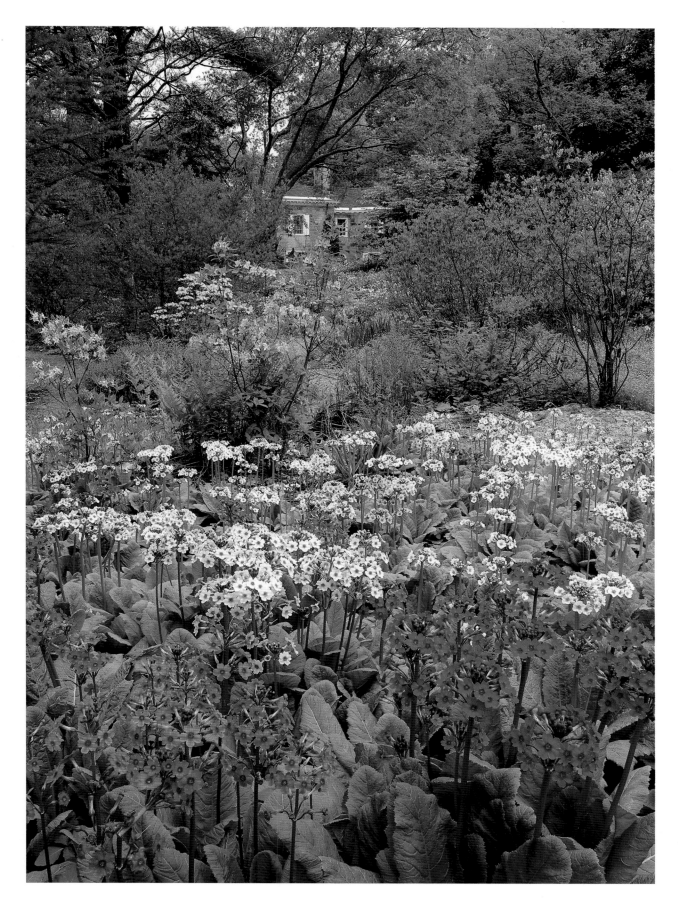

Japanese Primroses,
Lantern Court

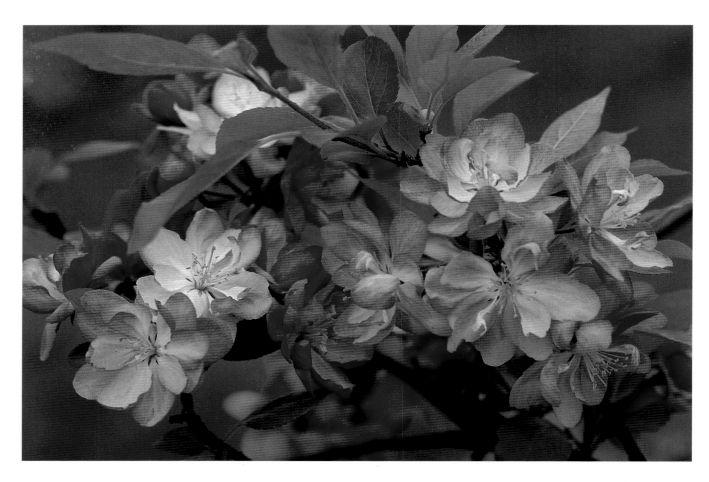

Crabapple Blossom
near Warren G. Corn-
ing Visitor Center

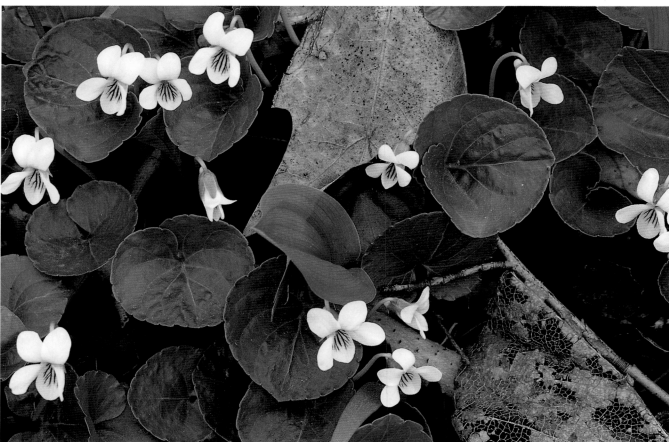

Northern White
Violets, Pierson
Creek

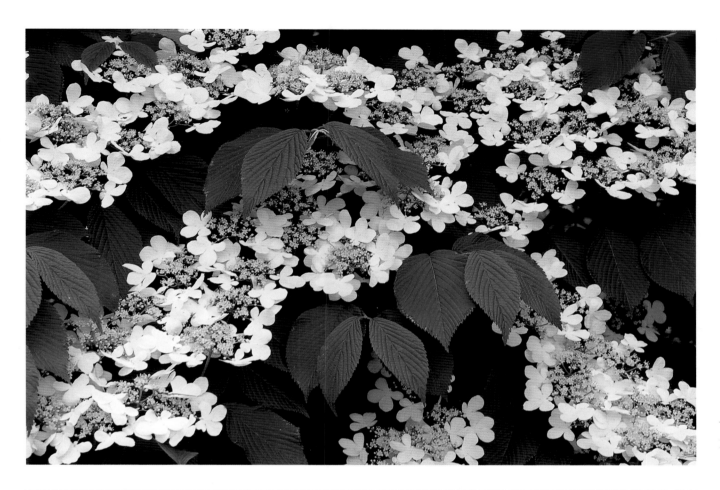

Viburnum, Leach
Research Station

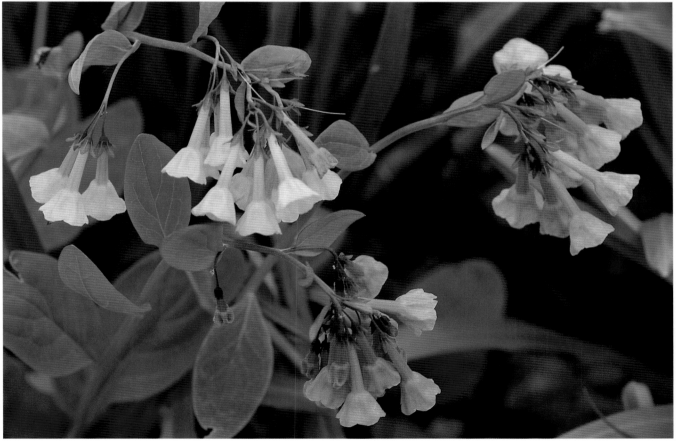

Virginia Bluebells,
Myrtle S. Holden
Wildflower Garden

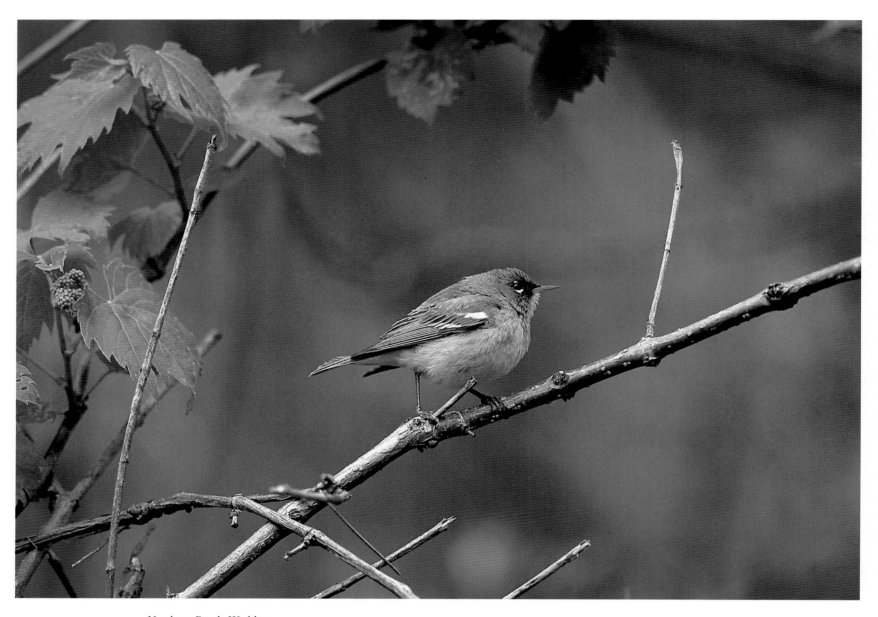

Northern Parula Warbler
near Corning Lake

Facing page: Spatterdock
Lilies, Heath Pond, Helen S.
Layer Rhododendron Garden

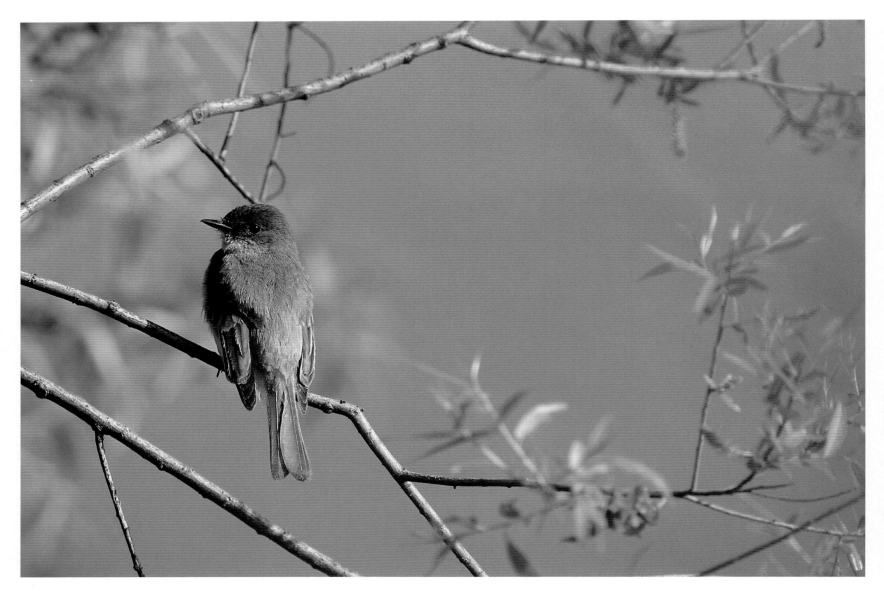

Eastern Phoebe near
Corning Lake

Facing page: Rhododendron
'Charles Dickens,' Helen S.
Layer Rhododendron Garden

Frog Sculpture, Leach
Research Station

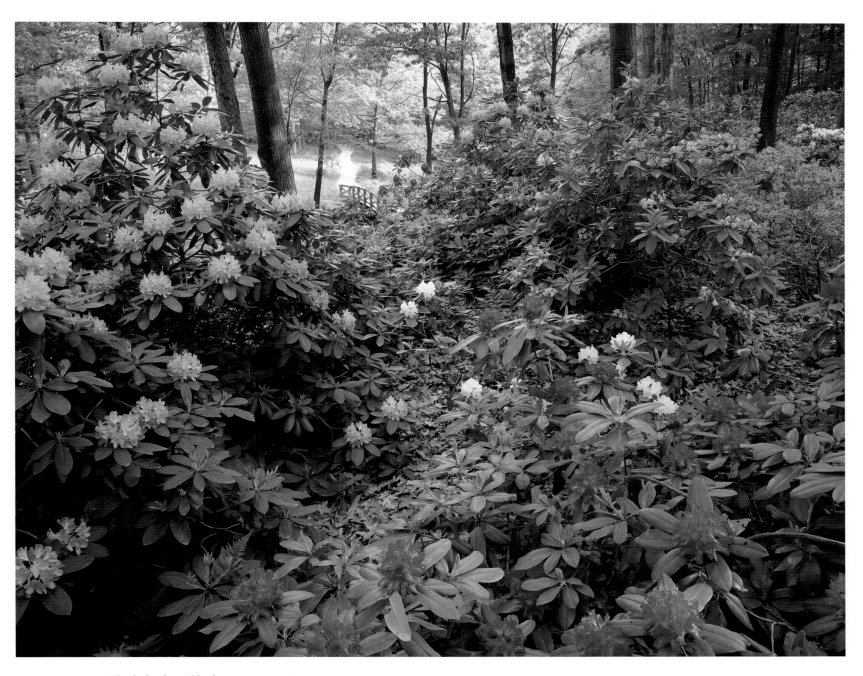

Rhododendron 'Charles
Bagley,' Helen S. Layer
Rhododendron Garden

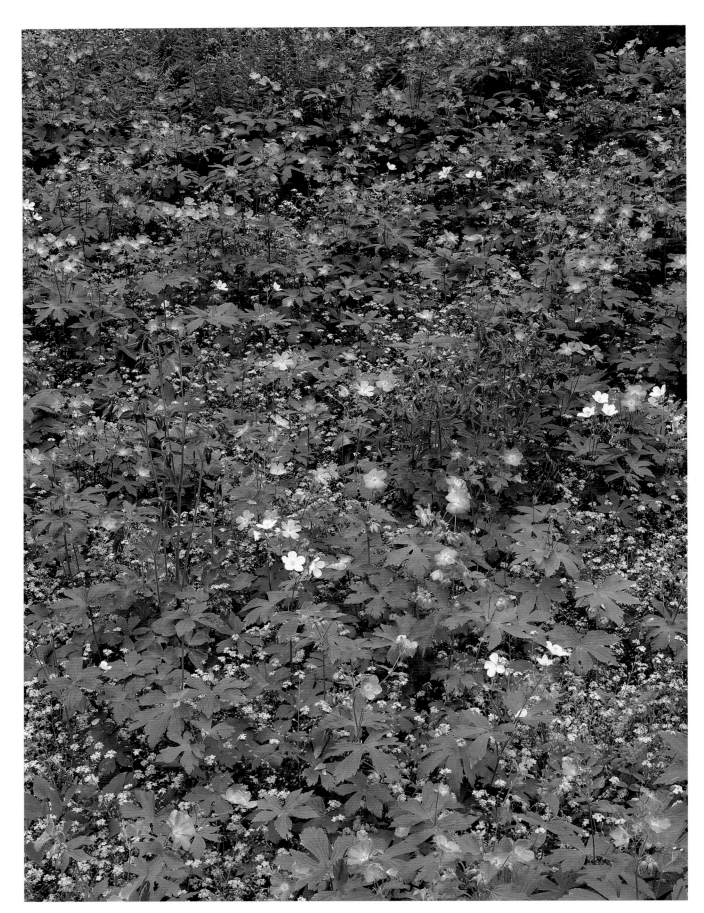

Previous pages:
Orange Azaleas near
Heath Pond

Wild Geraniums,
Forget-Me-Nots, and
Columbines, Lantern
Court

Facing Page: Weeping
Cherry, Lantern Court

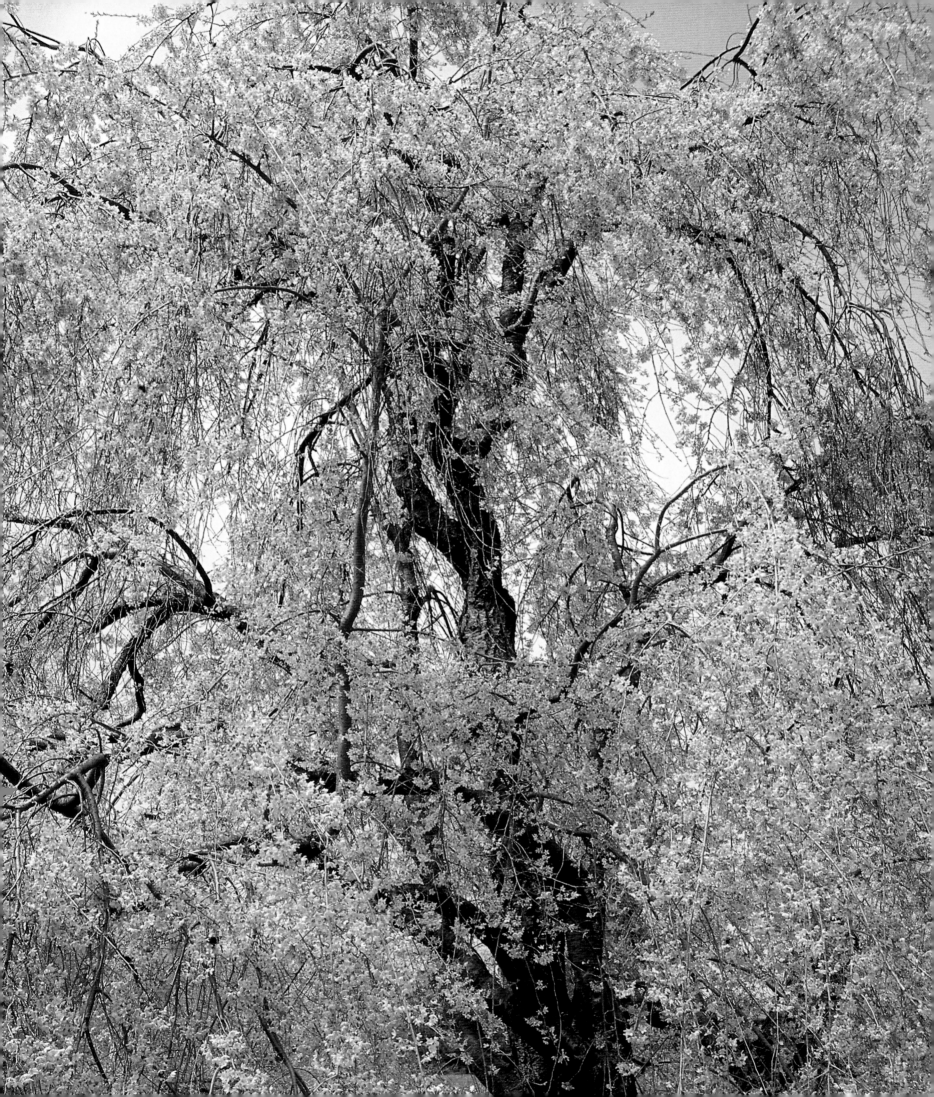

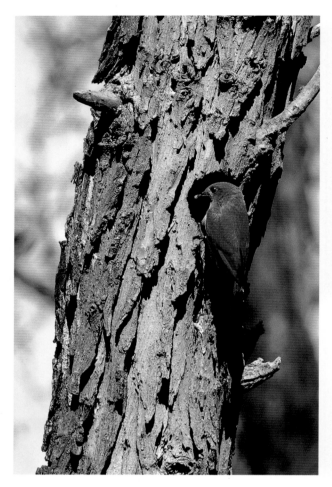

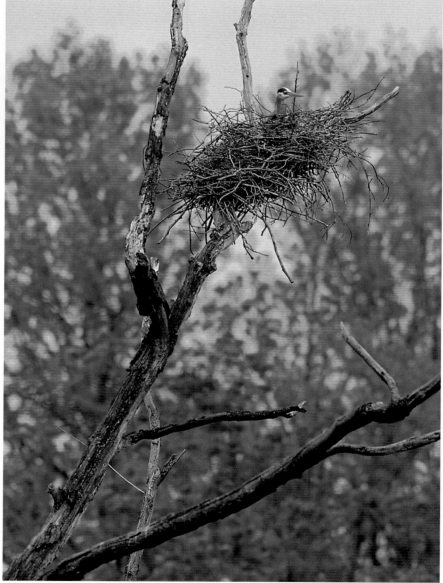

Bluebird near Corning Lake

Meadow Rue Foliage, Myrtle
S. Holden Wildflower Garden

Heronry, Carver's Pond

Facing page: Button Bush
Pond

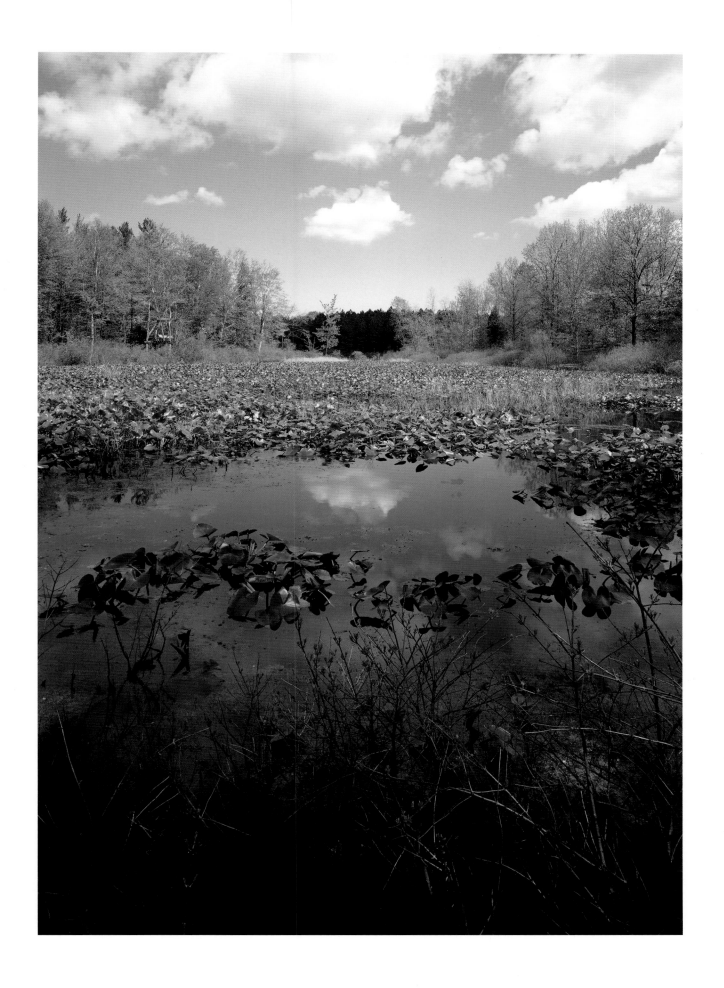

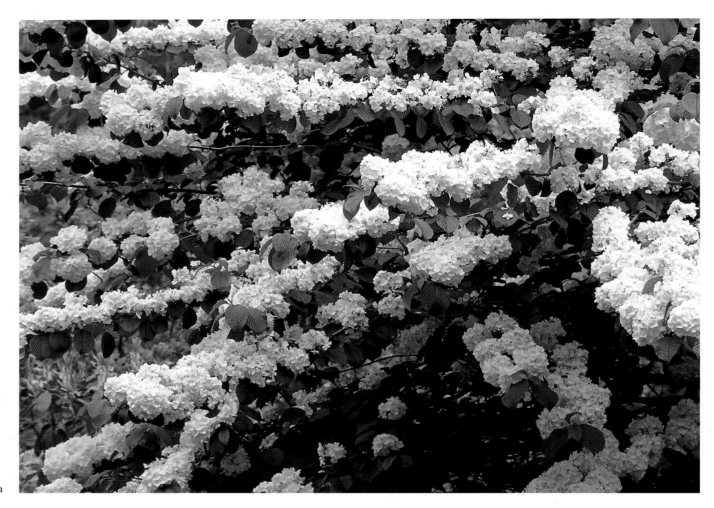

Previous pages: Clouds
over Corning Lake at
Sunrise

Viburnum 'Popcorn,'
Leach Research Station

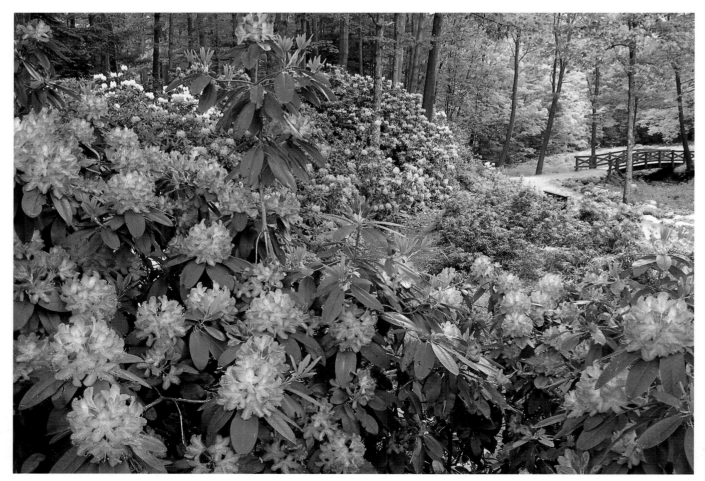

Rhododendron
'Purpureum Elegans,'
Helen S. Layer
Rhododendron
Garden

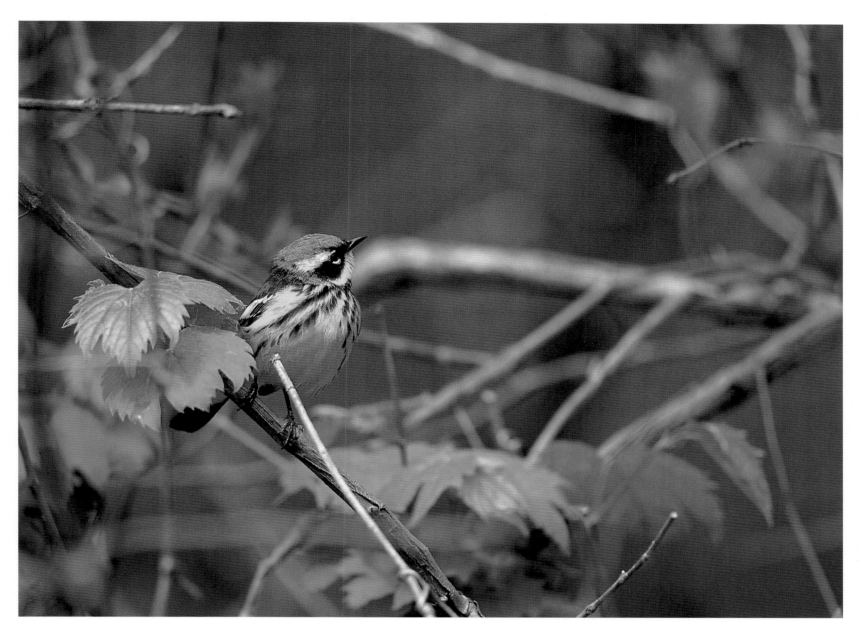

Magnolia Warbler
near Corning Lake

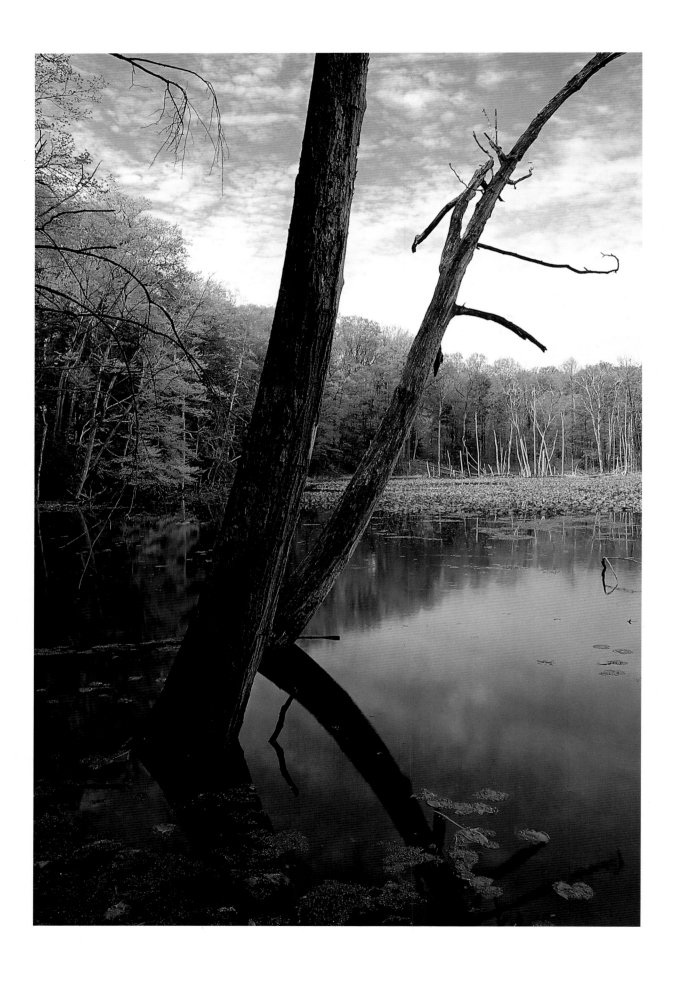

Carver's Pond

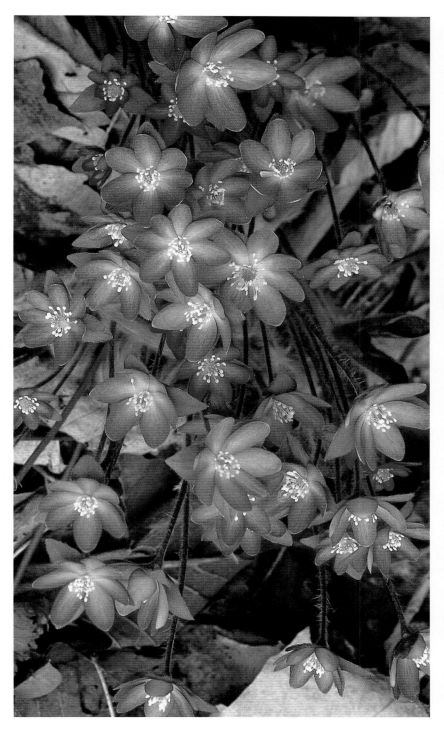

Hepatica, Pierson Creek

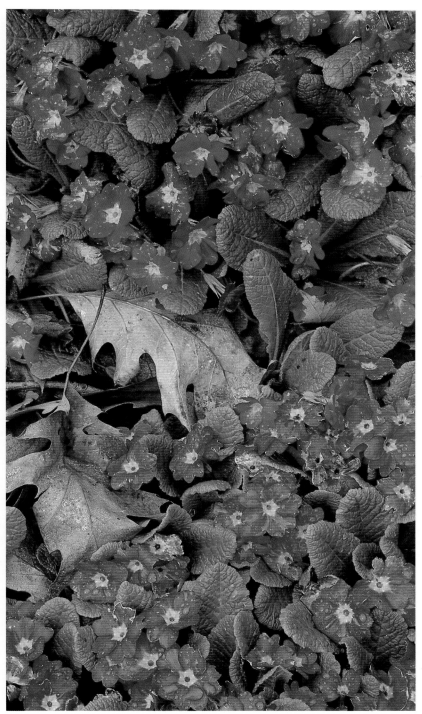

Primroses, Lantern Court

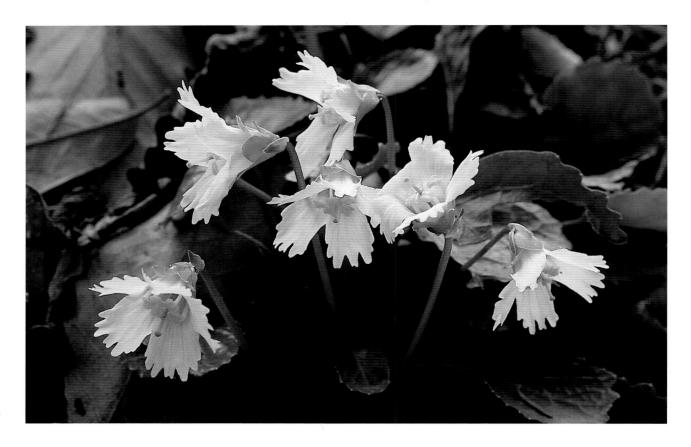

Oconee Bells, Lantern
Court

Viburnum, Leach
Research Station

Facing page: Azalea
'Gibraltar,' Knapp
Hill, Helen S. Layer
Rhododendron
Garden

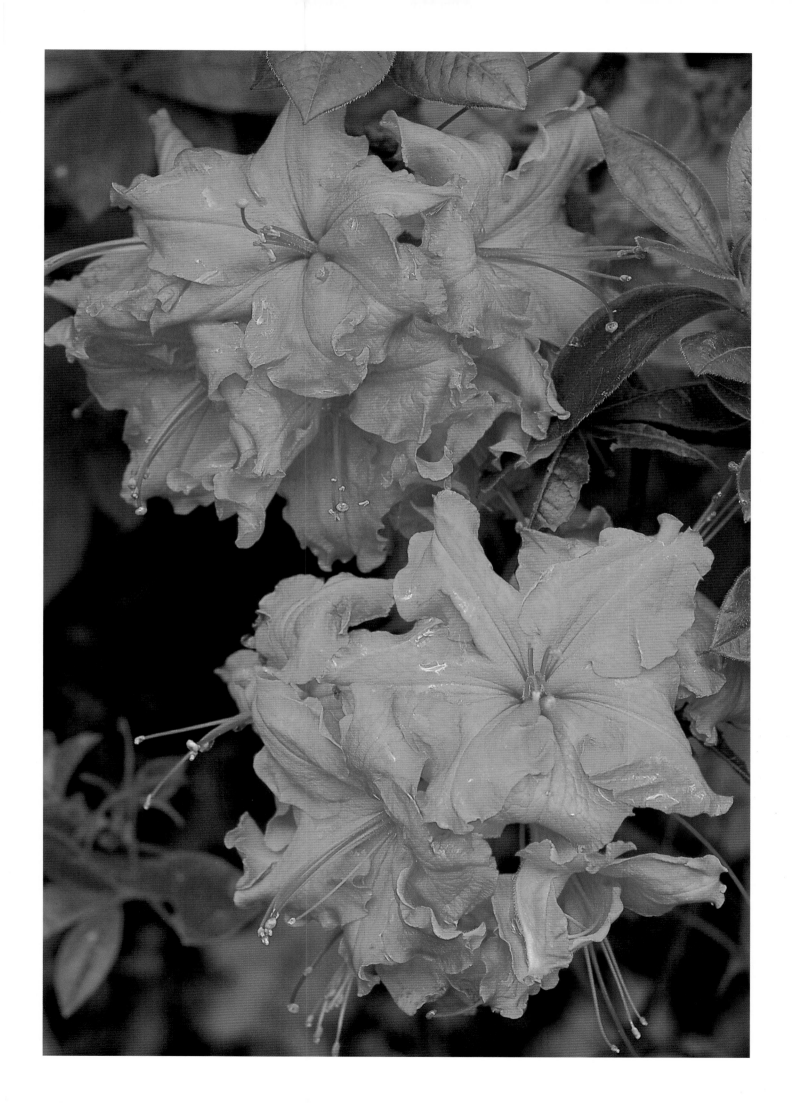

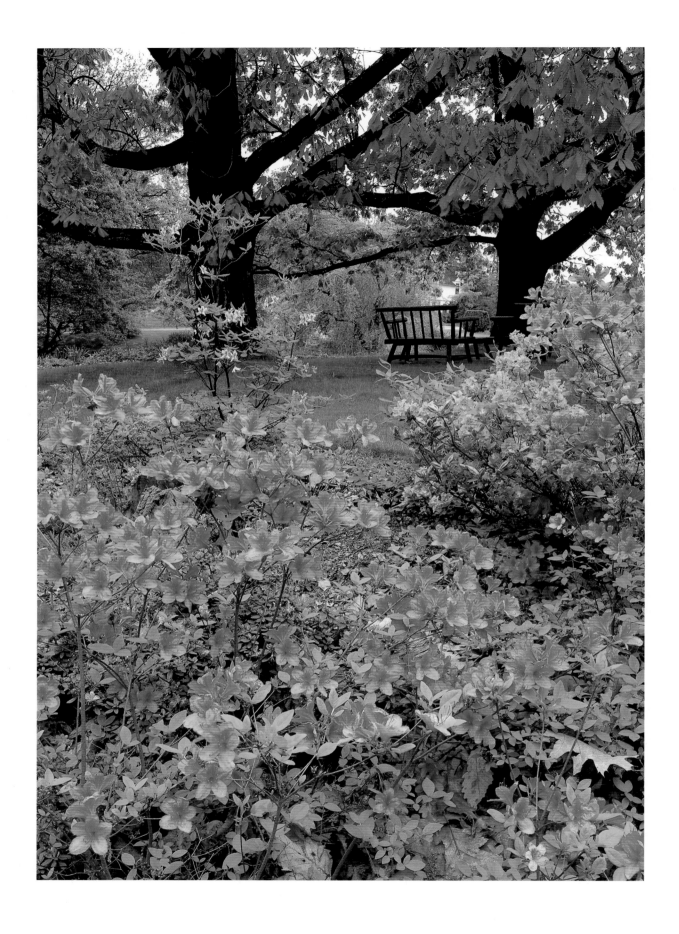

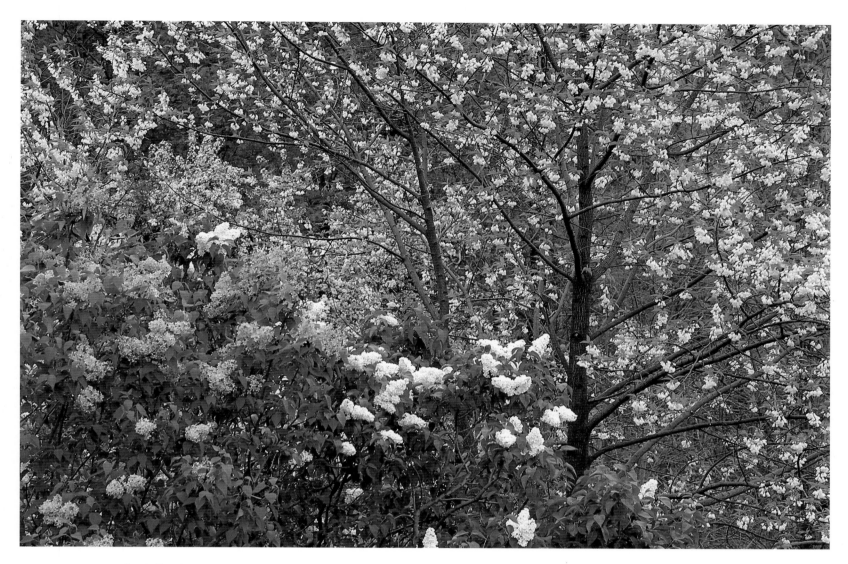

Silverbell and Lilacs,
Display Gardens

Facing page: Azaleas,
Lantern Court

Myrtle S. Holden
Wildflower Garden

Myrtle S. Holden
Wildflower Garden

Facing page: Rhodo-
dendron 'Blue Peter,'
Helen S. Layer
Rhododendron
Garden

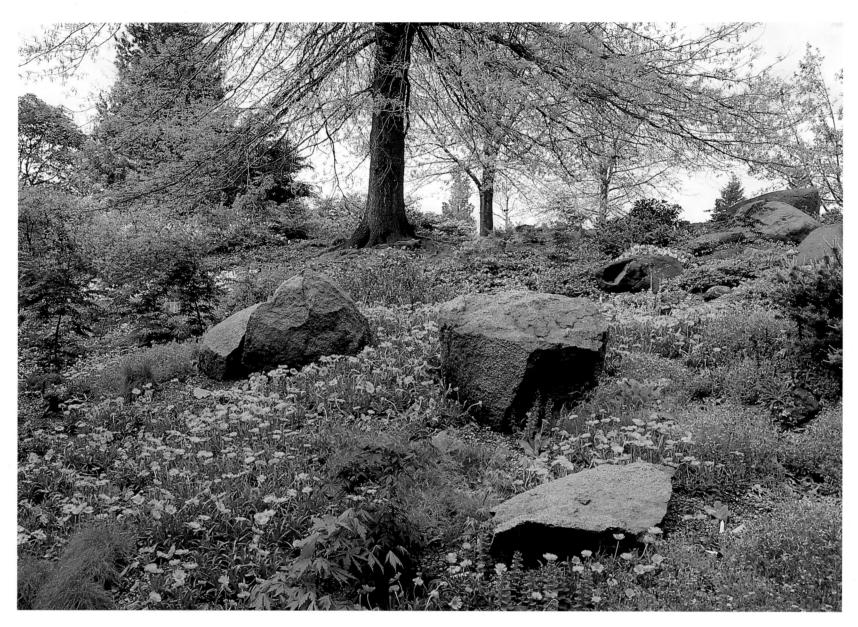

Rock Garden with Lakeside
Daisies, Lantern Court

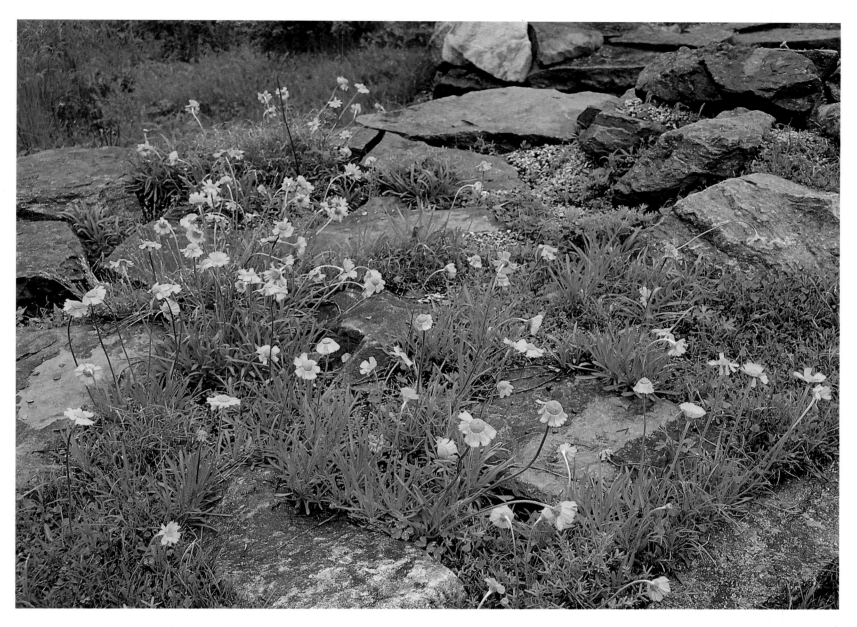

Lakeside Daisies, Myrtle S. Holden
Wildflower Garden

Bill Isner came to the Holden Arboretum for a summer and stayed a lifetime, as much a part of the Helen S. Layer Rhododendron Garden as the plants themselves.

As he stands atop Beech Knoll and looks out over the garden he manages, Bill knows that when he retires the arboretum will require a detailed map of the more than 1,900 rhododendrons, 1,400 azaleas, and 2,600 companion plants. Bill himself needs no such map. Each plant is in his head and heart.

Once, someone stole six azaleas. The thief plucked the plants from an inconspicuous spot. Bill knew immediately. When he came to Holden in 1967, however, he knew nothing about rhododendrons. But he had been taught to love plants by an aunt in West Union, West Virginia. He was growing wildflowers in a little garden of his own by the time he was eight years old.

During that first summer at Holden, Bill proved to Superintendent Paul Martin that he had two important qualities as a gardener: He would work the sun right out of the sky, and he possessed a refreshing inquisitiveness.

Clifton "Tip" Volans, one of the arboretum's earliest and most dedicated employees, had invited Bill to Kirtland to fill a summer job after a member of Volans' family had introduced him to Bill. When the summer ended, Martin decided the arboretum would benefit if Bill stayed. So he offered Bill a job. This surprised R. Henry Norweb Jr., the arboretum's executive director, because there was no money for another employee. Despite this, Norweb let the offer stand and was always glad he did.

"He proved to be the only real gardener we had here," Norweb said. "He always had a great sense of plant material."

Though he worked in maintenance and at Lantern Court, it is in the Helen S. Layer Rhododendron Garden that Bill has made his mark, though not his only one. He once lived in an arboretum-owned house at the corner of Kirtland-Chardon and Sperry Roads, where he planted an iris garden so spectacular it sometimes confused new visitors to the arboretum.

His garden and a sign near his house welcoming visitors to Holden often caused motorists to mistakenly turn into Bill's driveway. On one Sunday, Bill had left his car keys in the trunk keyhole of his car outside his house. There came a knock on Bill's door. A man and woman Bill did not know stood there.

The woman said: "You left your keys in your car." Bill thanked the woman. Then she added: "We really enjoyed looking at your Holden Arboretum." Through the years, many people seeing the irises in Bill's garden have made that mistake!

"No," Bill kept telling his visitors, "I'm not the arboretum."

In his way, though, Bill Isner has been.

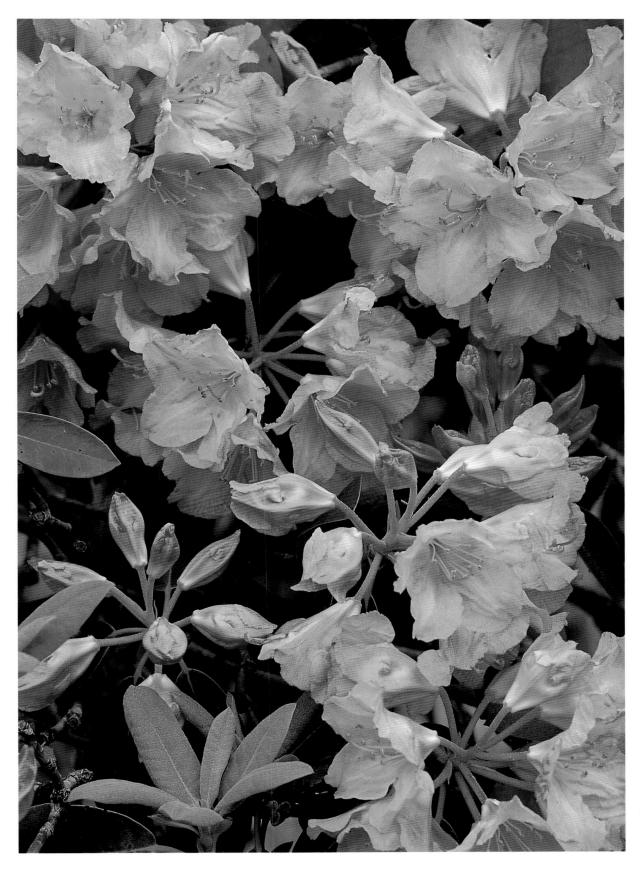

Rhododendron
'Rio,' Leach
Research Station

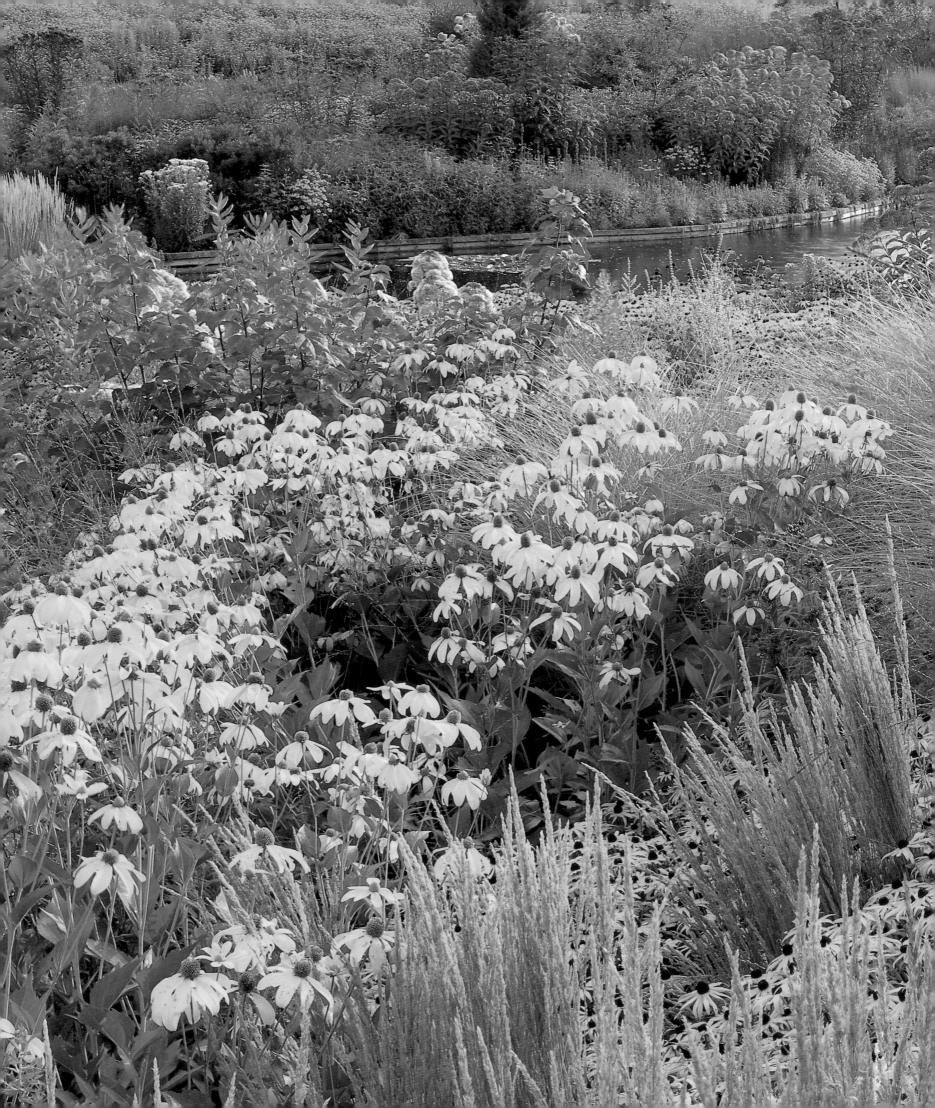

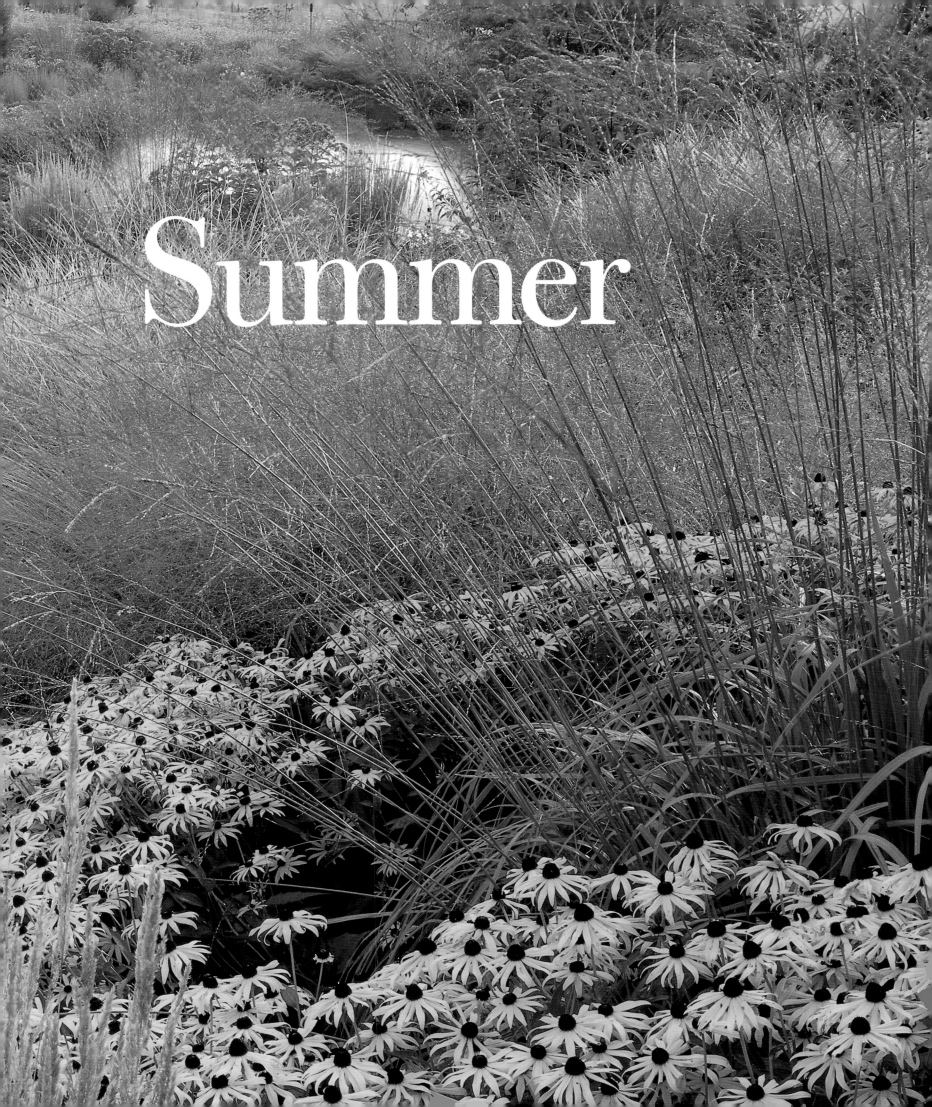

Summer

Baldwin Acres, 1995

Previous pages: Arlene
and Arthur S. Holden
Butterfly Garden

SINCE THE 1930s when Pat Bole led legendary birdwatching walks over the land that his family had donated, birding has played an important role at Holden. Arboretum birders are anything but passive. They not only watch the birds that frequent Holden but also count them and, in the case of the Eastern bluebird, have provided an example of the natural sustenance and education the arboretum has made a part of its mission.

Once, bluebirds were as common to Northeast Ohio as the wooden posts and fence rails that enclosed country pastures. Bluebirds nested in post knotholes and in dead limbs in orchards or other wooded lots. They fed on insects and laid their eggs. Then man improved the fence posts, trimmed the orchard limbs, and cleared the lots. He strung wire fencing on metal posts and the fences lasted longer. A bluebird habitat disappeared, with more aggressive birds such as starlings and sparrows taking over. Man also improved ways to control insects. He sprayed with pesticides such as DDT. The pesticides killed the insects that bluebirds needed to survive and caused the shells of the bluebirds' eggs to be thinner and thus more vulnerable.

Bluebirds virtually disappeared from Holden. In 1965, only eight nesting pairs—the males with their rusty breasts and bright blue backs and the females with their less ostentatious hues—were counted. They might still be few in number had it not been for Project Bluebird. Since 1965, volunteers have created bluebird trails and walked them at least twice a week from late March or early April through August, some of the volunteers doing this for more than thirty-five years. This volunteer project could serve as an arboretum prototype. By 1995, there were sixty-nine nesting pairs of bluebirds, and more than 500 eggs were laid, 450 of those hatching and almost 400 young birds fledging or leaving the nest. In 1999, the fledglings numbered 427, and in 2000, the number was a still respectable 365.

Fourteen bluebird trails lead to houses that have been placed in open fields in which the grassy habitat, nearby surroundings, and birdhouse locations are all key elements to the growth of the bluebird population. Holden bluebird volunteers do their work by the numbers: They place two boxes 25 feet apart, one for bluebirds and the other to accommodate tree swallows that would otherwise threaten the bluebirds. The pairs of boxes must be at least 300 feet apart, giving the birds a proprietary nest. To protect the bluebirds from wrens, another bird that seeks out woody cavities for nesting, the boxes must be at least 100 feet from heavy woods but no more than 50 feet from smaller trees or brush substantial enough to welcome the first flight of the fledglings.

Though the Bluebird Project makes significant and sometimes strenuous demands on its fifty-five volunteers, some of whom are arboretum staff members, the rewards go beyond seeing those flashes of

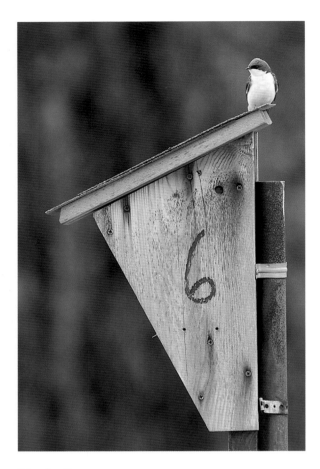

Tree Swallow at
Bluebird Nesting
Box

blue against the morning sun or hearing the bluebirds' fluty voices through a morning mist. Before they make their first flights, bluebird fledglings are carefully banded by the volunteers. This allows the birds to be registered with the Patuxent Wildlife Research Center in Maryland and Holden's records to be combined with those from elsewhere in the Cornell Lab of Ornithology's Citizen Science program. The Bluebird Project has regenerated a vanishing winged population.

Similarly, Holden wants to nurture the relationship between the casual visitor and the arboretum. To do so, it has created a garden that makes both a stunning first impression and has staying power. For the first decade after the Warren G. Corning Visitor Center was completed in 1980, little stood between it and the small Crystal and Reflecting Ponds behind it. The ground sloped sharply away from the center. This changed in 1991 when terraces were built and dedicated in honor of Claire D. Holden, first wife of Arthur S. Holden Jr., great-nephew of Bert Holden. In the distance, visitors, now with an attractive place to stand or sit, could glimpse the Crabapple Collection in one direction and Foster's Pond and woodlands in the other.

Some visitors do not have much time (though the arboretum is a site and an experience that cries out for a slow walk away from the frenetic, workaday world). Others cannot or do not want to stray far from the Warren G. Corning Visitor Center. Today, when such visitors take that first step onto the patio, they find themselves in the arboretum's summer showcase—the Arlene and Arthur S. Holden Butterfly Garden (dedicated in 1994, the garden is Art Holden's tribute to his second wife; he has been steadfast in establishing these living family memorials, including one for his father—the Arthur S. Holden Sr. Hedge Collection—and another for his mother—the Myrtle S. Holden Wildflower Garden).

There are other summer places at the arboretum where colors shimmer red and golden, as if a reflection of the noonday sun. Holden has taken care to be as colorful as possible in all seasons. (Some people would be satisfied with just the greens of the woody plants and their associates. The multiverdant hues, from the pale tall grasses at the Sperry Road entrance to lily pads on Oak Pond that can turn nearly black in the slanting light of late afternoon, comfort the eyes and cool the spirit.) The colors of summer can be found in the main display gardens, where perennials are incorporated into the beds, in the gardens at Lantern Court, and in the Myrtle S. Holden Wildflower Garden.

Though a spring beauty, the Wildflower Garden, depending on the month and the weather conditions, can still provide a summer surprise in color. It is the Butterfly Garden, however, that has become Holden's special summer place, for two reasons: first, its proximity to the Warren G. Corning Visitor

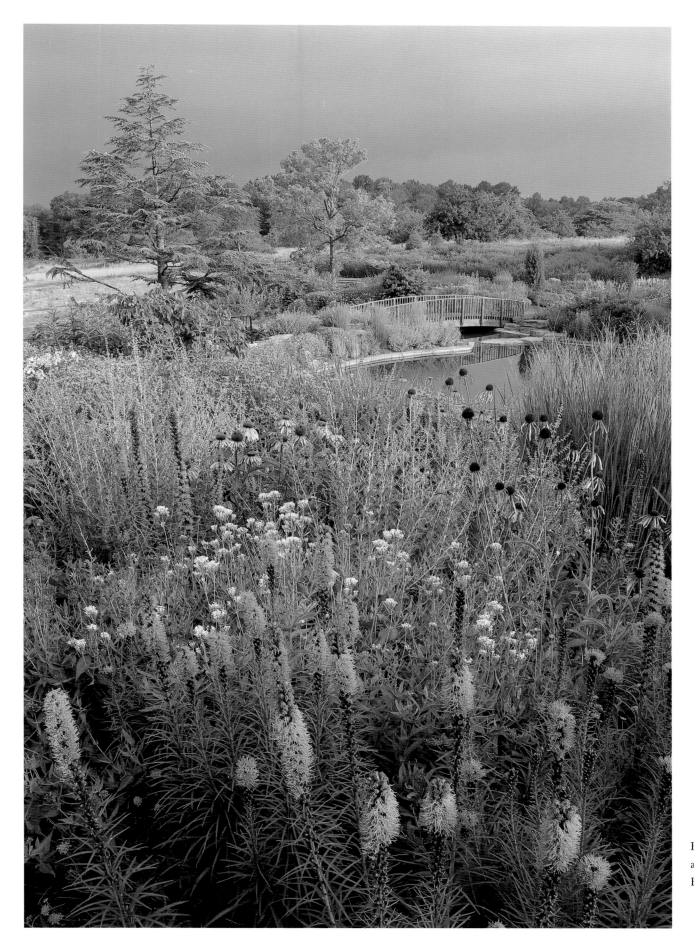

Blazing Star, Arlene
and Arthur S. Holden
Butterfly Garden

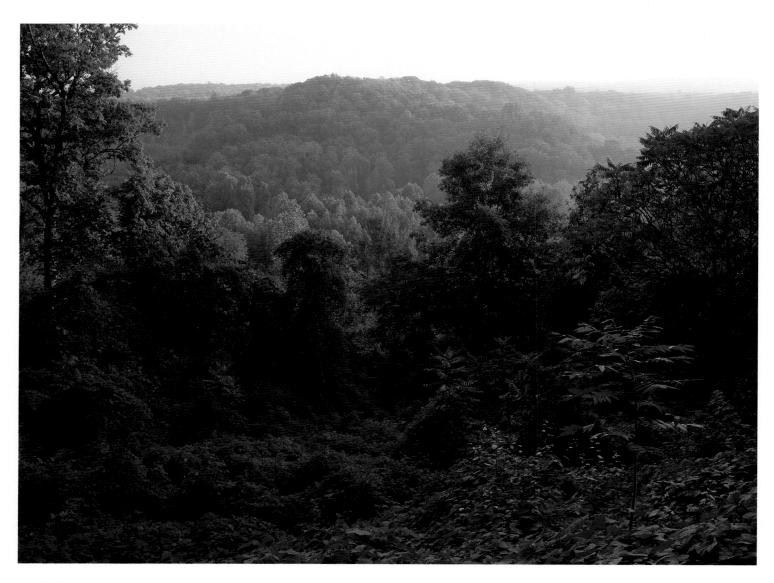

Overlook near Sperry
Road

Center. The garden, as alluring as any at the arboretum, is literally a step away. Second, the garden has arresting color and the signature element that may be even more important.

It has butterflies, many butterflies, that can generate in people much the same warm glow of delight that animals do. Butterflies are people magnets. The Butterfly Garden is the arboretum's equivalent of the backyard birdfeeder. Think about butterflies—the Swallowtails, the Monarchs—and today's backyards. A dearth of abandoned land in our urban and suburban communities, land which naturally provides what the butterflies need—food, cover, and water—has caused their number to diminish.

Acting on a longstanding but still valid dictum that summer color is a people magnet every arboretum should have, the arboretum set out to create a garden that was more about color than butterflies. They used some grasses, some perennials, but saw the potential for more, for a richer texture. The water was there. If cover and food were created, using the right flowers with milkweed and other vegeta-

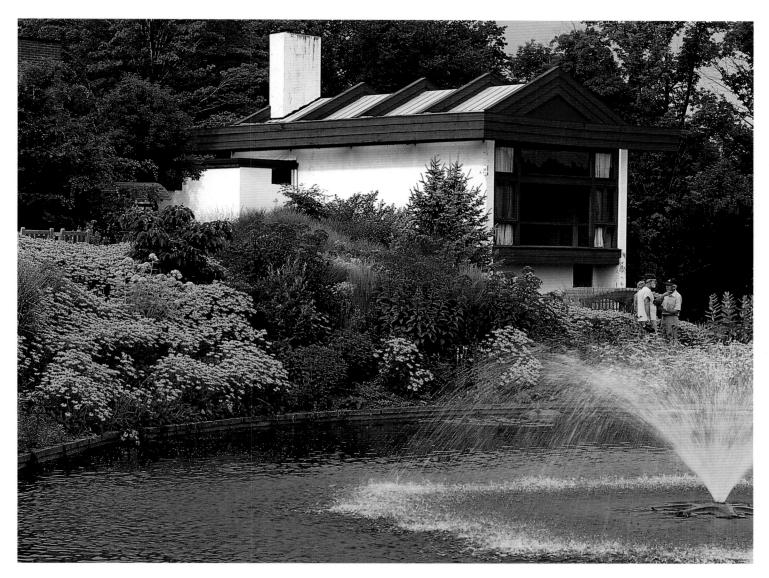

tion, there would be a wildlife garden that could serve multiple purposes and be an example to others who might want to bring the butterflies back to their yards. That is part of the arboretum goal: to set an example.

In addition to a horticultural display supporting a large butterfly population, this summer garden includes two of the other important aspects of the arboretum—education and research. Through extensive and expansive new interpretative signage added in 2001, the Holden Butterfly Garden provides visitors with a better understanding not only of butterflies but also of all pollinators that frequent the flowers.

As crucial as the Holden Butterfly Garden and similar gardens it has inspired are to sustaining butterfly populations, gardening in ways that will attract bees is even more important. Butterflies and moths pollinate 4 percent of the world's crops. Bees pollinate 73 percent. Northeast Ohio species of bees—bumble, carpenter, squash, leafcutter, and mason—can be encouraged not only by what people

plant (heirloom plants, those our grandparents had in their gardens, are often richer in nectar and pollen than today's cultivars) but also by avoiding the use of pesticides. Pesticides kill bees, as well as less desirable insects. Better to put ladybird beetles, lacewings, or praying mantises in a garden or, at least, to ascertain the least toxic of insecticides (agricultural extension agents and the World Wide Web are good sources of information).

The Holden Butterfly Garden exposes visitors to both beauty and the knowledge of how it has been achieved. As much as any Holden garden, the Butterfly achieves the arboretum's multiple goals of conservation (the butterflies), horticulture (the display of perennials, native and nonnative; a few woody plants; some annuals), education (creating an aesthetic that will lead people to try these plants and procedures at home), and even research.

By including in the Holden Butterfly Garden some of the witch hazels and buckeyes, including the *Aesculus pavia* or red buckeye, that Holden's research staff are working with, Holden is exposing people to collections not otherwise readily accessible. As much as tools are used in the garden, the garden itself is a tool to learn from nature, about nature, and for nature.

The Holden Butterfly Garden is just one of many opportunities the arboretum has to work with the green industry, to show those in the nursery business that if they educate the public about the value of cultivating native plants instead of exotic invasives, of giving over lawn to some of the plants to be found in the Butterfly Garden, that they can join in creating a universe of ecological concern, a nation of "backyard conservationists."

Butterflies are like people. Bright colors attract them. Reds. Pinks. Yellows. Oranges. But they will come to almost any fragrant flower. In the garden's peak blooming period of July and August, there may be as many as ten to twelve species of butterflies attracted to Holden. Each year, the Ohio Lepidoptera Society conducts a Fourth of July butterfly count at Holden. Each year, the number and variety of butterflies observed seem to grow.

Summer newcomers to Holden can walk from the arboretum parking lot into the Corning building without realizing what is behind the building and on the other side of the sliding glass doors. When they get their first glimpse of the Holden Butterfly Garden, newcomers often are lured past the reception desk. They slide open the doors. They gape. Then, they go into the garden and they are hooked by Holden's summer showcase. There is much more to the arboretum, of course, but the lure of the Holden Butterfly Garden is undeniable. In the mornings longtime Visitor Services Manager, Judie Gause, liked to get a cup of coffee and take her staff out onto the patio to plan the day's events. There is no better way to start the day. Now, people can sit on a wooden bench that has been placed alongside one of the pathways in the Holden Butterfly Garden in honor of Judie Gause's thirty years of service with the arboretum. Judie died on July 4, 2001.

"The best thing we ever did," Judie Gause said, "was to build that Butterfly Garden."

Zebra Swallowtail,
Myrtle S. Holden
Wildflower Garden

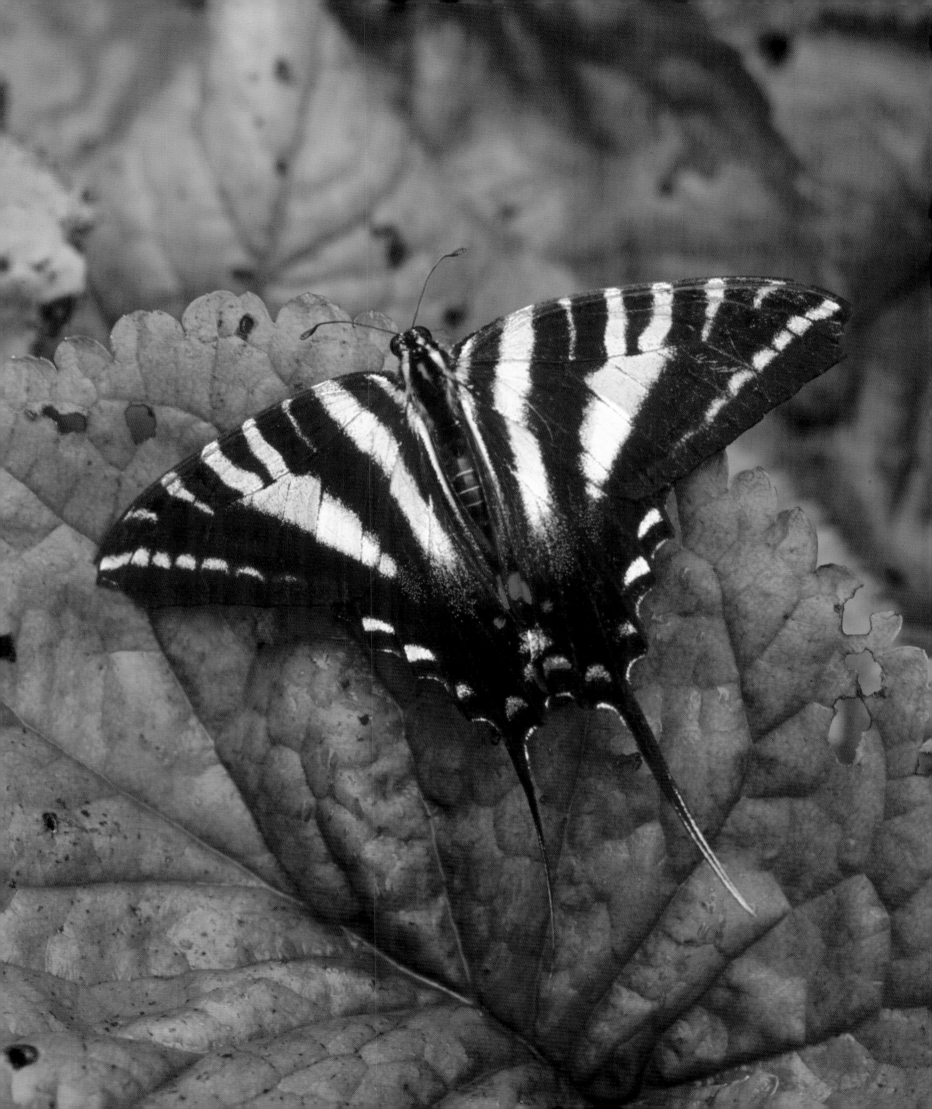

Butterfly Bush, Arlene
and Arthur S. Holden
Butterfly Garden

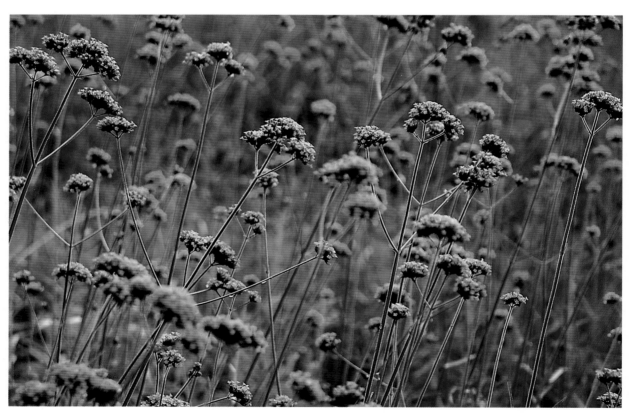

Verbena, Lantern
Court

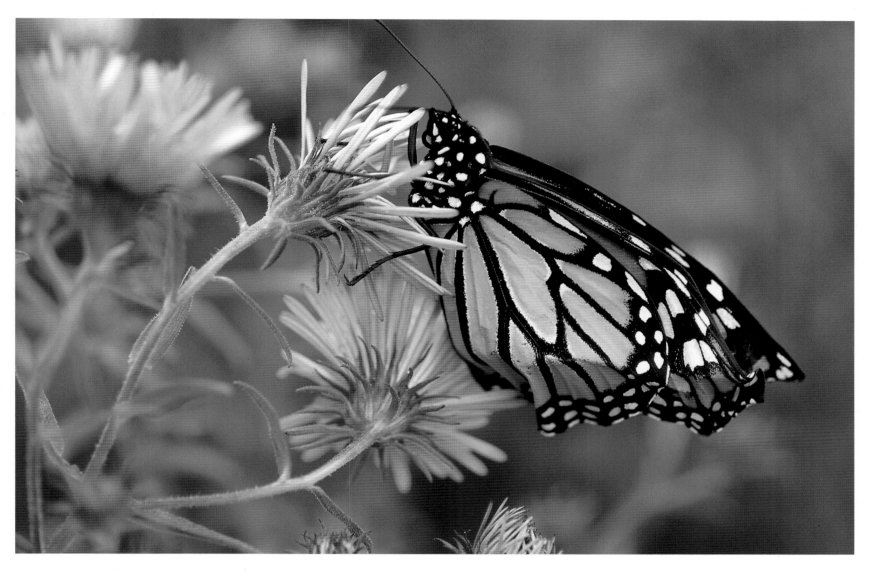

Monarch on Aster, Arlene
and Arthur S. Holden
Butterfly Garden

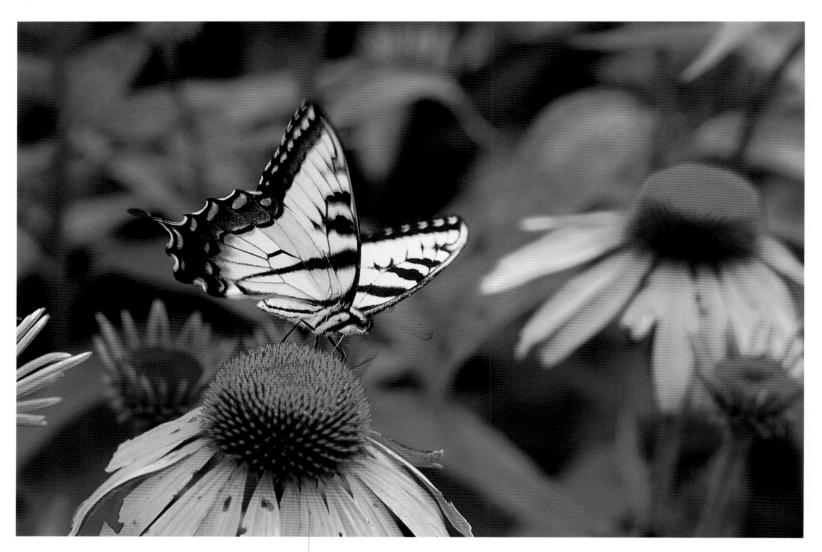

Tiger Swallowtail on Purple
Coneflower, Arlene and Arthur
S. Holden Butterfly Garden

Black-Eyed Susans and
Purple Coneflowers,
Lantern Court

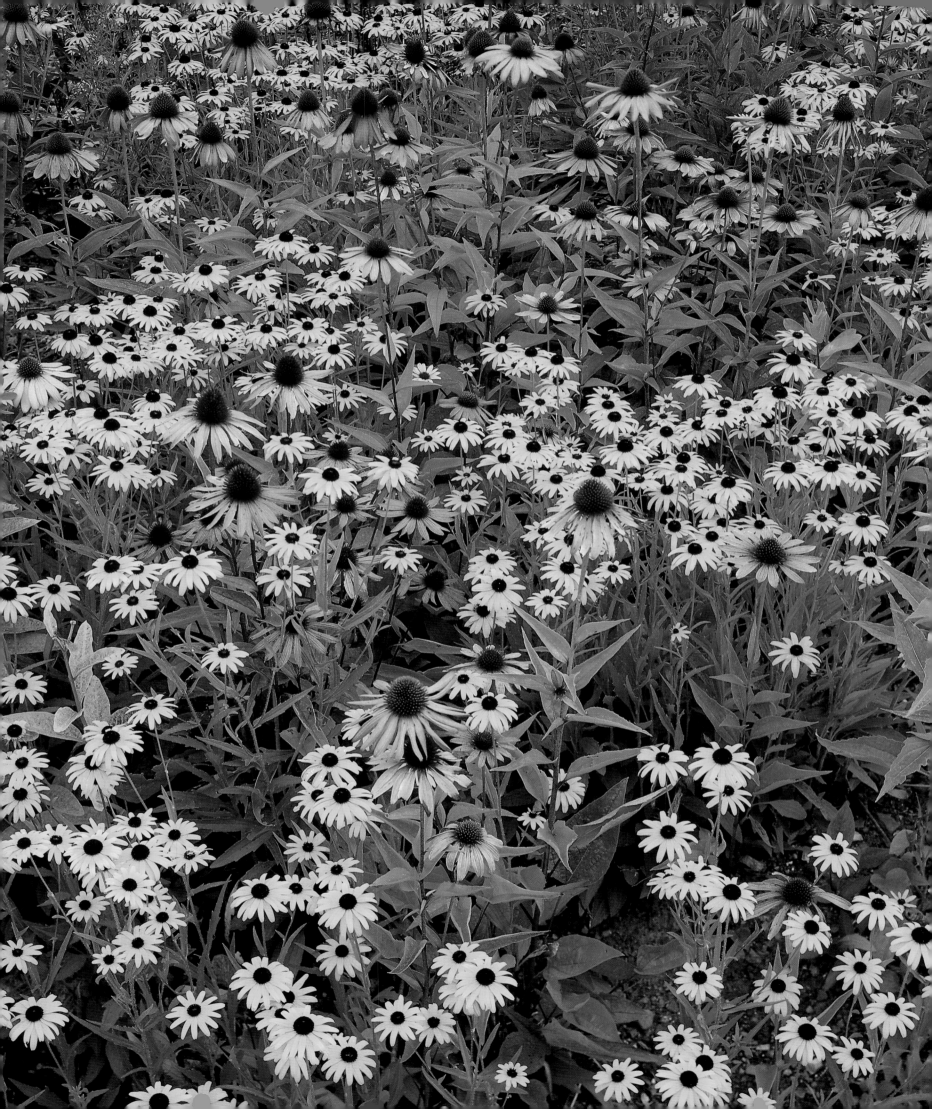

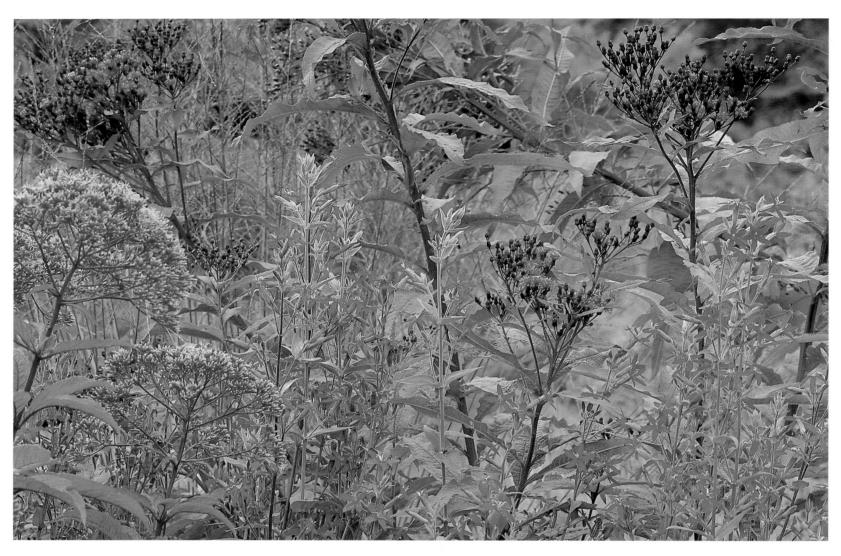

Joe Pye Weed, Ironweed, and
Royal Catchfly, Arlene and
Arthur S. Holden Butterfly
Garden

Butterfly Weed, Myrtle
S. Holden Wildflower
Garden

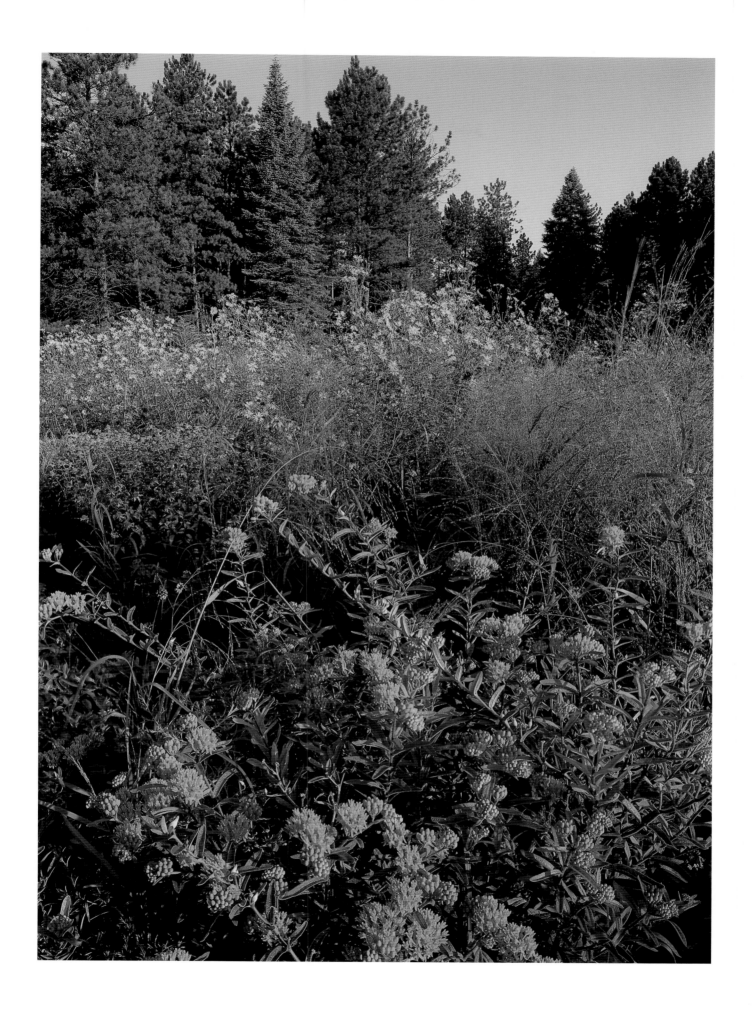

Rabbit in Garden at
Lantern Court

Crocosmia, Lantern
Court

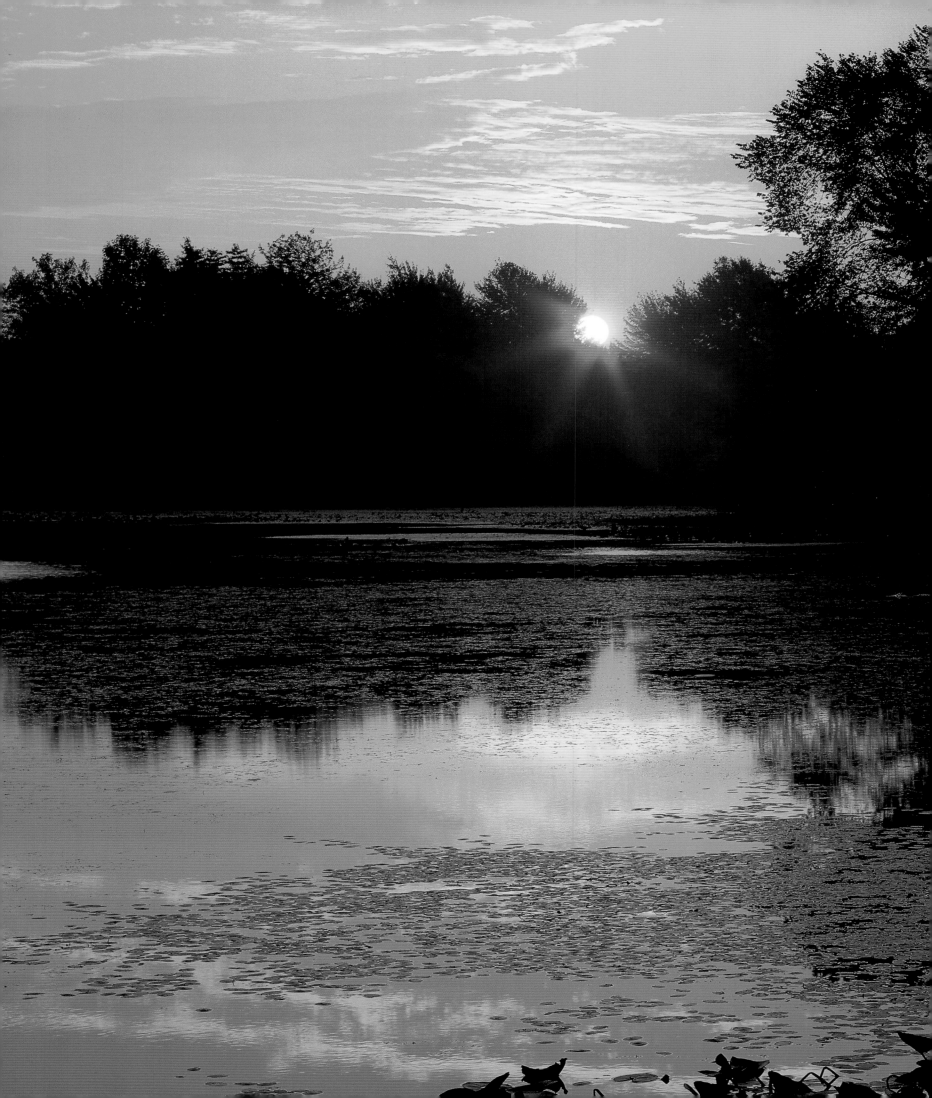

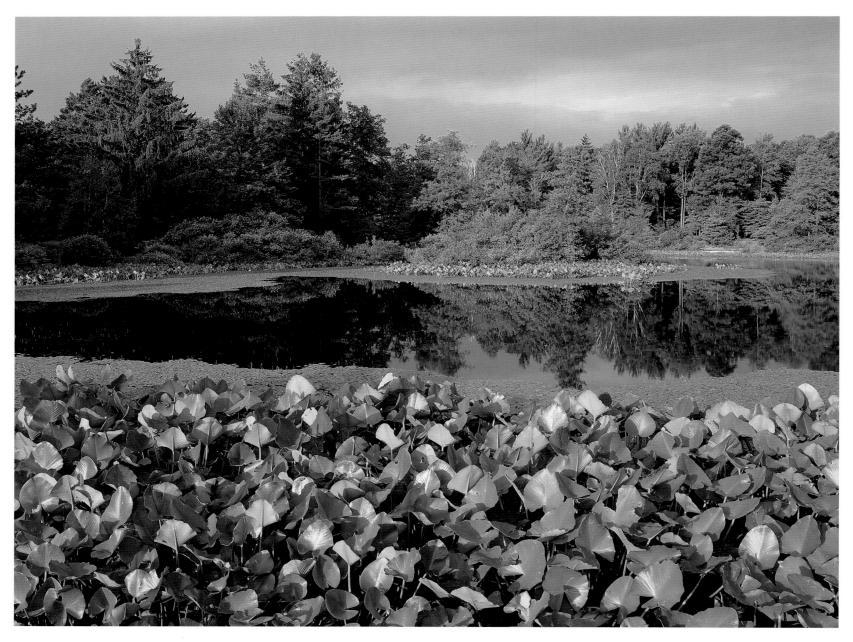

Blueberry Pond

Previous Pages: Sunrise,
Corning Lake

Water-Shield Leaves,
Corning Lake

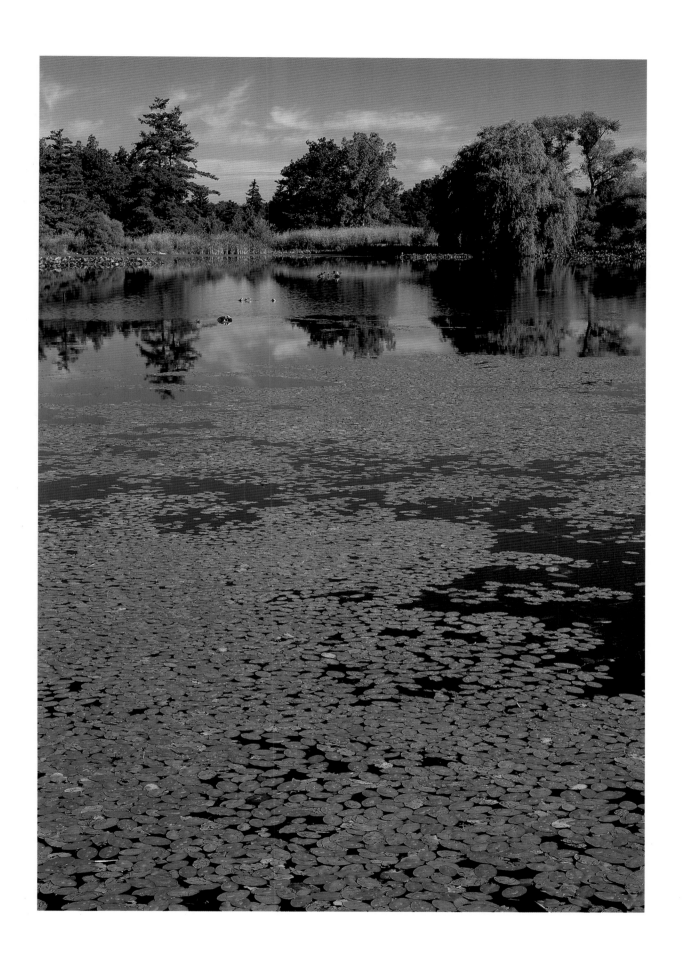

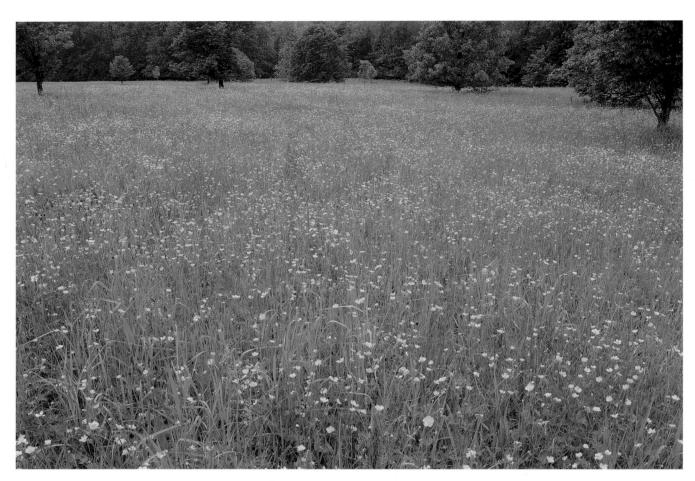

Buttercups, Ash
Collection

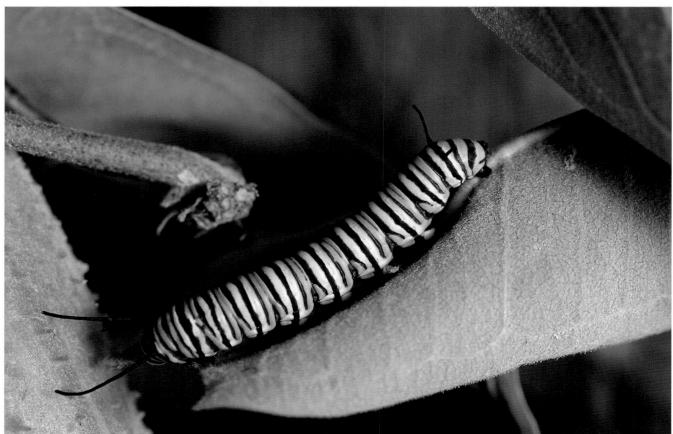

Monarch Caterpillar
on Common Milk-
weed near Corning
Lake

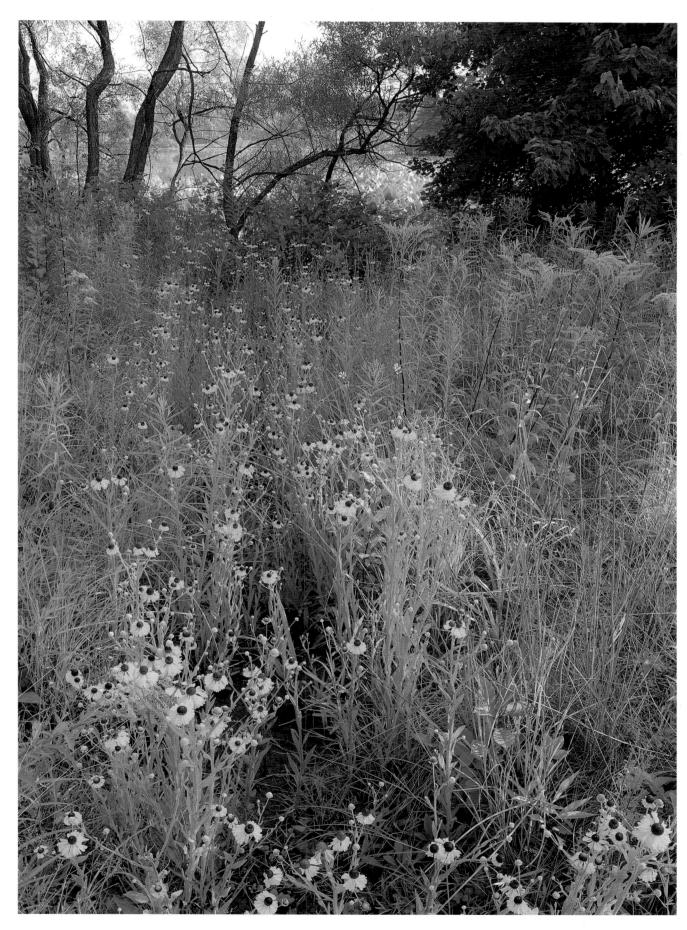

Sneezeweed near
Corning Lake

Prairie Dock,
Prairie Garden

Goldfinch in Prairie
Dock, Prairie Garden

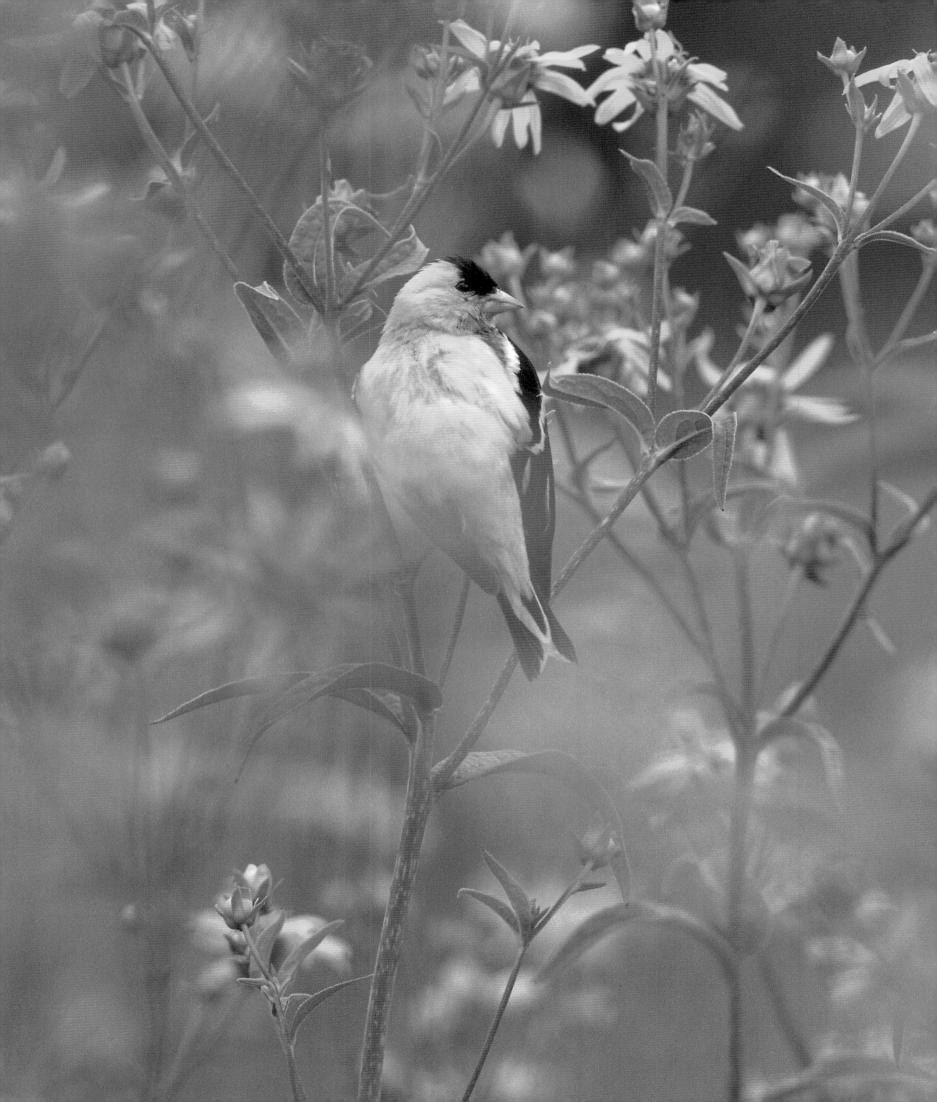

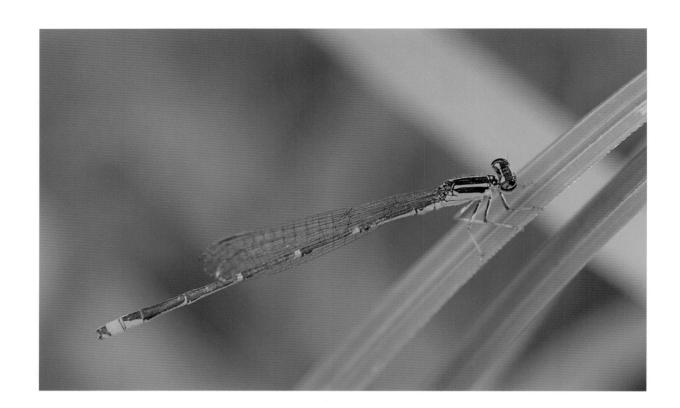

Stream Bluet
Damselfly near
Wisner Road

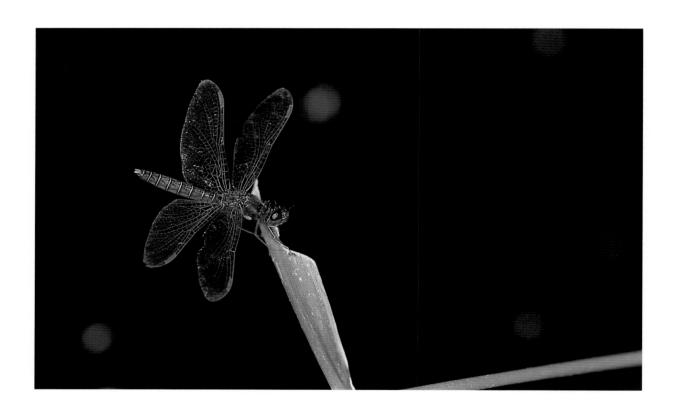

Eastern Amberwing
Dragonfly near
Wisner Road

Water-Shield Leaves,
Corning Lake

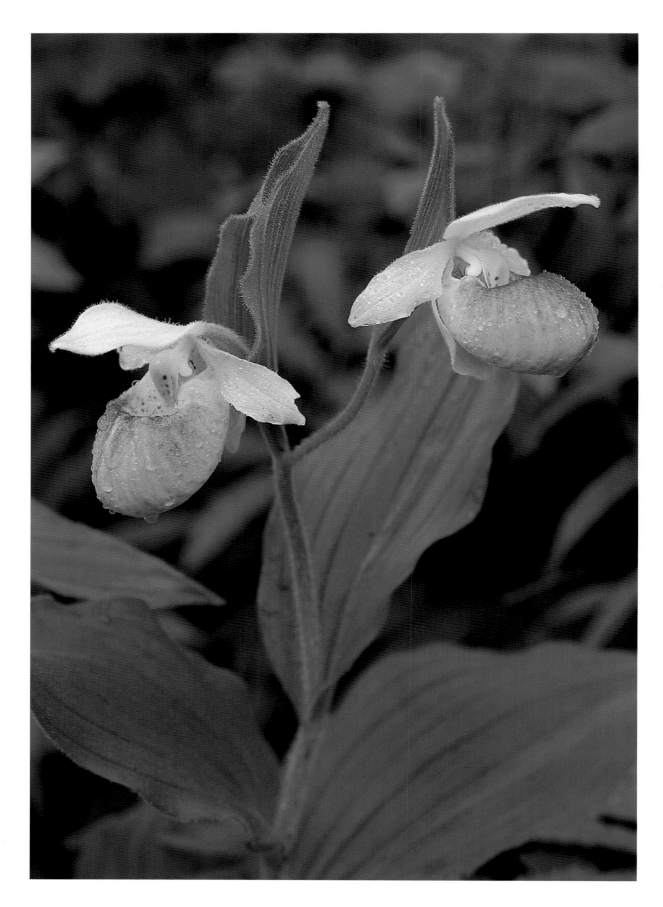

This page and facing page: Showy Lady's-Slipper Orchids, Brainard Bog

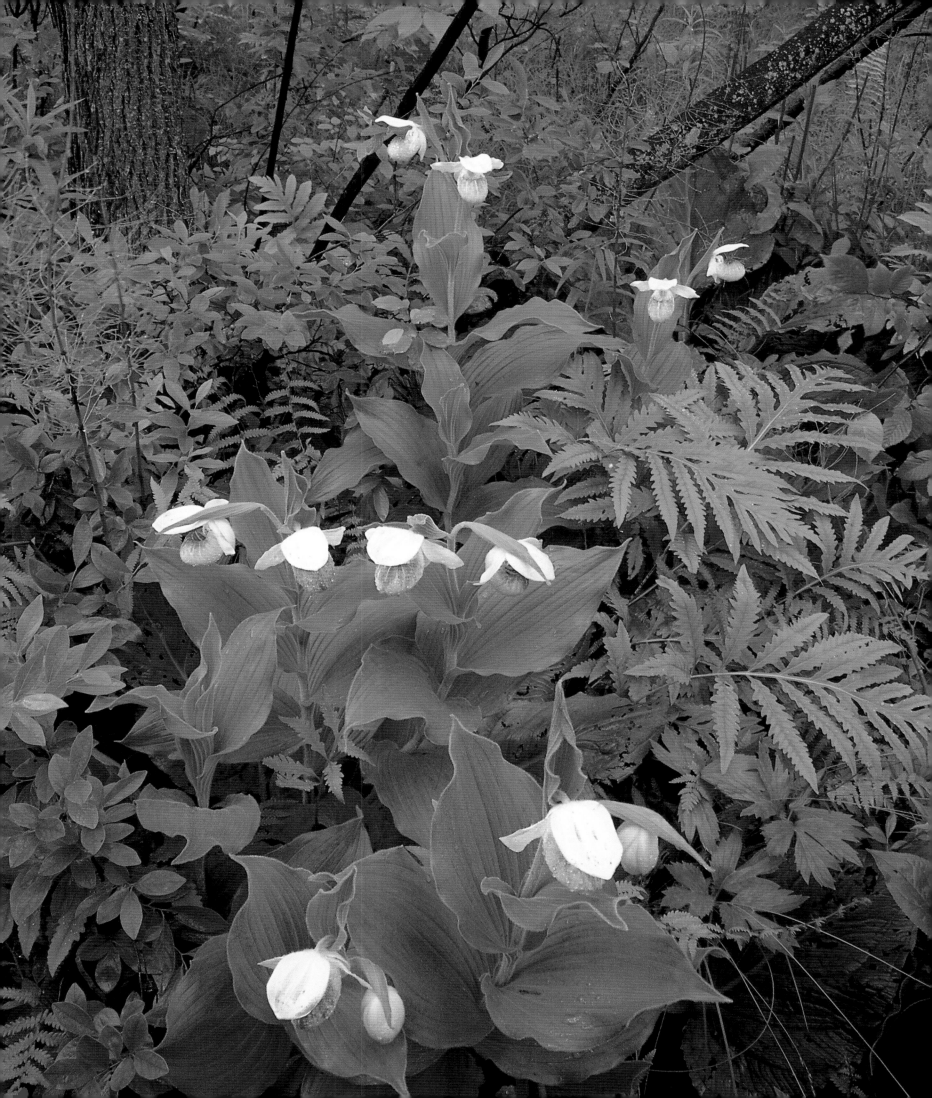

Frogs, Corning Lake

East Branch of Chagrin River
near Wisner Road

Beaver Lodge at
Brainard Bog

Sandstone Crevice,
Little Mountain

Hiker and Dog near
Blueberry Pond

Volunteer Ted Yocom
with School Group
near Foster Pond

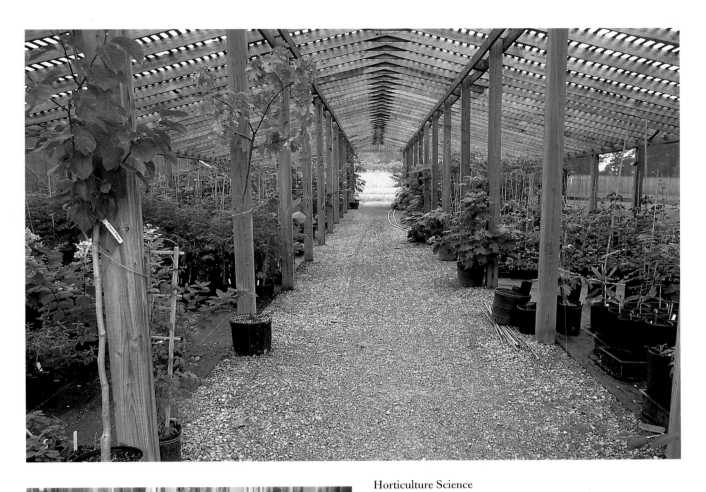

Horticulture Science
Center Lath House

Horticulture Science
Center Tissue Culture
Plant Propagation

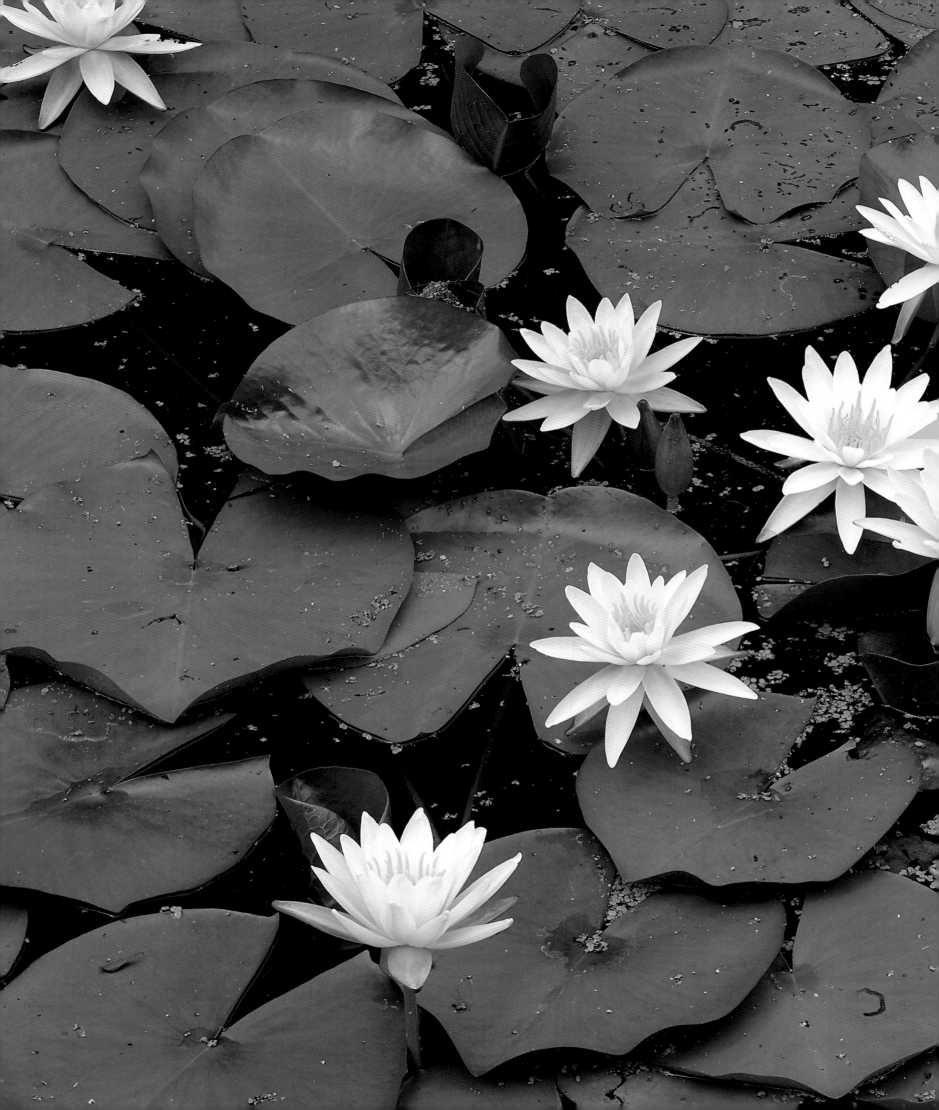

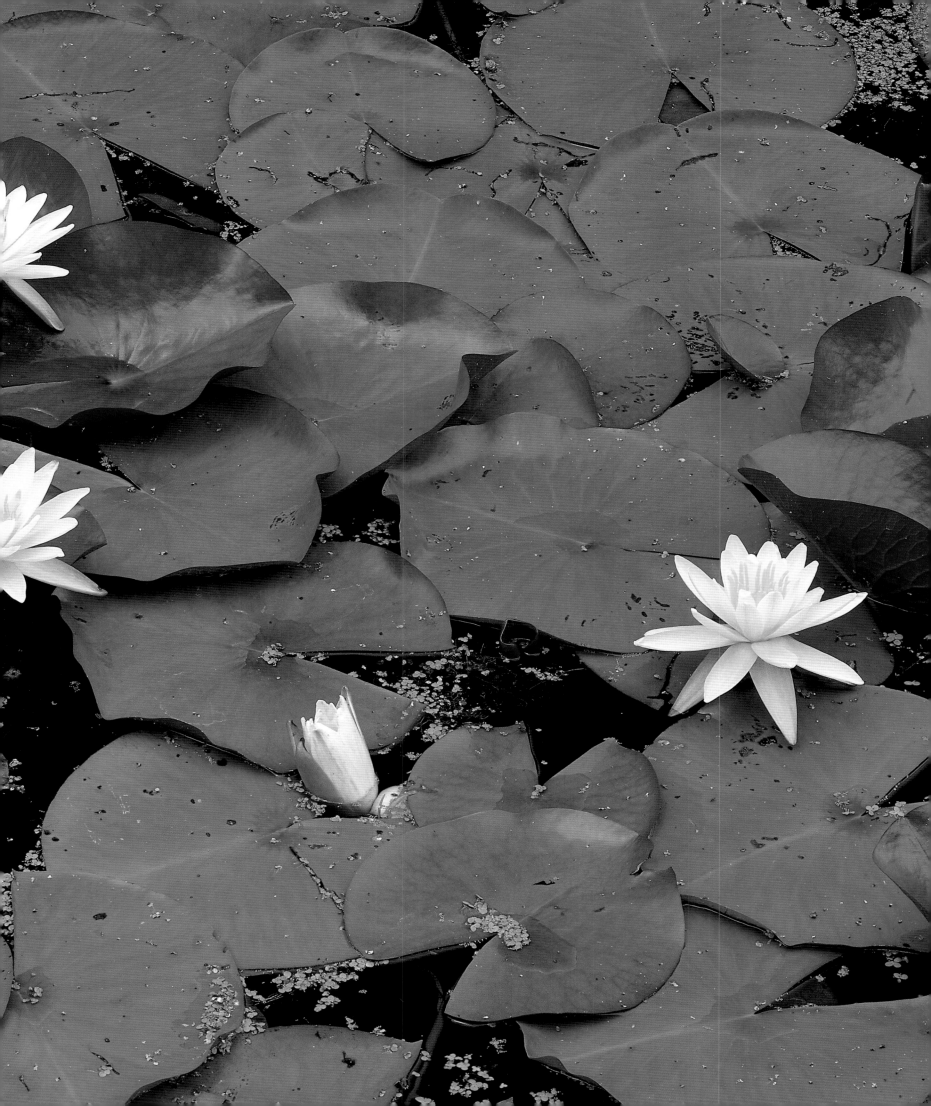

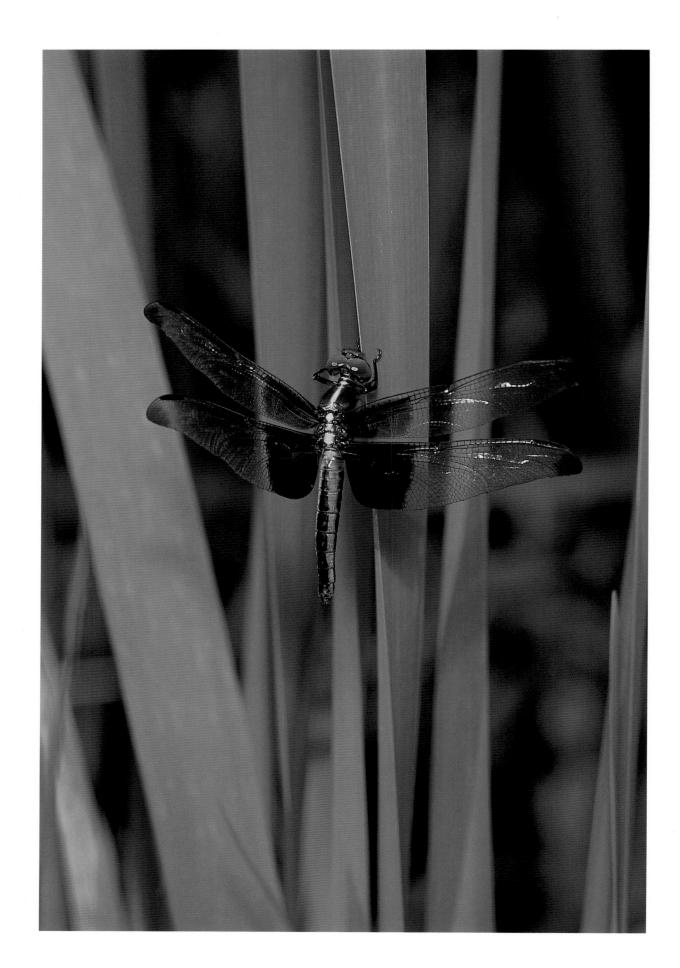

Previous Pages:
Water Lilies,
Heath Pond

Female Widow
Skimmer, Corning
Lake

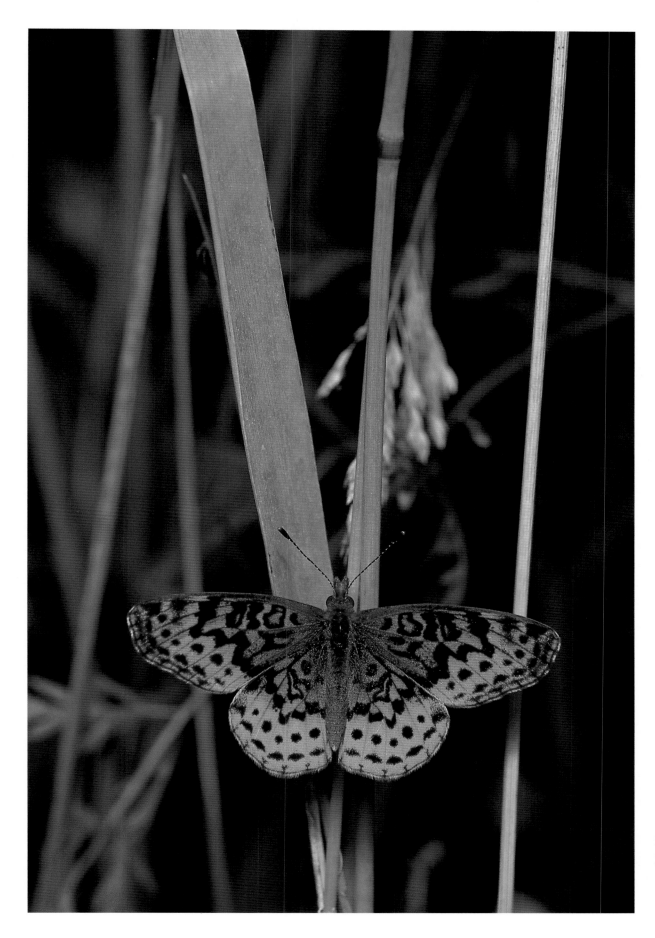

Meadow Fritillary,
Baldwin Acres

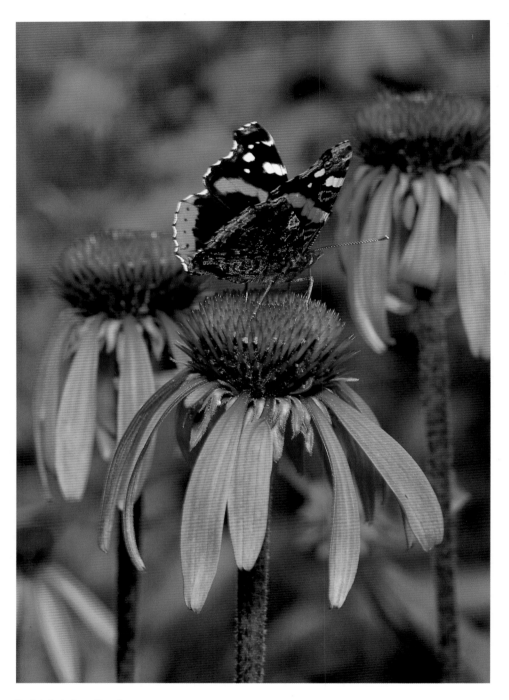

Red Admiral on Purple
Coneflower, Arlene and
Arthur S. Holden Butterfly
Garden

Purple Beautyberry,
Display Gardens

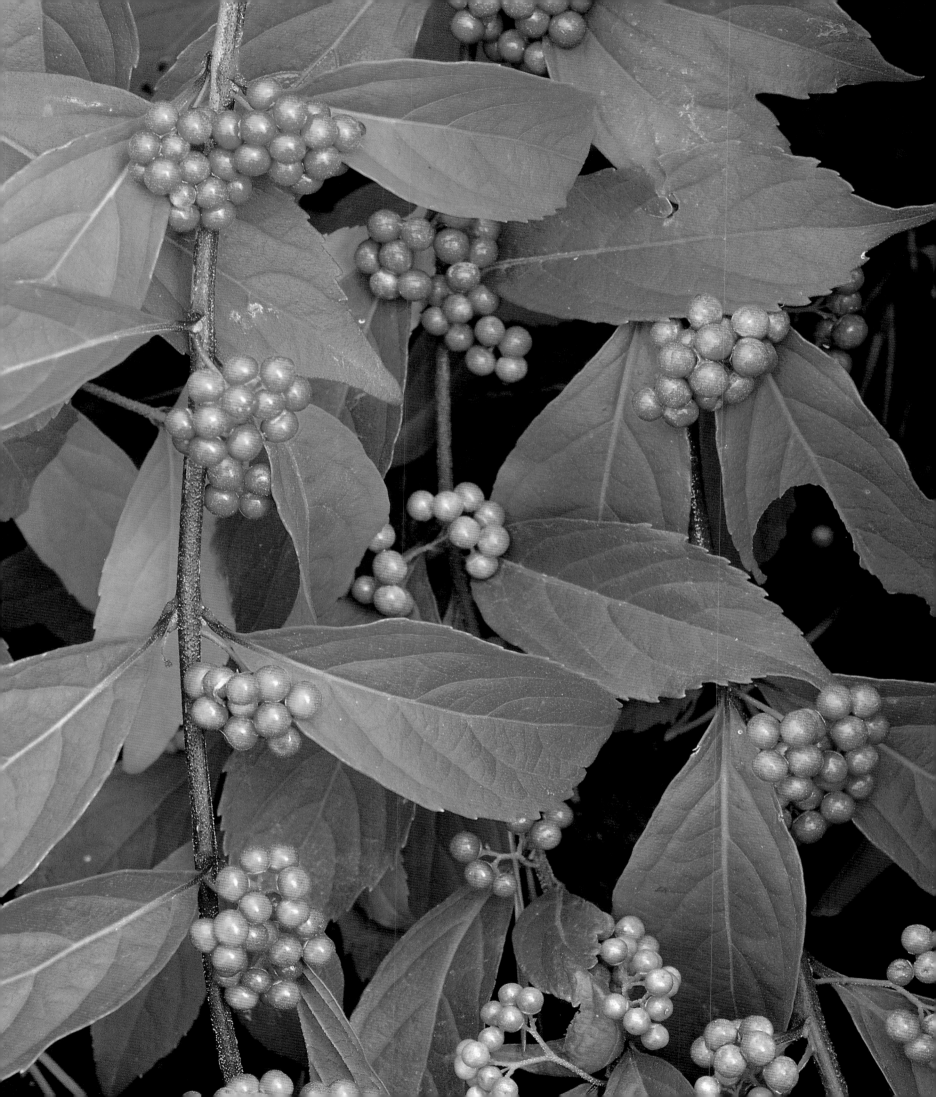

Cow Column, Firman
Nursery

Cottonwood Tree,
Firman Nursery

17-Year Cicadas,
Display Gardens

Conifer Collection

Lantern Court

Warren and Maud Corning knew how to play the perfect hosts. They still do—even years after their deaths and still more years after they made arrangements for their American country house estate, Lantern Court, to remain in family hands yet be operated by the Holden Arboretum they both loved.

Lantern Court is all that it was when the Cornings left it—and more.

Wend your way past the gatehouse and up the driveway off Kirtland-Chardon Road. Soak in the natural setting. Stroll into the house and hear the echoes of clinking glasses at the cocktail hour, the warm, comfortable silence of the Corning library, the all-season shouts of children frolicking in woods that appear to be behind the house but are, in reality, in front of it.

Lantern Court always has been able to have it both ways, to look good from every angle (the back of the Georgian Colonial faces the driveway, though most visitors will not recognize it as the back of the house until they see the front!)—a house so impressive yet welcoming that a visitor senses immediately that this was not just a grand place but a true home.

Lantern Court still is having it both ways: Its gardens have been done or redone mostly by hand. The work is at once substantial yet on a scale to which home gardeners can relate. Simple, hard handwork does not mean unimpressive work. Quite the contrary. Lantern Court's gardens are such a unique blend that they are the place where Holden staff bring visiting horticulture experts when they want to "elicit a gasp." C. W. Eliot Paine calls Lantern Court "an Oh! My! garden, because that's the first thing you say when you see it."

Construction of the gatehouse began in 1930, at almost the same time that Roberta Bole was donating the arboretum's first 100 acres nearby. The main house of Ohio sandstone was designed by Edward Maier of the Cleveland firm of Maier and Walsh and completed in 1932. Cleveland landscape architect Donald Gray conceived the original gardens that Holden's staff have nurtured and supplemented. The result is a gardener's garden. There are tremendous displays of color, of perennials and annuals. It is one of the main areas where the arboretum grows herbaceous plants.

If Lantern Court can be overlooked, it is because it is a singular destination, a specialty store for those shopping for manmade and natural beauty. In comparison, the core of the arboretum, with its Warren G. Corning Visitor Center and a variety of nearby gardens and collections, is nature's mall, a one-stop shopping experience.

A visit to Lantern Court yields beautiful dividends, even in this electronic age of sensory overload. The Cornings and their heirs have left in the house the furnishings and paintings and unique collections that suggest beauty understated is no less beautiful. Lantern Court's curving staircase, careful woodwork, and Vermont and Italian marble reflect the Georgian period, but the master suite and its art deco touches are perfect. The coffee table is a display of Warren G. Corning's mounted butterflies. It feels as if Warren and Maud Corning stepped out of the room only a moment ago, instead of in the mid-1960s.

Likewise, the arboretum's horticultural staff has remained true to Lantern Court's landscape theme, even as it has enhanced it. The Rose Garden has been restored, new roses added to old, sandstone walls trued, soil beds improved, and drip irrigation installed.

Native plantings such as the big-leaf Magnolia from Southern Ohio and Mountain Laurel are combined with a ground cover called Golden Seal, found in Ohio ravines. Use of local natives have augmented the wonderful existing wildflowers on the property.

The horticulture staff, with the blessing of the supervisory Lantern Court Committee, which includes one of Warren and Maud Corning's daughters, Alison "Sunny" Jones, has created a series of rock gardens in which can be found such favorites as the mountain avens. Island beds of perennials were added in the lawn area, as well as planted groundcovers around the trees. The cutting garden has also been expanded. Lantern Court is available to community groups for meetings, lectures, recitals, and similar activities. House and ground tours are offered, and the grounds are open at select times. More than anything, though, Lantern Court is an education and can become even more of one in the future. That's Sunny Jones's goal for the estate, that it become "a resource for expanding the arboretum's educational opportunities."

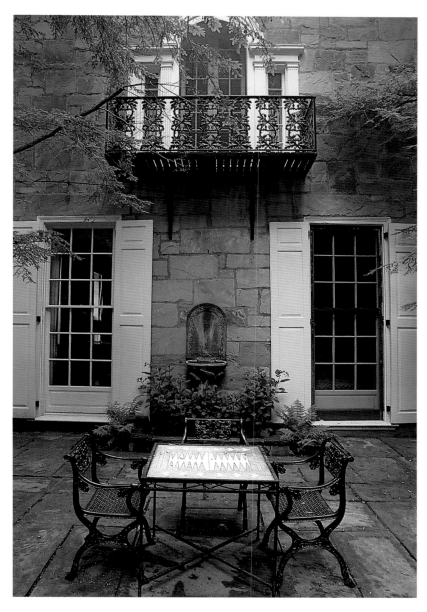

South Courtyard, Lantern Court

Like its gardens, Lantern Court's relationship with the arboretum is evolving. One day, the Corning descendants may not be directly involved, as Jones is now. She is confident, from what she has seen, that the relationship with the arboretum will continue to develop as Warren and Maud Corning would certainly have wanted.

Garden at Lantern
Court

To a very large extent, the uniqueness of the grounds of Lantern Court reflects the interests and commitments of one man: Tom Yates. In the hands of a garden-variety horticulturist, Lantern Court would have been a simpler, standard, merely pretty garden.

Instead, Lantern Court has many plants which are there only because Yates researched them and actively sought them. Many of the plants are rarities. Lantern Court's gardens are what Yates's longtime assistant George Rosskamp calls "the blueprint of Tom's mind."

Yates was trained as a draftsman, work to which he had intended to return after serving in Vietnam. Instead, he found his true calling when he joined Holden April 1, 1970. Yates's mentor was Joe Kenny, a man trained at the Dublin Botanical Garden. It was from Kenny, who died in 1972, that Yates learned about formal gardens. He also learned something more important: that it is okay to be a gardener.

Yates's patience and meticulousness are legendary, from the hauling and placement of rocks, to the slow generation of the desirable acidity of the medium. It's Yates's skill and delicate and curious mind that have made Lantern Court an "Oh! My! garden."

Waterlily, Lantern
Court

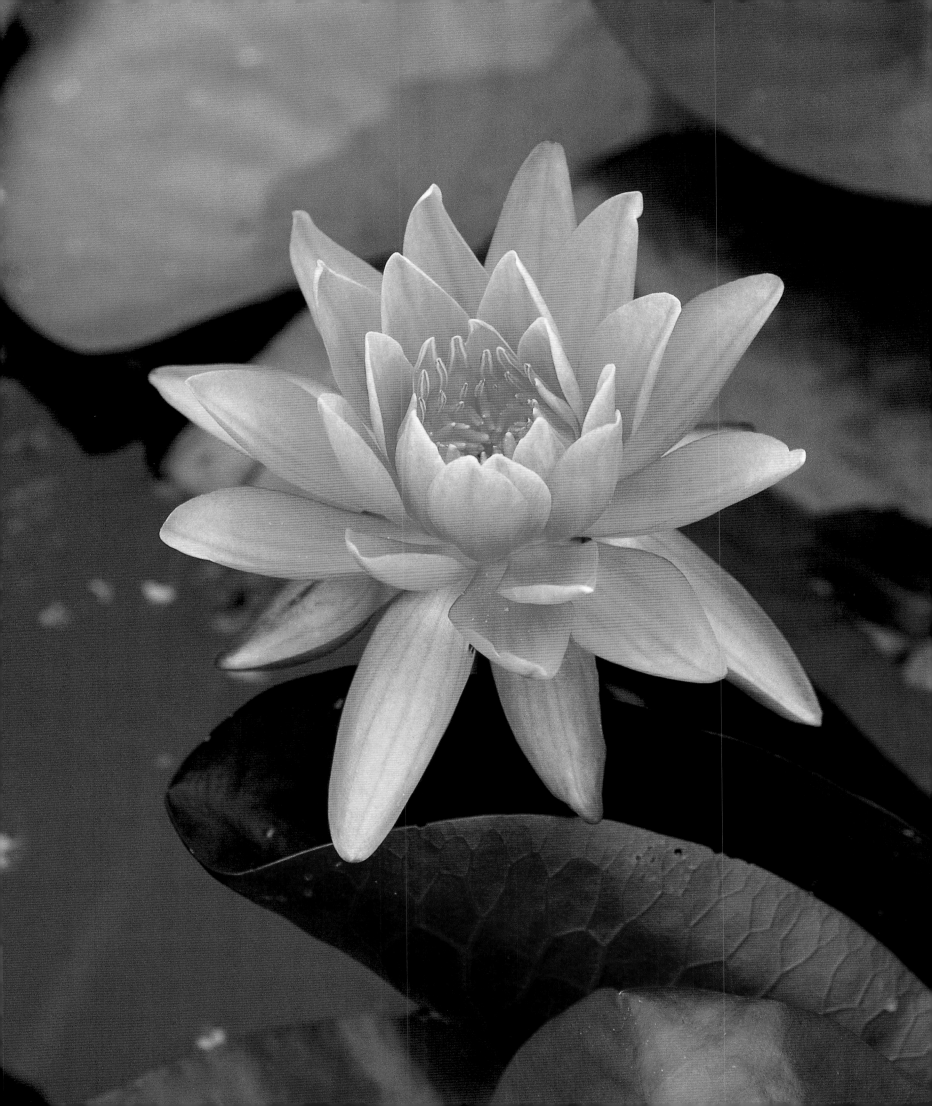

Fall

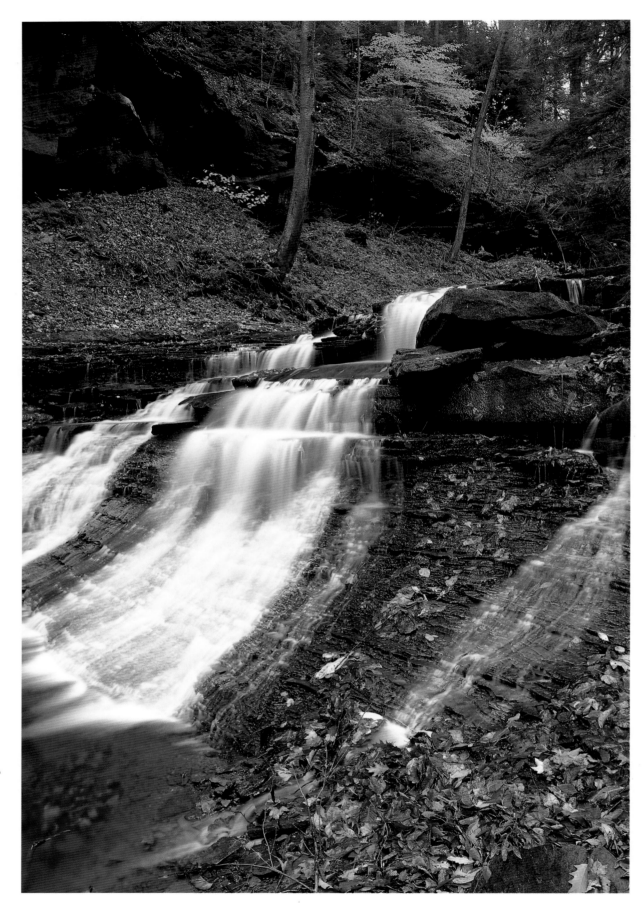

Previous pages: Tupelo
Tree, Foster Pond

Waterfall, Stebbins
Gulch

THE FIELDS FORETELL FALL at the Holden Arboretum as surely as the reds of the sugar maples or the yellows of the beeches. Fall color in the woods can be unreliable, sometimes arriving early, other times showing up late. Holden's colors are rich and full, nature's painting, accented with sun and sky, wind and rain. But an occasional fall can be not only a slacker but also comparatively subdued in its colors, lingering greens melting into browns, a half-hearted imitation of the season at its brightest.

The grasslands, on the other hand, are trusted predictors of fall. When summer wanes and fall begins to set in, the fields serve first notice. They are mowed, sometimes as soon as late August, their tall grasses taken down, the cover for the birds that Pat Bole so dearly loved no longer necessary. Nesting season is over, fall on its way.

Pat Bole was one of those early forces in the arboretum's history that seem almost as immutable as nature itself. Pat was the son of Ben and Roberta Holden Bole and the nephew of arboretum benefactor Albert Fairchild Holden. The Pat Bole stories are legend. Even his admirers—and they are legion—say Pat could be difficult. As often as not, though, his difficult side would manifest itself in a devilish, if unintentional, way.

The assistant in charge of the mammalogy department at the Cleveland Museum of Natural History and teacher at then Western Reserve University, Pat Bole's contributions to the arboretum were many, but as Dixon Long, board member and former board president, puts it: "Pat was the teacher and plantsman, a guy who loved to be out on the grounds. He didn't really care to go to meetings, to committees, to try to make decisions." Pat Bole worked with his hands to create the arboretum when sweat was more readily available than money. He would willingly share his vast knowledge of the natural world with anyone who wanted to accompany him on one of his Sunday-morning hikes for birdwatchers. Even so, he was less certain than others about how public a place the arboretum should be.

Emery May Norweb, the elder of Bert Holden's two daughters and mother of the arboretum's first full-time executive director, R. Henry Norweb Jr., spent both her influence and money to assure that Holden would become more than one of nature's exclusive country clubs, a professional horticulturists-only sort of place. She wanted Pat Bole and others who lived in or near the arboretum to have company. So Emery May Norweb, as she often did, provided money for internal access roads and for trails for the public.

When the big day came that the arboretum officially opened to the public, Bole, who enjoyed sunbathing in the nude, had forgotten that he should be expecting visitors. Instead, he was sunbathing in his usual location near his home and in his usual state of undress. When he heard voices, as Emery May

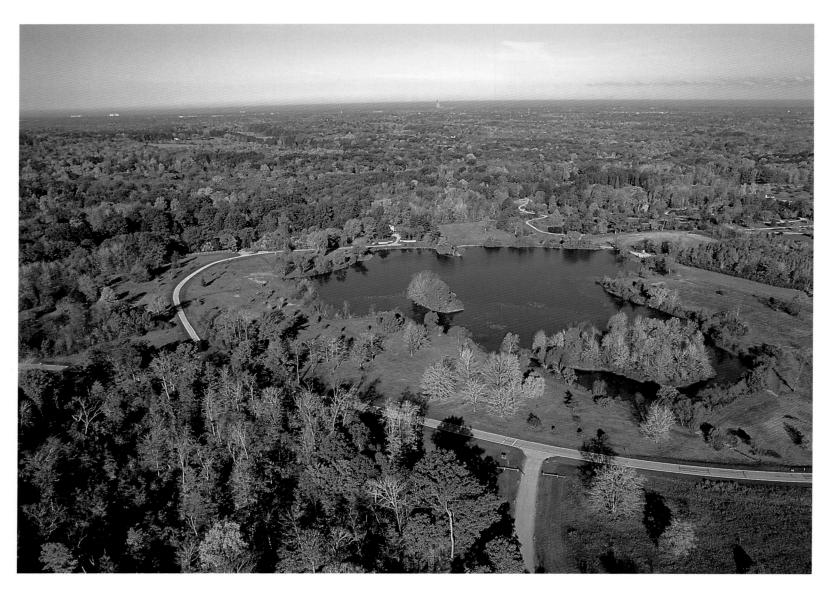

Aerial View of
Sperry Road and
Corning Lake

Norweb liked to tell the story, Pat clambered beneath some nearby bushes. The bushes were sufficiently full to save Pat the embarrassment of being recorded as the first naked-as-a-jaybird gentleman sighted by visitors to the arboretum, but the evasive action was not without its consequences. With no time to assay the ground cover before beating his bush retreat, Pat Bole found himself lying in a bed of poison ivy. As soon as was safely possible, he rose and raced for his house. It was too late.

"He had a wonderful case of poison ivy and none of us was sympathetic," said Emery May Norweb.

Pat Bole, clothed, became a common sight to arboretum visitors, especially to those who enjoyed his Sunday-morning birding walks through the unmowed fields that provided cover for the birds, past his own arboretum plantings, and into the woods he knew so well, including those named for his father. Years later, perfect strangers would stop Jonathan Bole and suggest that he had to be Pat Bole's son. The

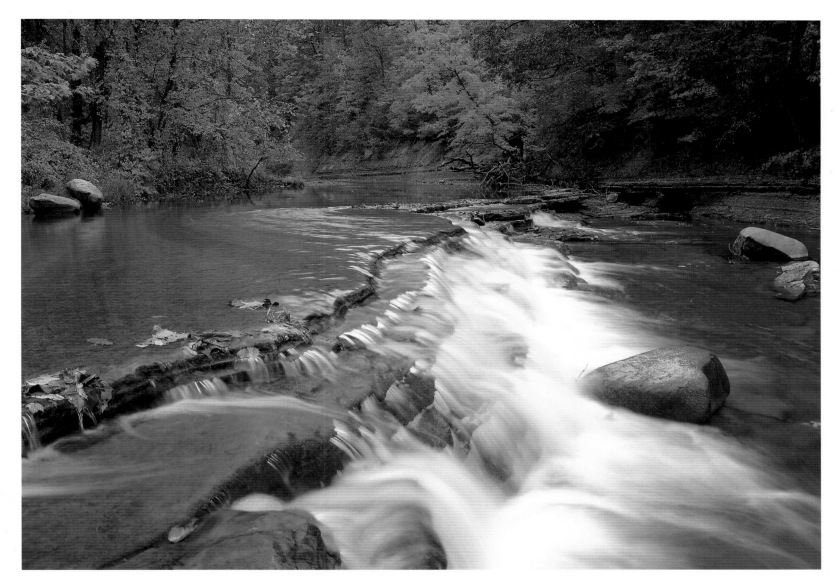

two men looked alike, because they are father and son, but it was not just Pat Bole's physical appearance that remained vivid for people who had taken his courses at Western Reserve University or hiked with him at the arboretum. It was Pat Bole's ability to share in a plainspoken way his knowledge about all things natural and the enthusiasm with which he did it.

Jon Bole received an indoctrination into the natural world, as did houseguests, neighbors, arboretum staff, visitors, virtually anyone whom Pat Bole happened upon during, as Jon Bole has said, "some very detailed hikes." When Pat Bole and his fellow hikers came to the end of the trail on Sundays, he would quite often invite everyone to return to his house for a late breakfast.

Those who lead hikes today through the mowed fields and into the brightly colored woods may not invite everyone over for a meal at the end of an all-day fall hike, but others are carrying on, even extending, Pat Bole's tradition of opening up the wonders of the natural world through expedition and

explanation. They know the unmarked paths to rare vistas and hidden treasures. More important, they can open the eyes of those who accompany them to the subtleties of nature that might otherwise go unnoticed and therefore unappreciated. For instance, on the edge of upper Baldwin Acres, above the East Branch of the Chagrin River and not far from the Bole family home, stands a white oak that is between 200 and 250 years old. It is one of the older trees on the arboretum's more than 3,400 acres, and it may be dying. A long black scar well up the trunk explains why: lightning. Not the direct hit that can take down a stout, old tree like this with ear-splitting suddenness, but a shot that has done more internal damage than is visible, with as yet unknown consequences.

The development of Baldwin Acres, an interesting combination of grasslands and odd plantings, reveals the relationship between Lew Lipp, the arboretum's first propagator, and Paul Martin, longtime superintendent. Each contributed mightily to the arboretum that lights up with color in the fall. The Holden staff was small in the 1950s and 1960s. During meetings, everyone could gather around one small table. Lipp would walk into the room and throw down the fragments of a sliced up or otherwise mangled tree.

"Well," Lipp would tell Paul Martin, "you got another one."

"Dammit," Martin would reply, "put up bigger stakes."

All that Lipp planted during his eighteen years at Holden could not have survived. There was just too much of it. On occasion, Martin's mowers chewed up one of Lipp's young trees hidden by the tall grass. It may have been, in part, because of the way Lipp went about setting out the huge number of plants that he brought to life, like some great magician with a green thumb for a wand. Many of the Baldwin Acres plantings were Lipp's doing. They may have been unusual in design but they were not uninspired.

C. W. Eliot Paine cannot suppress a smile when he recounts the wars of the woody plants waged between Lipp, the man from Massachusetts, an urban dweller during his years with the Arnold Arboretum at Harvard University, and Martin, the man from the hills of Kentucky. Both men wanted the same thing: To make Holden so beautiful and of such scientific significance that fall hiker and horticultural researcher alike would be stopped dead in their tracks with awe. The problem was the early system. One man (Lipp) grew the plants and the other man (Martin) looked after them when they had been planted. They did not, however, tell each other what they were doing.

"It was a crazy system," said Paine, who held jobs in the horticulture and education departments on his way to becoming Holden's executive director and, in retirement, a trustee.

Lipp's propagation outpaced the ability of Martin and his staff to plant and care for trees, shrubs, and flowers. Lipp would load up his little green truck with plant material and head over to the Baldwin property, first planting nut trees on the lower portion of the property in what has become an area for research and then moving to upper Baldwin, going into the pasture grass, and without soil preparation, planting other material, creating this glorious specimen tree collection, with varieties from around the world. The problem was, without the availability of some of today's herbicides, and with all the hand-

Maples and Birches,
Buttonbush Bog

work required, the collection could be a nightmare just to keep alive, much less to care for properly. Lipp would plant so fast that Martin often did not even know what had been planted and where until Lipp complained that his plants were not receiving proper attention.

Holden benefited from the creative tension between Lipp and Martin. Today, the Baldwin Acres old white oak scarred by lightning has lots of company on the property. All manner of tall, handsome trees are growing beautifully, thanks to the man generally regarded as the best propagator in the country and a superintendent who somehow got more done than anyone could ever have expected (except Lipp).

Beyond the mowed grasslands that surround Corning Lake, with its reds, golds, yellows, oranges, and every fall shading in-between reflected in its waters, and across Sperry Road lies the property that Roberta Holden Bole gave to the arboretum in 1942 in memory of her husband, Ben, Pat's father. Since 1968, Bole Woods has been, along with Stebbins Gulch, a National Natural Landmark. When a field investigator from the National Park Service explored Bole Woods, he found a "near-virgin climax beech-maple complex . . . one of the finest examples of this type anywhere."

Whether a person is seeing for the first time the arboretum all dressed up for fall or grew up with it, as did Holden Trustee Connie Abbey, granddaughter of Emery May Norweb and daughter of R. Henry Norweb Jr., the first executive director, the impressions can be enduring. "Seeing the architecture of the land in the fall," Abbey said, "takes my breath away still."

This forest is old (more than a hundred years in age), tall (tree crowns of 100 feet and more), and comparatively untouched by modernity. A mile-and-a-half-long trail allows visitors to pass through three plant communities (large tulip trees and sugar maples; beech-maple; mixed mesophytic of immature trees seeking their place, largely red maples and tulip trees) and a small wetlands area.

Though this is no hike for the timid, any immediate fatigue or day-after soreness from investing seven hours over eight or nine miles in the arboretum comes with the dividend of having seen flora and fauna other people have not and gone places most have missed. And there is much to miss: Inching down ravines with tenuous footholds, finding evidence of the damage the jackhammer beak of a pileat-ed woodpecker has done to a shagbark hickory (Paul Bunyan-size wood chips), learning about the road without a middle (Wisner Road, part of which was wiped out by a severe rainstorm), discovering that American Indians used to make thongs from an uncomfortable-sounding shrub called leatherwood, fol-lowing the trail of a wild turkey from its droppings, admiring the lavender blossoms of the woodland New England asters, being startled by horseback riders who have dismounted and are leading their ani-mals up a trail to a vista near Carver's Pond from which a person can see for miles.

Standing like a sentinel near a path to the infrequently visited Carver's Pond, a majestic old black walnut invites measurement and an estimate of its age. Several years ago the arboretum received an offer of between $20,000 and $25,000 for the tree. If its prime wood could be reduced to board feet, Holden could have had a financial leg up at a time before the interest from the arboretum's trust fund was avail-able. No sale. Some things are priceless, and this tree is one of them. It measures 130 inches in circum-

Carver's Pond

ference and is 143½ years old, based on a formula that has a relatively significant degree of error of plus or minus twenty years.

Like its walnut guardian, Carver's Pond is a natural wonder, though it did have help from its original owner, Lorenzo D. Carver, and from the Hitchcock brothers (Reuben, Charles, Lawrence, and Morley) to whom he sold it. Someone built a dam on the pond to improve the hunting. Even before the man-made construction, the beavers may have been at work, as they are today. Nocturnal, none is visible in the late fall afternoon, but a beaver lodge, well out in the pond, could not be missed. It resembles a giant mound of wood, a home in what otherwise appears to be some of the arboretum's most striking wilderness.

A hawk soars overhead. Frogs leap from lily pads. Turtles take the dwindling rays of the fall sun

on logs. Blue herons have been spotted here. The evidence (a nest high up in the dead branches of a tree) still exists. To traverse some of the wet fingers that extend from Carver's Pond, a hiker does not have to follow the contour of the bank. The beavers have built shortcuts the hikers can follow. They also keep raising the water level.

Trekking away from Carver's Pond in the direction of Baldwin Acres, a hiker with a knowledgeable guide or a bit of luck can find the largest living American chestnut on the arboretum, a tree that somehow defied the blight that killed almost all of the other American chestnuts, leaving them rotting on the ground, renewing even in death. The tree apparently has survived because of an immunity to the blight that the other chestnuts lacked. No one knows what created this one tree's immunity. Of course, it is to explore such questions that Holden exists.

Hike out of the trees below Baldwin Acres, across the East Branch of the Chagrin River—missteps mean wet feet for the final mile or more—and into the old greenhouse area (called Main Street by some). With the onset of fall comes a reminder of how alert the early horticulture staff had to be to changes in the weather. Richard Munson, the arboretum's former executive director, began the first of his two careers at Holden living in a house 150 feet away from the greenhouse. As the plant propagator, Munson had responsibility for the greenhouse and its valuable contents, much of them left over from Lew Lipp's propagating days. Munson watched the sky more closely than the hawk at Carver's Pond. No motors existed to crank open and then close the vents of the greenhouse glass. When a large cloud blocked the fall sun and threatened to drop the temperature, it was enough to cause Munson to head for the greenhouse to crank the vents closed. Munson had an academic degree and would acquire others, but those fall days taught him invaluable practical lessons about the season—and the surprises it can bring—that cannot be learned in a classroom.

As it turned out, the hikers, too, learned something practical, about where to look for fall's brightest colors at Holden. They made their way from the old Mather Farm and back up the edge of Pierson Creek toward the Warren G. Corning Visitor Center, climbing—no stairs for them—to connect briefly with the Old Valley Trail. After a short time, they abandoned the trail to head in the direction of the Crabapple Collection, Foster Pond, and a surprise ending, not unlike first discovering fall in the mowed grasslands of the arboretum.

There, behind the visitor center and Thayer Center, the maples had turned a blood red, as strikingly deep and rich in color as any to be found deep in the woods of Holden's natural areas. It does not require an all-day hike to discover Holden's beauty. For years, no matter where a person has looked—to the fields, in Pat Bole's bushes, or out the back door of the Corning building—Holden has been filled with surprises.

East Branch of
Chagrin River near
Carver's Pond

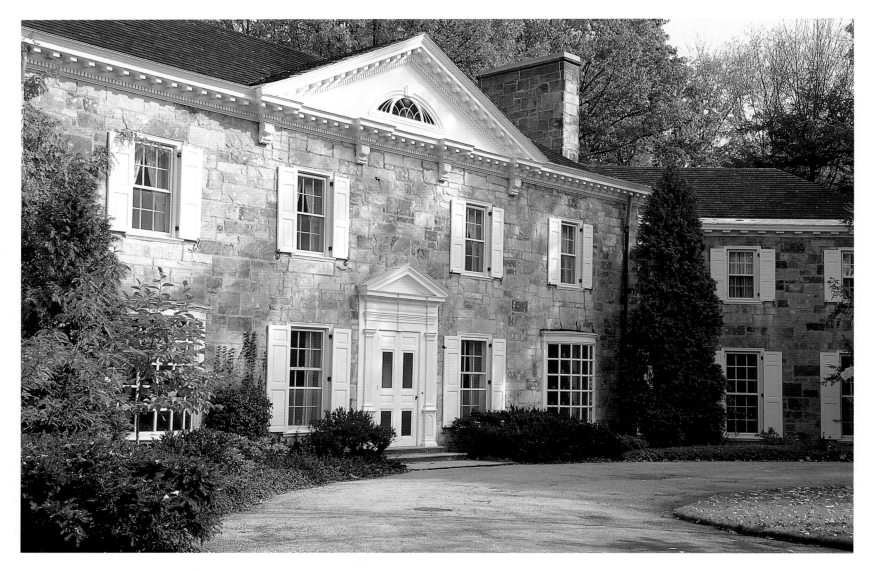

Lantern Court

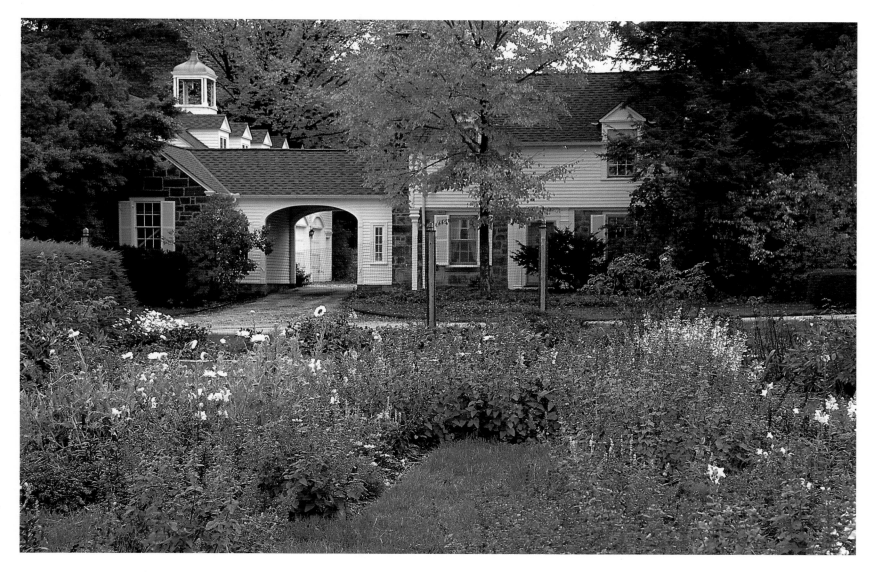

Gatehouse at
Lantern Court

Birch Roots, Little
Mountain

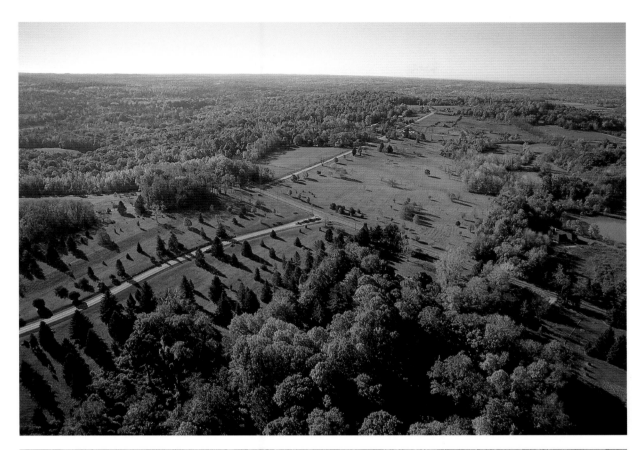

Aerial View of Sperry
Road and Conifer
Collection

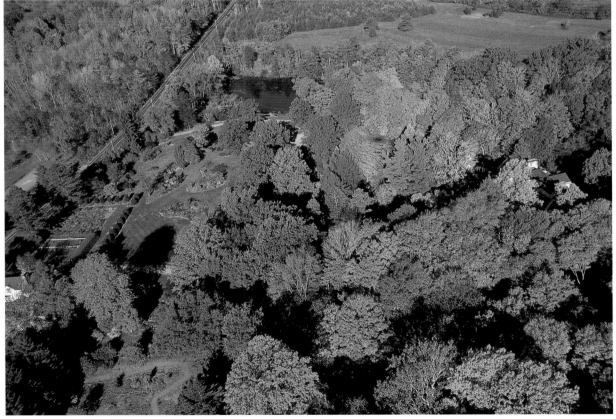

Aerial View of Lantern
Court

Blue Spruce Cones,
Blueberry Pond

Vine at Firman
Nursery

Tupelo Leaves,
Lantern Court

Beech Tree and
Leaves, Pierson
Creek Trail

Facing page: Sugar
Maple 'Green
Mountain,' Display
Gardens

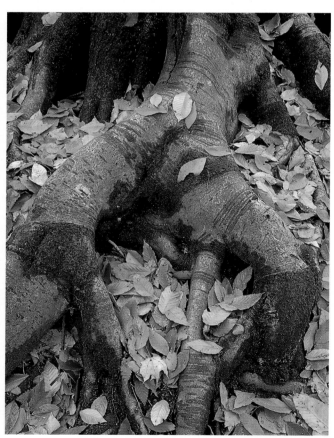

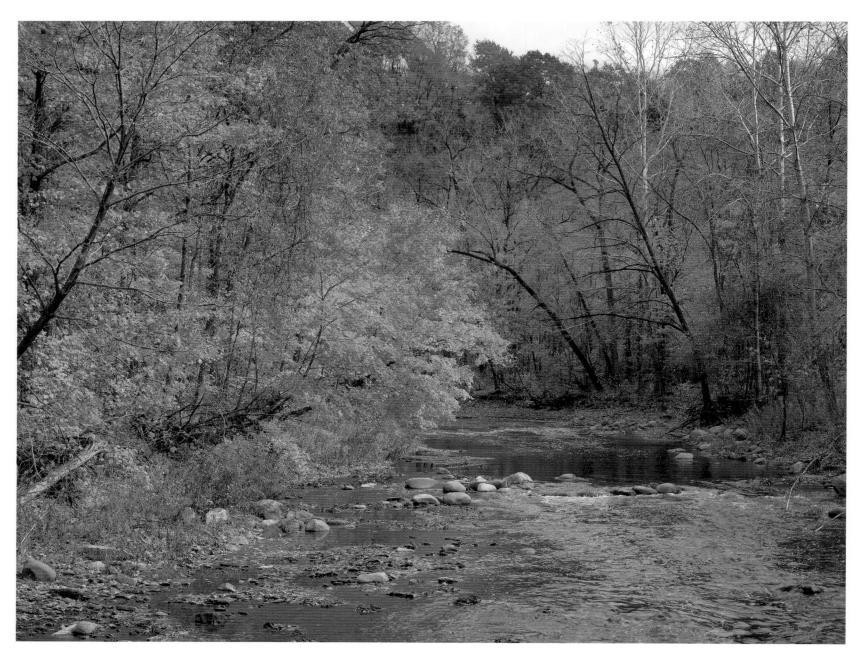

East Branch of Chagrin River
near Sperry Road

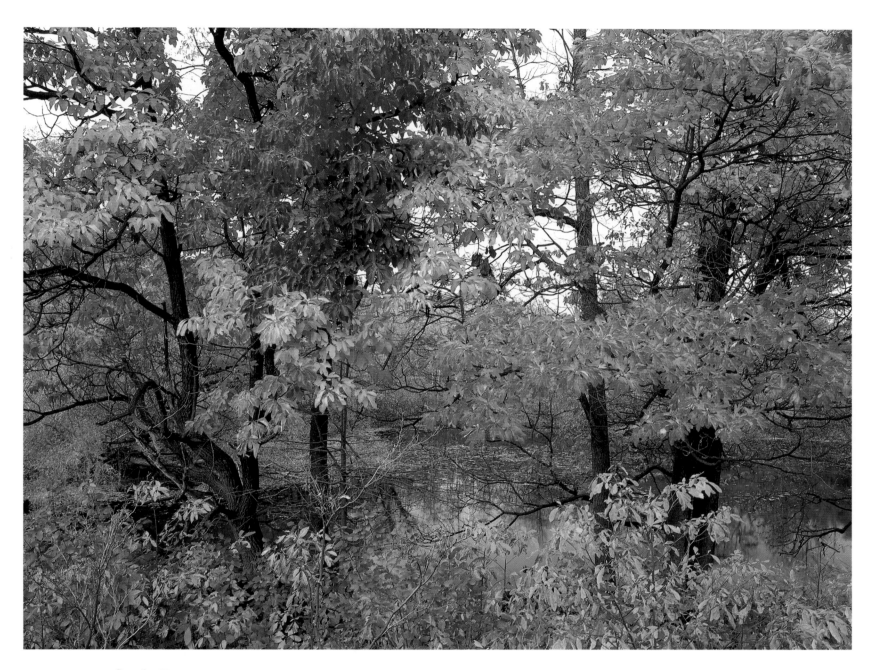

Sassafras Trees and Pond,
Lantern Court

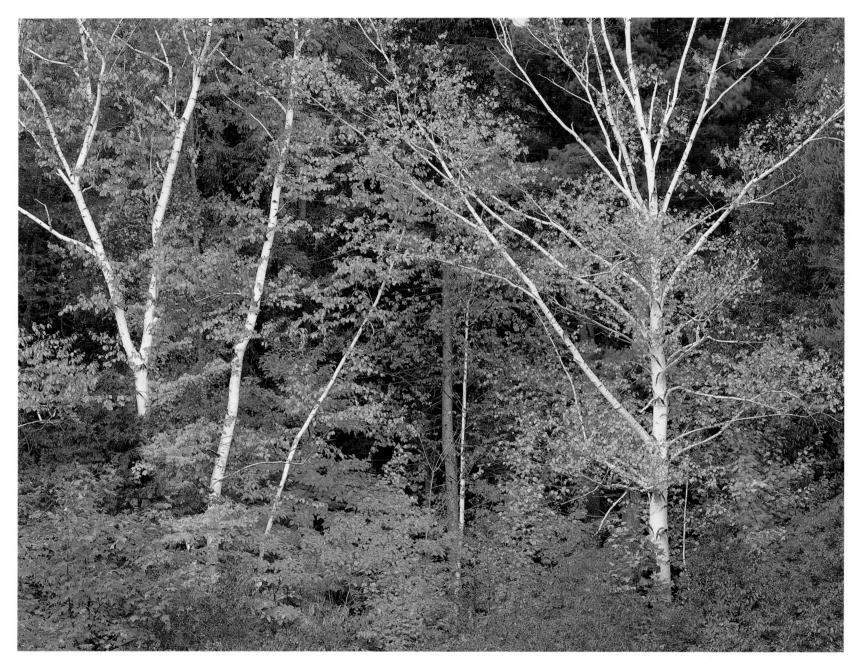

Birches, Maples, and Pines
at Buttonbush Bog

Observation Tower,
Buttonbush Bog

Stairway, Pierson
Creek Trail

Pierson Creek Trail
Marker

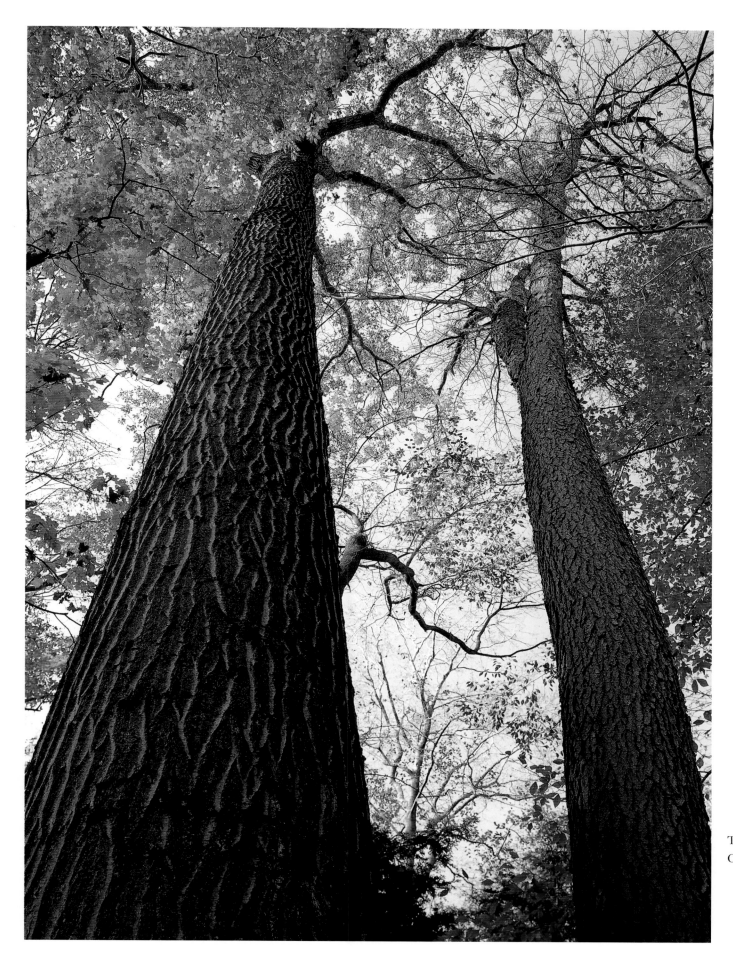

Trees along Pierson
Creek Trail

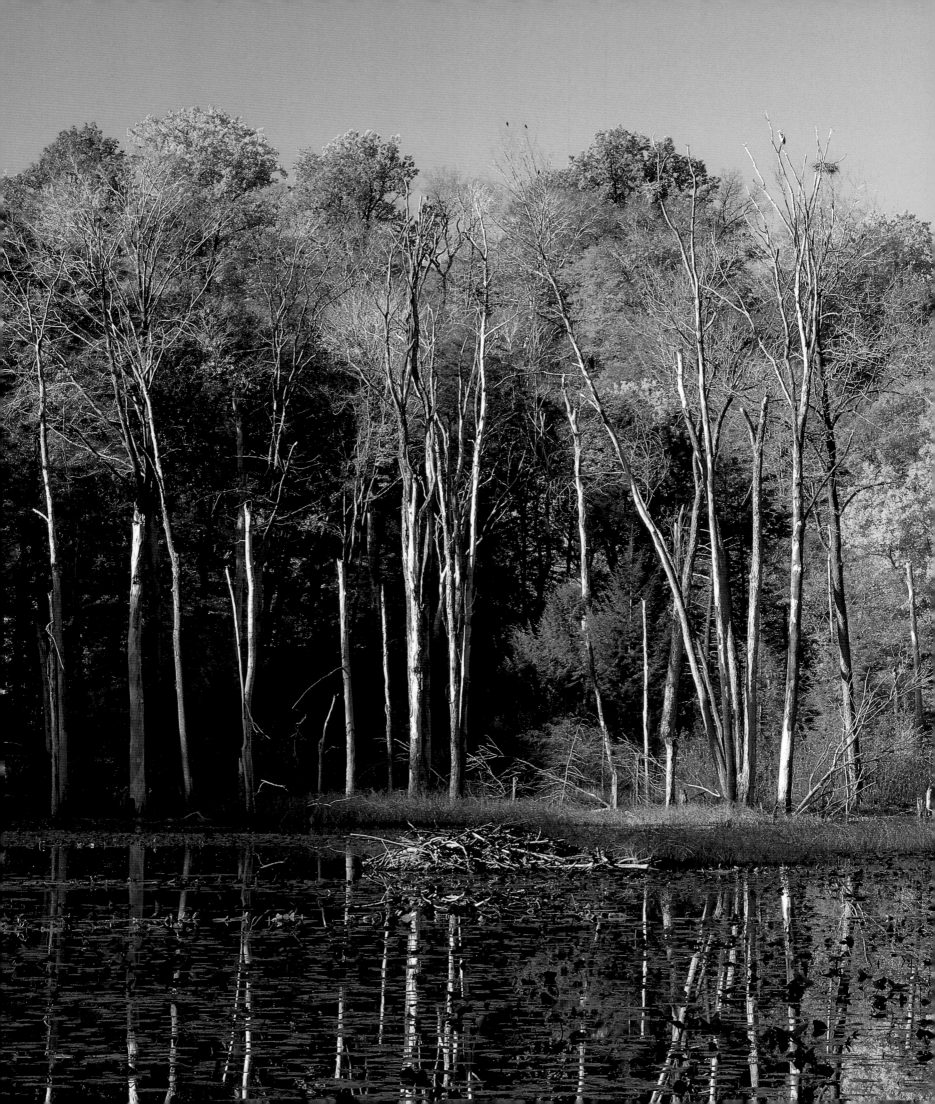

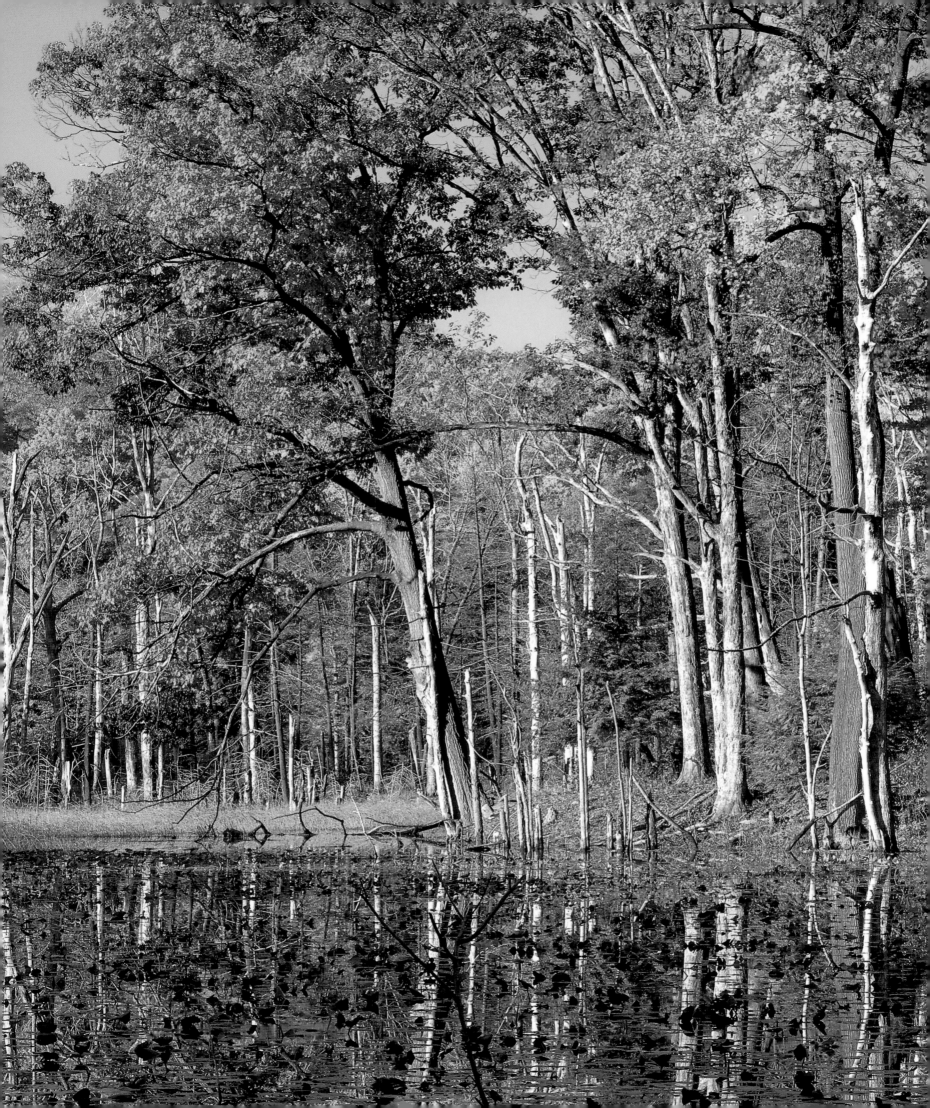

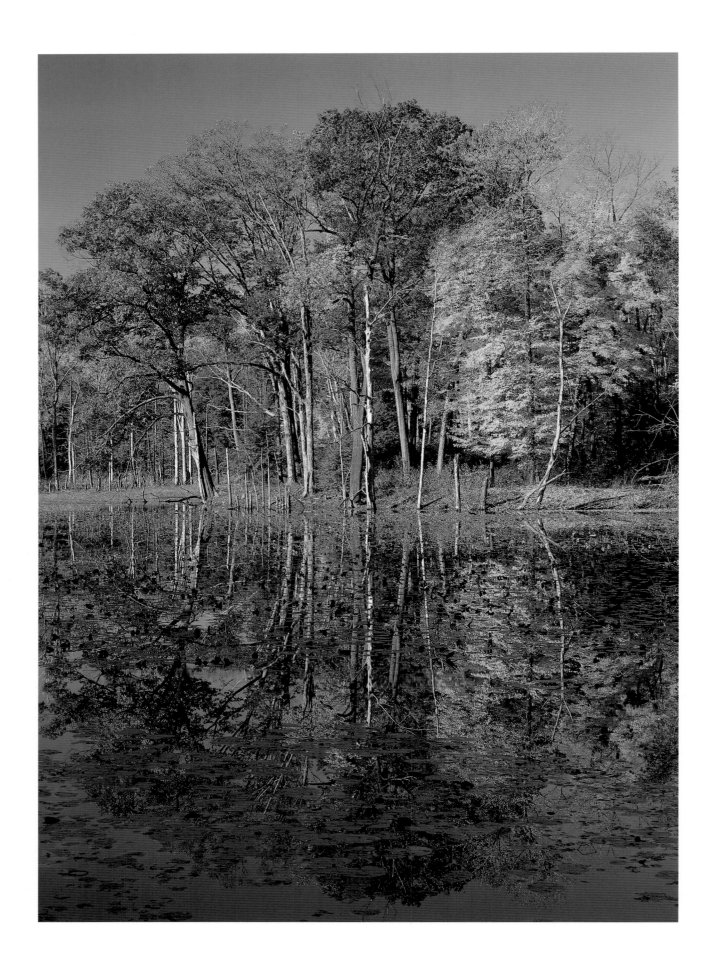

Previous pages:
View near
Carver's Pond

Reflections,
Foster Pond

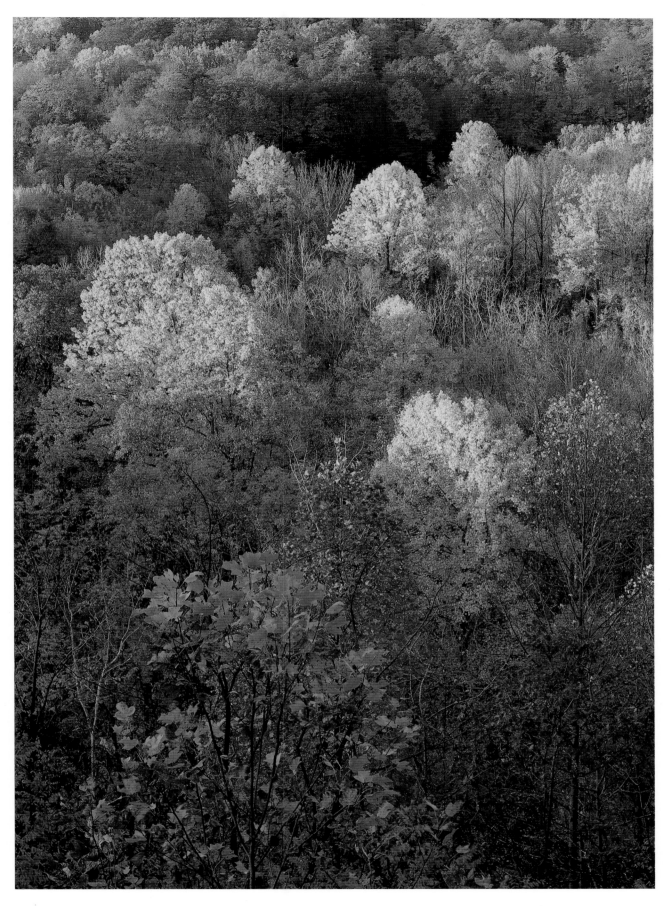

Fall Foliage near
Carver's Pond

Sperry Road

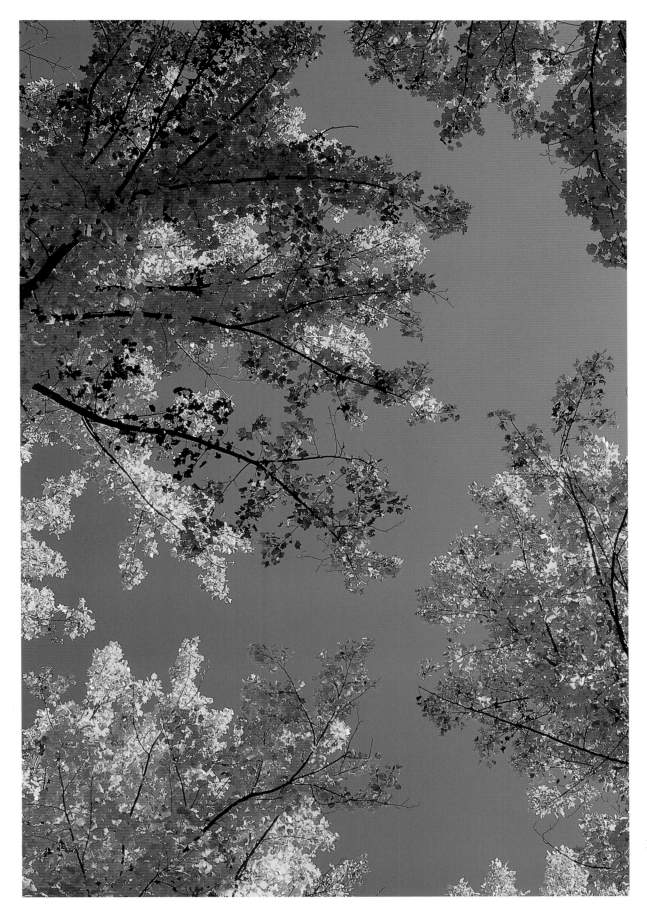

Bole Woods

Pierson Creek
Trail

Winterberry
'Autumn Glow,'
Leach Research
Station

Reflections,
Carver's Pond

Gingko Tree,
Lantern Court

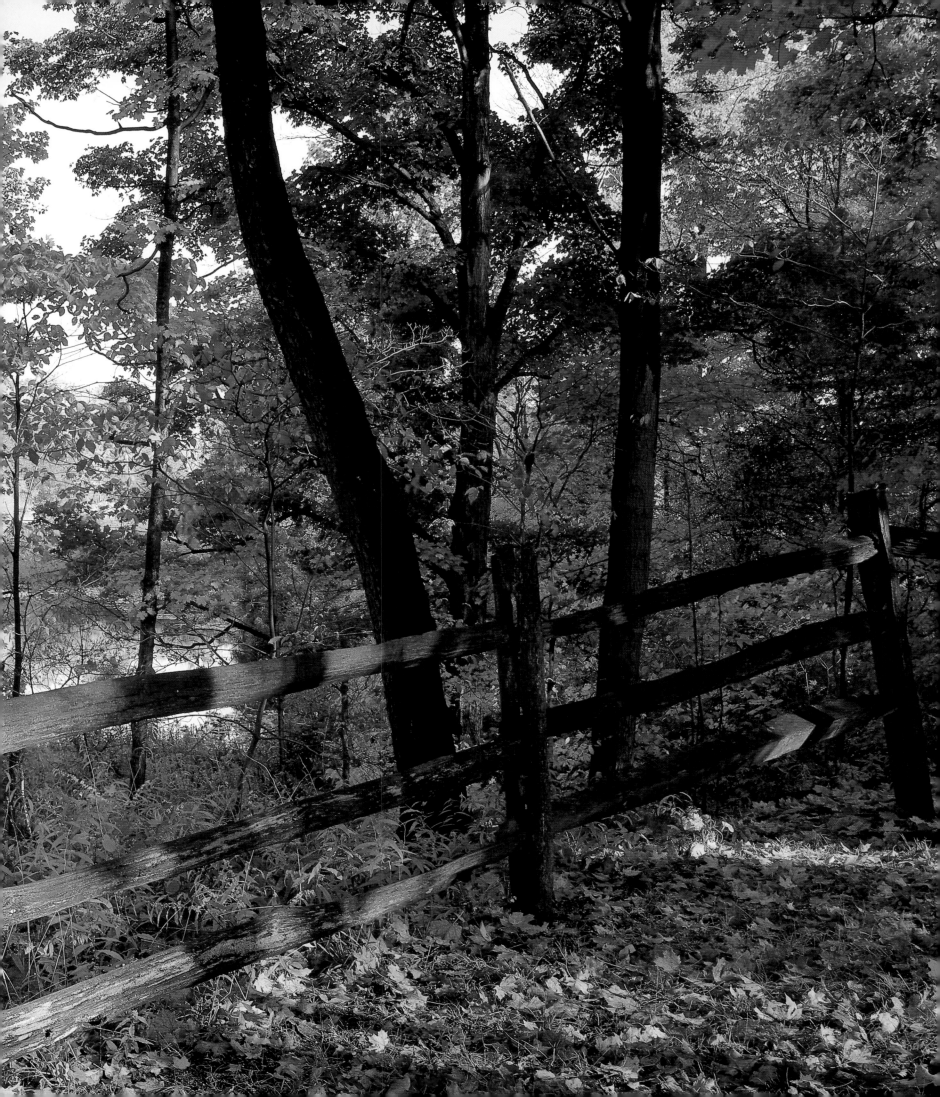

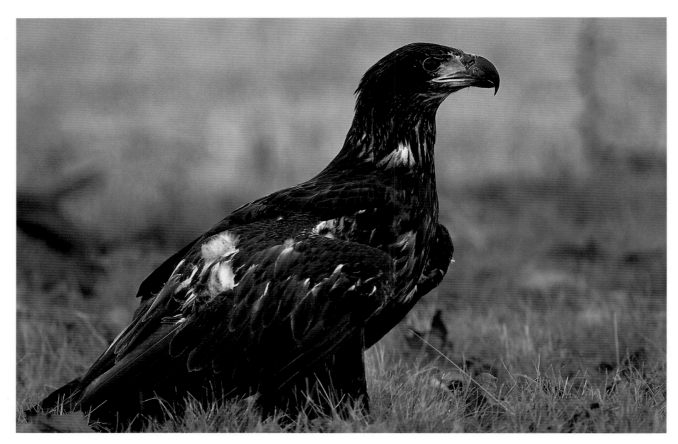

Previous pages: Fence near Foster Pond

Immature Bald Eagle in Buckeye Collection

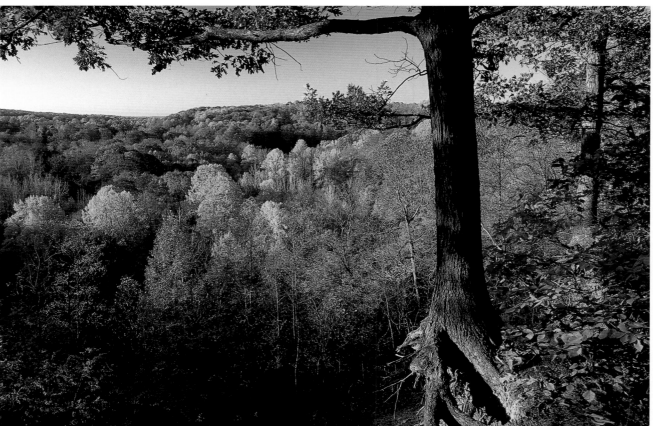

View near Carver's Pond

Facing page: Tupelo Leaves, Display Gardens

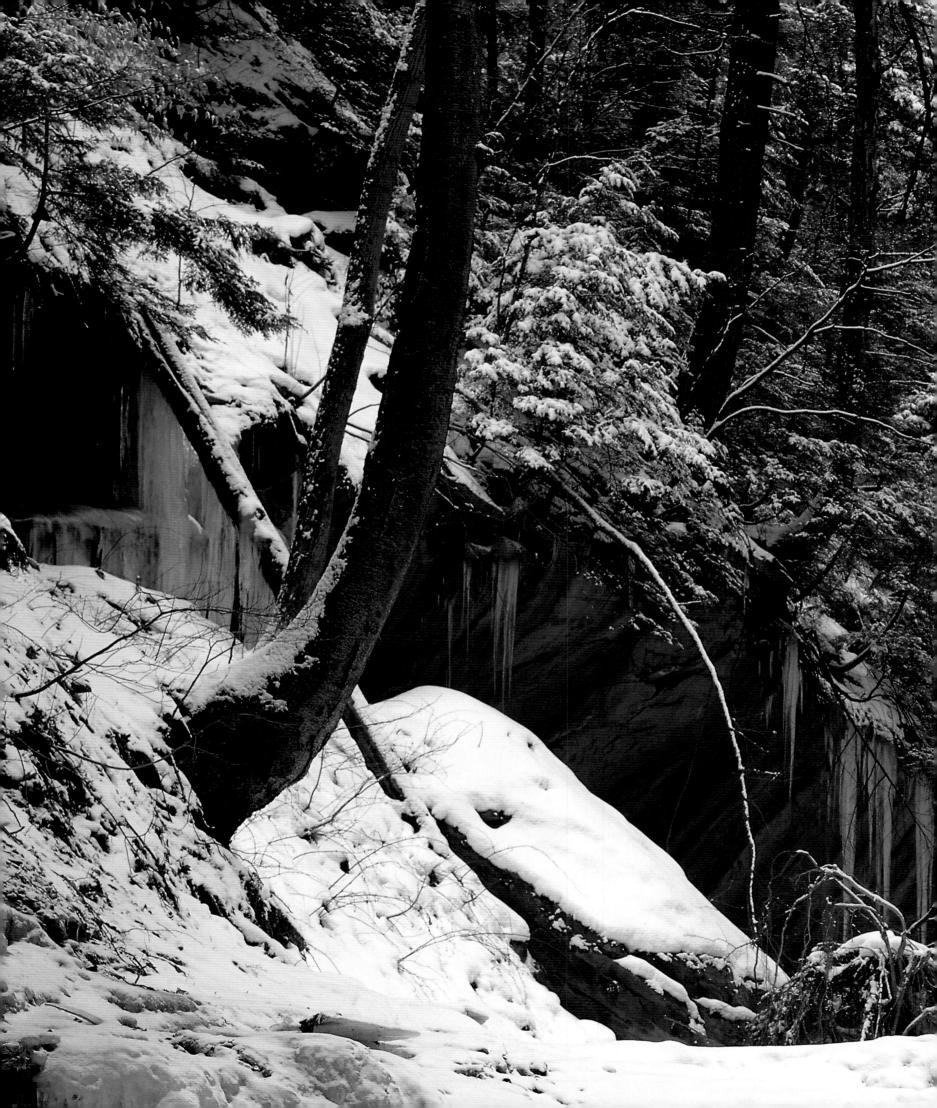

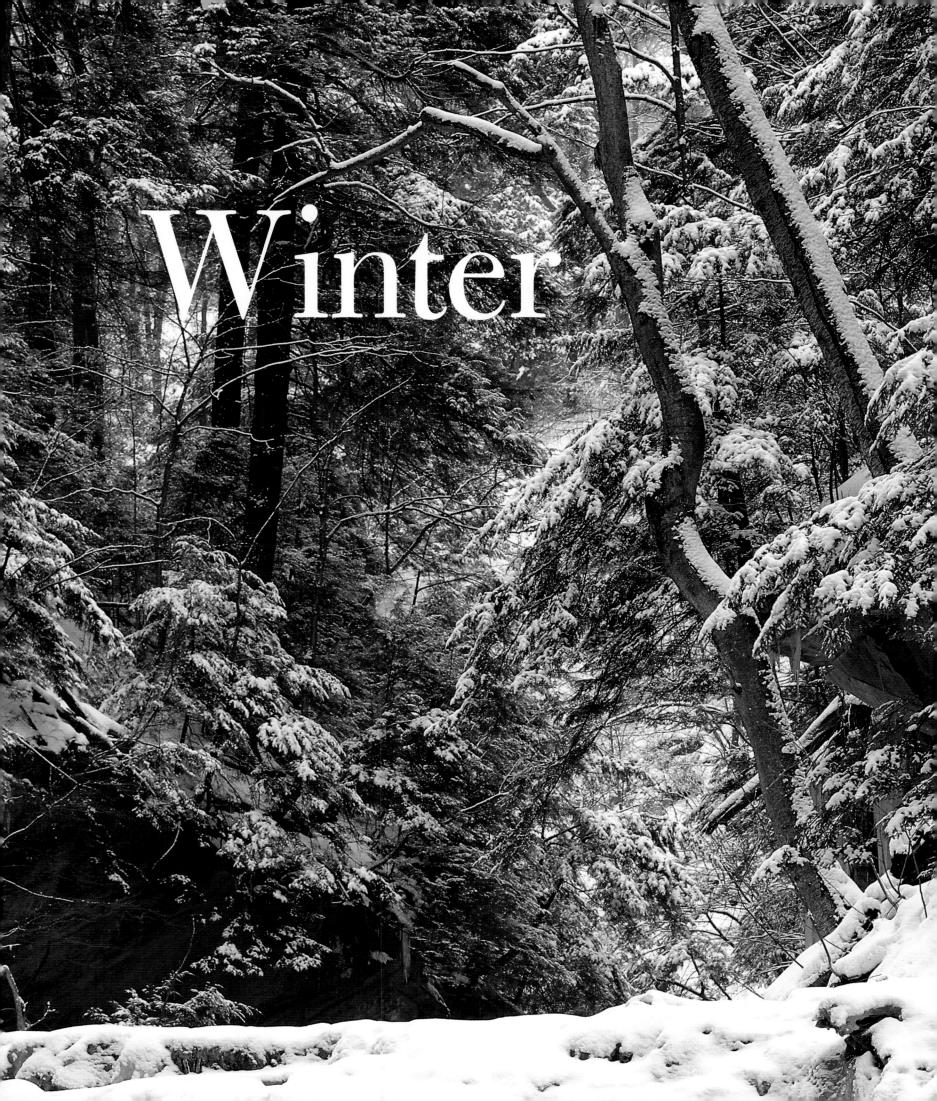

Winter

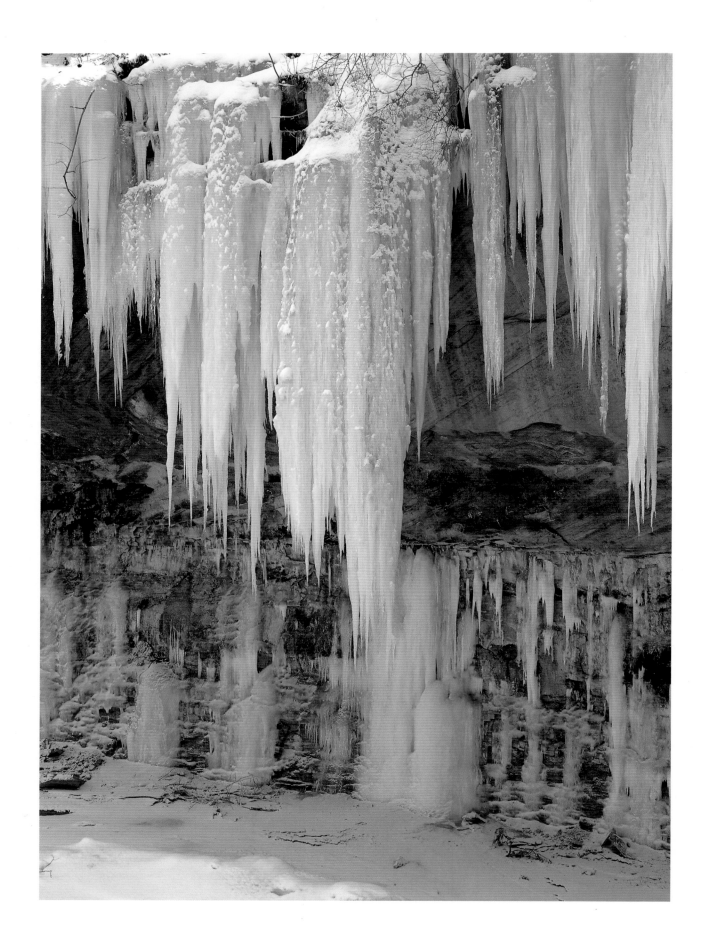

Previous pages:
Stebbins Gulch

Icicles, Stebbins
Gulch

WINTER WRAPS Stebbins Gulch in a state of pure grace and white. The nameless rain-engorged stream that can turn overnight into a knock-you-off-your-feet torrent in June hides now beneath January's icy crust, a muffled trickle of its ebullient self. This is the quietest place in the Holden Arboretum at its quietest time.

Visitors still come to the arboretum in the winter. Some of them, such as the cross-country skiers who take advantage of fourteen miles of trails that wind past Corning Lake, through the Conifer Collection, and into hidden places in dark and snowy woods, come during no other season. They, and winter people like them, know inherently or from experience the heartwarming rewards of swooping along the trails or trekking up Stebbins Gulch, when one hears the sound of one's own labored breathing.

On an afternoon in January, Ted Yocom and another hiker returned to Stebbins Gulch, to what used to be known simply as the Big Gulch when it was owned by the Mather family. Though Ted, a retired General Electric accountant, is one of the arboretum's volunteers most experienced at guiding people through the wonders of Holden's natural areas, he and his friend had found themselves thigh-to-waist-deep in water, as it roared through the gulch at a depth and speed with which even Ted was unfamiliar. He had seen higher water. The water has been known to rise to four feet, or even five. He had never tested it at those times, however, never plunged into swift water at least three feet deep, with only a wooden staff and a sense of balance rare in someone half his eighty years. Creek rocks ice-slick with algae had made it difficult to remain upright.

The gulch, given to the arboretum in 1958 by S. Livingston Mather, is ten thousand years old, cut, at the end of the last Ice Age, into 425 acres of what is now a living lesson in geology and natural history. Chagrin Shale makes up the bottom layer of the geological equivalent of a tall stack of pancakes. The layers are piled into what amount to the gulch's cliffs. Rising in places to a height of 200 feet above the deep and narrow ravine, they were deposited as long ago as 370 million years. In each stratum of this tall stack, there is a storehouse of information for those who know where to look and what they are seeing. Above the grayish Chagrin Shale lies the blacker Cleveland member of Ohio Shale. Then, building toward the top of the ravine, there is Bedford Shale containing siltstone and sandstone layers, Berea Sandstone, and, finally, an Orangeville member of the Cuyahoga formation. Ted can see each layer, divisible, separate. His companion cannot. He carries an arboretum pamphlet with a drawing of the cliffs. It helps him visualize where one layer ends and another begins.

In the winter, even a sharp eye and a little knowledge of geology may not be enough to uncover all of the revelations that lie hidden in this ravine. Ted knows where most of the obscure treasures are to be found, but he cannot always locate them when winter holds Stebbins Gulch in its embrace. An ice

formation can hide, for instance, a pencil-thin seam of coal that Ted knows is there. He chips away here and there at the ice to expose the coal seam. (It has to be here somewhere.) Geologists have said that the source of the seam is most likely a tree that floated far out into the waters that once covered all of this land, as Lake Erie covers the land still only a few miles north of the gulch. On this winter day, the seam remains hidden treasure. No matter, for more than anything else, it is the ice formations that lure visitors to Stebbins Gulch in the dead of winter.

Some of the formations resemble monstrous icicles. They are as long, as sharp, and as dangerous as a javelin, only thicker. Much thicker. The most impressive ice can be found at the upper end of the gulch, near a stepladder waterfall with extra-wide rungs. These formations resemble not so much icicles as a berg that could have sunk the *Titanic* had that ship found itself up this creek. This ice is mountainous, an endless billow of blue-white clouds against the rock. There is nothing soft or fluffy about this ice cloud. It does not dangle from jutting rocks but clings to the side of the ravine, top to bottom, rim to stream bed. These formations can be thirty or forty feet high, maybe more. As wide and unavoidable as an iceberg, they are less subtle. They stand tall, not submerged. A winter hiker cannot miss them. They weigh as much as a ton.

The ice forms from multiple sources, creating a layered look. Surface water drips down the cold face of the ravine, over its ledges, into its cracks, onto its flat surfaces. Other water seeps out through the sandstone, the gulch's most porous geological deposit, seemingly building the formations from the bottom up. On a mile-and-a-half climb that crisscrosses from one side of the gulch to the other, there are points at which jutting overhangs occur ten or twelve feet above the edge of the stream bed. A hiker can slip behind the formations as if they were nature's icy shower curtain.

Ted, along with another of the arboretum's veteran volunteer guides, and nineteen others, ranging in age from thirteen to eighty, ventured through this National Natural Landmark on a gray, misty January Saturday. A snow so fine it was almost indistinguishable from the mist fell for much of the three hours the hikers shared the gulch and the mostly untouched forest that surrounds and protects it. Ultra-fine flakes dusted the hemlocks and left fresh, thin tracings on beech trees stripped bare of their leaves.

It was nineteen degrees Fahrenheit, but warmer in the gulch, where the walls of the ravine offer protection from the wind and moderate the temperature. In the summer, these same walls trap cool air. The temperature rarely rises above seventy-five degrees. The stream that had raged through the gulch in June had been twice as warm as the thirty-degree water that awaited the adventurers as punishment for January missteps.

Ice had formed on much of the stream. In many spots, it was thick enough to walk on; in others, it had to be tested carefully, or wet feet colder than the ice itself could result. Anyone without knee-high waterproof boots was at risk. Ted Yocom wears this style of boot for all but a couple of the months that he comes to Stebbins Gulch. He knows the deepest holes in the creek bed. He knows the unmarked paths to take around them. Knowledge is no guarantee against small disasters.

June's rain had raised the stream to a point that boots became irrelevant. Leaden with water that

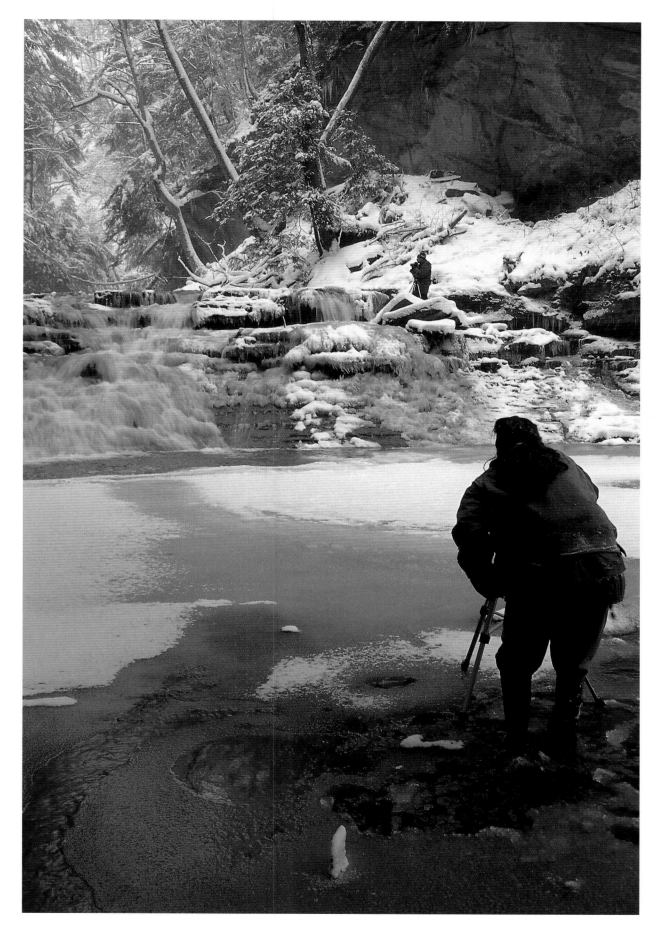

Photography
Workshop Partici-
pants in Stebbins
Gulch

poured in over their tops, they felt like the weighted boots worn by the navy's deep-sea divers. Ted continually had to pause upon reaching a shallow place on the edge of the stream, stand on one leg, like a flamingo—one of the few birds not to be found on the arboretum, by the way—and bend the knee of the leg lifted out of the water. When his boot was above the knee, water would pour out. Then he would repeat the procedure with the other lead foot, laughing at himself all the while. Good teachers can do that: Laugh at themselves and still heighten the respect a student feels for them and the knowledge of the natural world they so willingly share.

Ted was not laughing in January when he reached out to help a less suitably shod winter hiker navigate from a frozen portion of the creek across open water to a rock. Ted slipped and found himself once again in water over the top of his boots. Some things about the gulch do not change with the seasons. It is always full of surprises.

Surprise also fills the arboretum's greenhouses. As in Stebbins Gulch, winter is a quiet time in the greenhouses, a time for cleaning and preparing for the hubbub of spring, but also a time for research and experimentation both with plants to be found in natural areas, such as the gulch, and with those materials that may one day find places of honor in the cultivated collections such as the Helen S. Layer Rhododendron Garden.

The glass that is the greenhouse roof invites in the winter sun, and a movable mechanical screen beneath it traps the sun's warmth and retains it at night. Even so, the sun needs help at this time of year. It is supplemented by high-pressure sodium lamps so that, as quiet as the greenhouse is in winter, it is always growing season.

Among January's research projects is an extension of the work done at the Madison Station property obtained by the arboretum from David Leach, the late renowned breeder of rhododendrons. Leach's life work lives on through the arboretum. The Leach Station staff are seeking to determine which rhododendron seedlings are most resistant to root rot, a major problem for plants set out in the heavier soils typical of the arboretum. Though there are no totally root-rot-resistant varieties of rhododendron, observation suggests there are more tolerant varieties that exhibit better rates of survival. To separate the weak from the strong varieties during the winter, a fungus obtained from biologists at Ohio Agriculture Research and Development Center in Wooster, Ohio, is applied to the seedlings.

Weaker strains of seedlings die an ugly death. When the greenhouse behind the Horticulture Science Center first opened in 1993 and arboretum visitors began to take tours through it, the nursery staff found the attention to be a mixed blessing. Not everyone understood that dying plants are a part of a greater research goal.

As much as the arboretum horticulturists know, however, it sometimes is not enough, and even in the dead of winter, this can become obvious. If the arboretum's three greenhouses, with their seven rooms, are comparatively bare during the coldest months, it is, in part, because plants have been moved to complementary buildings nearby—the poly tunnel (which is covered with polymer material in the winter), the lath house, and a building with an oxymoronic name: the above-ground root cellar.

The new above-ground root cellar was inspired by a round room in an old stone barn that was part of the arboretum's original nursery complex off Sperry Road. The old barn would remain cool into June and the round room, which was practically sealed, could retard the growth of plants during the winter. All that was needed to achieve the ideal temperature was one small electric heater. The above-ground root cellar is less constant in temperature than the old round room but effective nevertheless. It is cool inside, near but not at freezing. Plants that have been started in the greenhouse and moved outside to a protected area for further growth during the summer are moved inside for the winter. The nursery staff plays chicken with the cold. Move the plants inside too soon and they will not have gone dormant. Wait too long and the snow and cold may freeze them to the ground.

Even when the nursery staff guesses correctly and wins this game of winter chicken, problems can occur. The first few years the above-ground root cellar was in use, the staff noted that the rhododendrons looked as if they had wintered on a hillside in a howling gale. They were wind scorched. The problem also occurred with other plants that retained their leaves. Stick a finger in the topsoil and there was no sign of trouble. The soil felt moist.

Arboretum horticulturists and researchers share with nurserymen, particularly those nearby in Lake and Geauga Counties, their expertise on and experiences with plant material. This deepening and sharing of knowledge separates arboreta from nature preserves, as R. Henry Norweb, the arboretum's first executive director, used to observe. Such educational exchanges are not a one-way street.

So arboretum staff showed Gied Stroombeek, of Romer Nursery in Madison, the condition of the rhododendrons wintering in the arboretum's above-ground root cellar. Stroombeek knew from his more than fifty years of plant experience what had to be done. Stroombeek did not waste any words of explanation. Few of the old Dutch nurserymen of Northeast Ohio do. It did not matter how moist the plants' topsoil felt to the touch, Stroombeek explained succinctly. The staff should water heavily once a month whether or not it looks or feels like the plants need it. The arboretum staff trusted Stroombeek's advice. The condition of the rhododendrons and other plants improved.

Trust was not the long suit of the single most important plantsman ever to work at Holden. When propagator Lewis Lipp joined the arboretum in 1954, coming from the Arnold Arboretum at Harvard University, his dedication to his work was legend. Planting was, quite simply, his life, winter or spring.

Lipp, the story goes, would refuse to take vacations because he did not trust anyone else to care for his plants. And there were a lot of plants, because it was in the winter that Lipp would send out a list of seeds that other arboreta and botanical gardens could obtain from Holden and he, in turn, would scour their lists for anything that Holden did not have.

These winters, the arboretum might make, at most, 100 requests from the seed lists of other institutions. When Lipp was in charge, Holden would have as many as 2,000 accessions a year, most of it seed, some of it collected by Lipp, much of it culled from the winter exchange lists.

In a cooler off the head house—a giant garage-like working area through which the greenhouses are accessed—acquired seed awaits the months of March or April, when it will be moved into the green-

house and planted, its first step toward finding its place in the arboretum. Germination is not guaranteed. Sometimes nothing happens. Sometimes nothing keeps happening for three or four growing cycles and the nursery staff gives up on the seed and tosses it on a compost pile outside. No one gives up willingly or quickly, though, because everyone at the arboretum knows of instances when seed tossed out has germinated.

Even without such empirical surprises, the greenhouse is a place of hope, a place where it pays to watch dirt. During the winter, horticultural therapy activities still take place in the head house and greenhouse. The programs can be better than any medicine. This is true for the young and healthy as well as for the old and sick.

It is in the arboretum greenhouses, as January and February turn into March, that the waiting and watching yield rewards, a seedling peeking up from one container in a flat of containers, a hint of success, a personal dose of horticultural therapy for the plantsman.

In the cold of January, as Ted Yocom and the others tramp from open fields, through young woods, and finally into older, climax forest on their way into the gulch, it is a more subtle form of therapy that they expect to observe. Old fallen American chestnuts and other trees that are rotting and turning into fertilizing dust for new growth offer reminders that nature's life cycle is always at work, even when it seems to have shut down for the winter.

Climbing over the boulders and the fallen trees that have become obstacles in the stream serves as a reminder of the June torrent—as well as those before it and those to come—that moved some of these rocks and this wood. The hand of nature makes Stebbins Gulch seem timeless yet ever changing.

Signs of regeneration appear when and where least expected. In the gulch in the midst of a gentle snowfall and surrounded by a winter palace of ice, the hikers come upon a witch hazel. Many witch hazel plants at the arboretum are under more or less constant study as part of a scientific research project. This witch hazel is not one of them, but like some of those plants that are watched so closely in the winter, it is blooming at this odd, late moment.

The witch hazel in the Gulch is in bloom, a pale yellow, hint-of-snow-white blossom sending an unmistakable message: Winter will not last forever.

Japanese Barberry
'Sparkle,' Display
Gardens

Ice Patterns, Pierson Creek

Snowfall, Little
Mountain

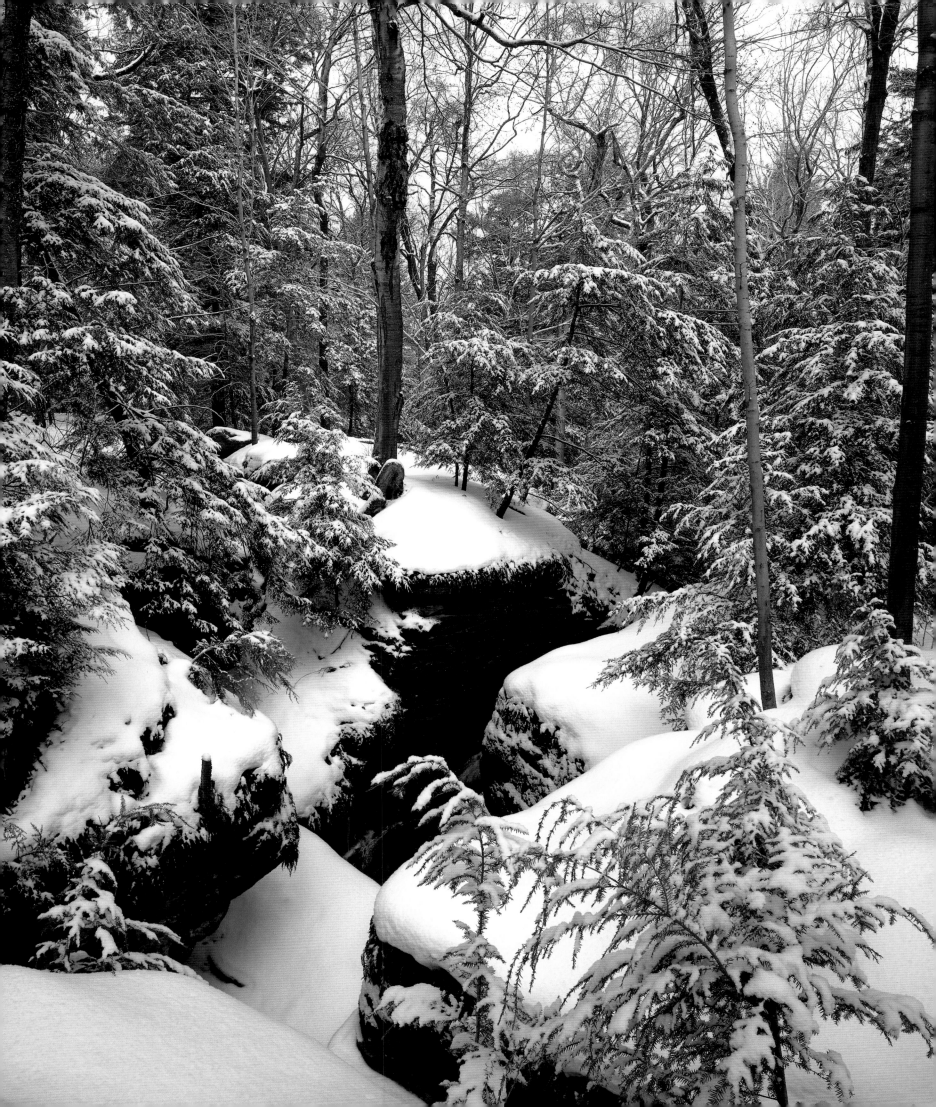

The Little Mountain

The natural essence of the Holden Arboretum's diverse 3,400-acre Northeast Ohio location—its ability to offer connections with nature, knowledge from nature, conservation of nature—can be found among the moss-covered crevices and towering white pines of Little Mountain. This is a place people have reclaimed from past generations for future generations.

Little Mountain, a tough testament to survival, would appear to be able to take care of itself. This three-knobbed, L-shaped natural wonderland was shaped from sandstone known as Sharon Conglomerate (look for telltale white pebbles embedded in a sandstone matrix). Unlike the typical mountain, risen from tectonic compression and uplifting, Little Mountain resulted from its resistance to the erosive grip of glaciers and the two river systems between which it lies. The Grand, Cuyahoga, and Chagrin Rivers worked around Little Mountain, never eroding it, and the glaciers only chipped away at the mountain's sides.

Neither did man leave much of a mark on Little Mountain until 1831, when Capt. Simeon Reynolds bought seventy-five acres on the north bluff and built a road to the top where he constructed the Little Mountain House. Reynolds's resort began Little Mountain's Hotel Era, which would last for a hundred years. It was an ideal location.

With Lake Erie shimmering in the distance, the Little Mountain resorts offered not only flora and fauna in abundance but also a lot of cool, from cool spring water to cool summer nights. It was a day-trip from Cleveland. Travelers took the Lake Shore Railroad to Mentor and then horse-drawn vehicles called tally-ho coaches to the mountain (extra horses were required to get to the top). Eventually, by auto, the trip became even more of a breeze and the rich and powerful—oilman John D. Rockefeller and James A. Garfield, the twentieth president of the United States, among them—came to the mountain. Rockefeller and Garfield were among the members of The Little Mountain Club, which was formed in 1872 when a group of Cleveland millionaires led by Randall P. Wade bought one of the struggling hotels—the Stocking House—and turned it into their private retreat.

As one hotel gave way to another, sometimes recycling into the next, more roads were built, a new schoolhouse went up, even a church. Lumber from the Little Mountain Eagle, originally built by William Gardiner in the late 1850s, went into the Church of the Transfiguration built in 1892 on a half acre sold by Honor S. Reynolds to church trustees for one dollar. As people found it comfortable to travel farther and farther for their getaways, Little Mountain fell out of favor with Cleveland, including with its millionaires. The church was boarded up and moved twice, first in 1916 to Trinity Cathedral's summer retreat near Lake Erie and ultimately to Baldwin Road in Kirtland Hills where it stands today as St. Hubert's Episcopal Church.

White Pine, Little
Mountain

In their day, though, the hotels were grand, with their sweeping verandas, their terraces and tennis courts, their ballrooms and even observatories. The natural world, on which the hotels could not help but impinge, was even grander. So it was an ecological blessing for Little Mountain and the arboretum when the Hotel Era ended in the 1920s and the staunchest of the Little Mountain devotees, families such as the Kings, Hitchcocks, Baldwins, and Mathers, bought up the land and added it to the property they already owned.

When her father, Ralph King, died in 1926, the largest portion on the north side of Little Mountain became Frances King Schafer's. She and her husband, Gilbert, built a home on the site where the Wades had had a cottage. More important, the Schafers, in 1971, gave the arboretum 53.1 acres—18.8 acres in Lake County and 34.3 in Geauga County—and access to the mountain from Pinecrest Road. The Schafers' gift was, like the gifts of Warren Corning, an example to others, and now the arboretum owns 191 acres on or around Little Mountain.

Though additional acquisitions of land on Little Mountain or the opportunity to purchase land important to the arboretum elsewhere may occur, the arboretum's recent strategy has been to work with nearby landowners, both old and new, to establish conservation easements. In previous years, the arboretum's natural areas were seen, including by neutral scientific observers, as buffers—land that stood between relentless urban sprawl and Holden's valuable collections. That view has changed.

Natural areas such as Little Mountain are seen increasingly as the ends rather than the means, the assets that distinguish Holden from other arboreta. Holden has always known what it possesses in these lands. It just has not always known how to use these natural areas in a way that allows the most people to connect with nature, learn from nature, yet permit the arboretum to conserve nature. The conservation easements that the arboretum is working to acquire represent a first step.

The easements, which restrict what can be done with certain properties or parts of them, have proved useful in many ways: They discourage the "edge effect." Think of Holden as a pie. When houses pop up on the outer crust or edge of the pie, predators, birds, and even certain vegetation retreat. The house may be on the edge but it can still take a slice out of the pie. Not permitting building on the rear of property that abuts Little Mountain can round off the edge, giving greater protection to a delicate ecosystem.

In addition, easements keep property on the tax rolls. Easements also contribute to a rural aesthetic, in which the long view of the landscape is enhanced by the occasional barn and field of horses or other animals. Even if Holden could buy more of these properties (the cost could be prohibitive), not every field should be allowed to return to woodland. The Little Mountain that exists today demands more conservation management than the arboretum has had personnel and will to provide. But a start has been made.

Near where a stone marker serves as a reminder of the church that once was there, white pines more than 135 years old and failing still stand, their lower trunks growing bare of limbs as they stretched higher and higher seeking the sun. This is one of the last such stands in Ohio, a tough bunch, genetically disease-resistant, it would seem. The white pine seeds have been planted and nurtured in the Holden greenhouses, the seedlings returned to the mountain and planted, with wire fences around them to protect them from the voracious deer, in areas with the bright sunlight of hope.

Little Mountain's plant communities are nourished by twice Cleveland's annual snowfall of fifty-four inches. Winds suck moisture from Lake Erie, at 571 feet, and deposit it as they sweep up Little Mountain, rising nearly 700 feet in just a couple of miles. Similar extremes mark the mountain itself. Climb down and through the deep rock crevices to the old spring house built to pump water to the resorts, and on a June day the temperature will vary twenty-five degrees in twenty-five feet. The presence of the hotels, though gone for seventy years, still has a chilling effect on vegetation. Wildflowers that otherwise would be predominant on the mountain must compete with myrtle *vinca minor,* a persistent, nonnative ground cover introduced by hotel owners.

Above Devil's Kitchen, one of the rock formations named by the white settlers who predated the Hotel Era, hemlocks spread branches into which men and boys carved their initials. These are trees that have stood the test of time yet bear signs of man's presence. On some trees high on the mountain, glass insulators on which telegraph or telephone wires once were strung remain, twenty or twenty-five feet up the tree's trunk. In recent years the hardy hemlocks have been threatened by the hemlock borer, an insect that deposits its eggs in the bark crevices of the weakest hemlocks. The larvae bore in and damage the tree's vascular system, much as plaque can damage a person's vascular system. The arboretum, in 1989, logged fifty dead or badly infested hemlocks off Little Mountain, choosing carefully among the diseased trees so as not to remove so many that it exposed the forest floor to excessive sunlight that could trigger the decline in other plant species. The arboretum's balancing act of forestry management will continue.

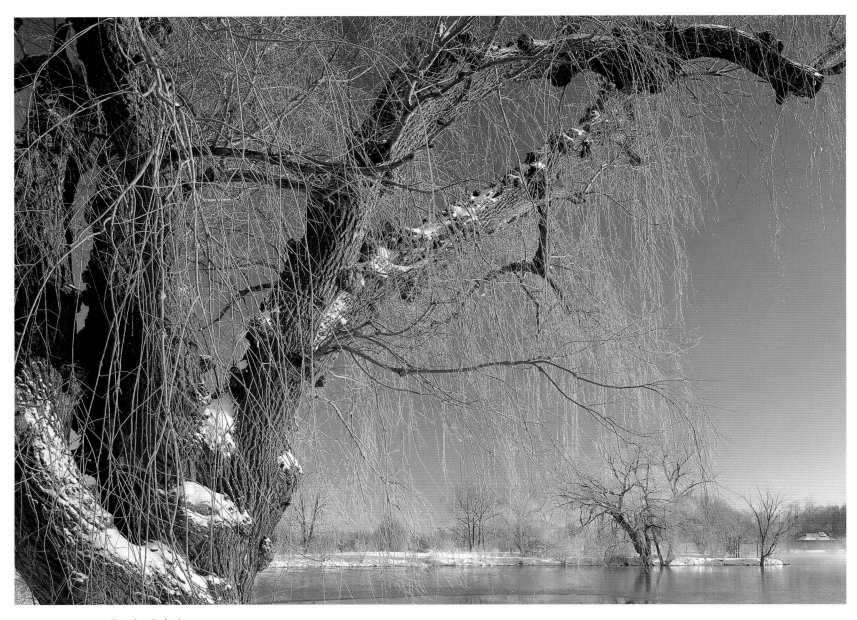

Corning Lake in
Late Winter

Sunrise, Corning
Lake

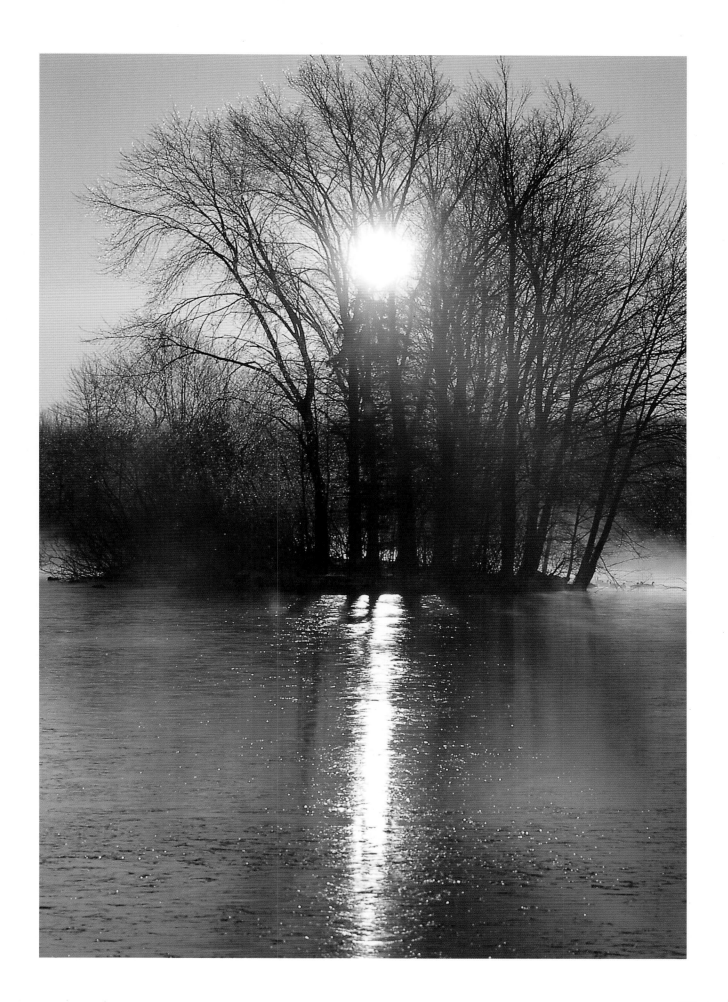

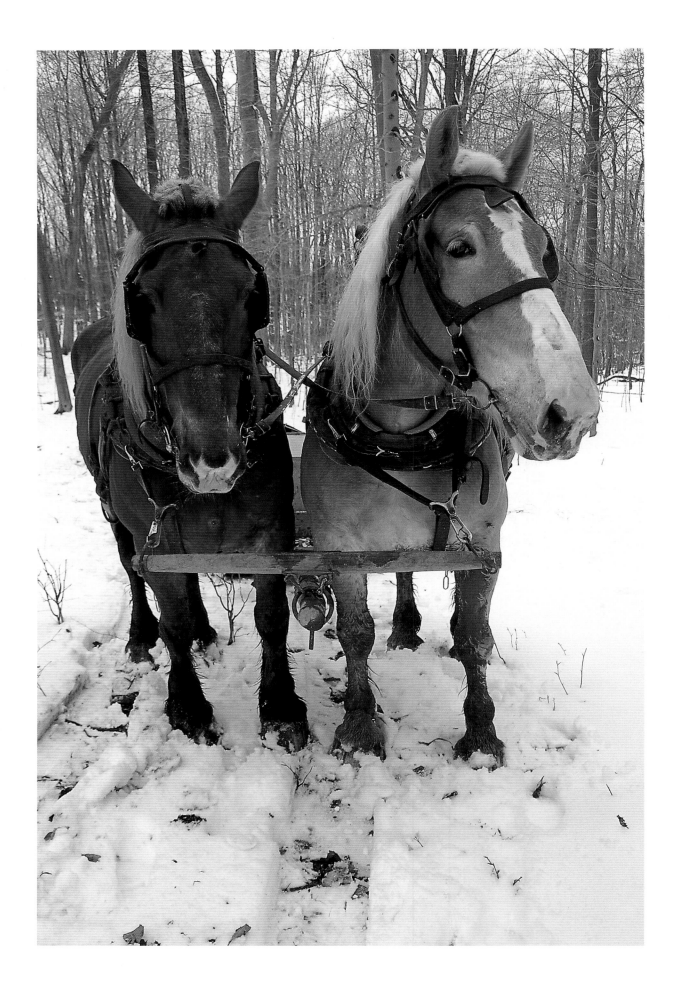

Previous pages:
Sugar Maples at
Sugarbush

Amish Belgian
Horses Used to
Pull Maple Sugar-
ing Sled

Warren Bicknell Jr. Sugarbush

How much of its money and attention the Holden Arboretum should devote to each of its many resources is always a question. Little Mountain offers unique educational opportunities—but how many people will take advantage of them, given Little Mountain's distance of six miles from the Warren G. Corning Visitor Center and the sensitivity of the ecosystem that limits visits to guided tours? At the Warren Bicknell Jr. Sugarbush, located in a stand of sugar maples across Sperry Road from Corning Lake, the answer is more obvious. Thousands of visitors, including countless classes of schoolchildren, can be accommodated each March, as the Eli Miller family merges past with present at the arboretum sugarhouse.

Real maple syrup is rare (only a tablespoon is produced per person per year in the United States), and the time-honored process that produces it is as sweetly appealing as a soft snowfall on a Saturday during sugaring season. What once was the site of a working sugarbush and a small shack used by the Bicknells to play host to friends for pancake breakfasts now offers visitors the opportunity to watch an Amish family make maple syrup. The arboretum's maple sugar museum (the first sugarhouse) exhibits old-time sugaring equipment, including candy molds, pitchers, buckets, evaporator pans, and spiles, as well as data on maple sugaring in the United States. Homer Jacobs, who retired as an arborist from The Davey Tree Co. in Kent, Ohio, and then created a second career as a consultant at the arboretum, inspired the building of the sugarbush and received the support of Henry Norweb.

Using no architectural drawings to guide them, Eli Miller and his father built the arboretum's sugarhouse (now the museum) and also, in 1989, the new sugarhouse. The Millers knew what was required. They are Amish professional builders, and their knowledge of sugaring flowed from their own family operation. The fit was perfect. The arboretum extended the link with the Millers by arranging to have Eli Miller supply most of the sugaring equipment, run the operation, and keep the maple syrup, selling some to the arboretum for its gift shop and the rest elsewhere.

The new house is a functional stage. It allows visitors to surround Miller and ask questions as he boils down 200 gallons of sap an hour, turning it into maple syrup the color of sunlight. Miller grew up in Middlefield making maple syrup. At the arboretum, he does that and more.

As winter loosens its grip, the March days begin to warm while the nights remain crisp and cold. Miller and his family attach 2,100 buckets to trees spread over thirty-five acres. A tree ten to fifteen inches in diameter will get one bucket, hanging beneath a tap. A sixteen to twenty inch tree can support two buckets. A three-bucket tree should be at least twenty-one to twenty-five inches around. Along the interpretive trail that leads into the sugarbush, visitors can learn how Native Americans collected sap and see an example of modern collection that utilizes plastic tubing. The trail leads to the sugarhouse and to questions that allow Miller, Holden volunteers, and staff members to connect the visitor, sweetly, to nature.

Miller has heard all the questions. Some still make him smile. There was this: "If you don't tap the trees," a visitor wanted to know, "what happens to the sap?" The questioner thought he had the answer: "The tree must explode."

Though he has been on the maple-syrup firing line for years, Miller has heard of no exploding trees. He took this opportunity to explain that there are always more trees that do not get tapped in a season than those that do. Neither the tapped nor untapped tree is injured. The taps heal quickly.

The sugarbush is a classroom with boiling pans instead of blackboards. Holden participates in the Supersweet program. In it, sugar maples that produce a higher level of sugar are identified and cultivated (forty gallons of 2 percent sap sugar content are required to make a gallon of syrup). Holden also is an integral part of the U.S. Forest Service's Northeastern Forest Experimental Station project, which is addressing a decline in Northeastern North America sugar maples due to pollution, climate extremes, urban sprawl, insects, and diseases. Eli Miller answers visitors' questions and also the occasional off-the-stable-wall question such as: "Do your horses have to stand up all night?" Miller's horses, Dick and Doc, pull sleds with a collection tank full of sap from the trees to the sugarhouse, where the horses are also housed (with enough room to lie down, if they choose). Miller tried modernizing. He used a tractor instead of Dick and Doc. The tractor got stuck in the mud. Besides, schoolchildren, in particular, love Dick and Doc.

Each school year, the arboretum's programs serve about 15,000 students, primarily from Lake, Geauga, and eastern Cuyahoga Counties but also from more distant counties such as Ashtabula and Summit. Led mostly by Holden volunteers, students make on-site visits, including to the sugarbush. Students especially appreciate Eli Miller—so much so that they often send the arboretum thank-you notes for the educational experience he has provided. One schoolchild whose class visited sent such a note, expressing appreciation for the traditional Amish touch that the Millers bring to the sugarhouse.

"It's really great of you," the student told arboretum officials, "to have those Pilgrims out there."

Such a memorable response—if a little off the mark—is important to the arboretum's education department. Education distinguishes the arboretum. The sugarbush proves it can be palatable.

Bicknell
Sugarbush

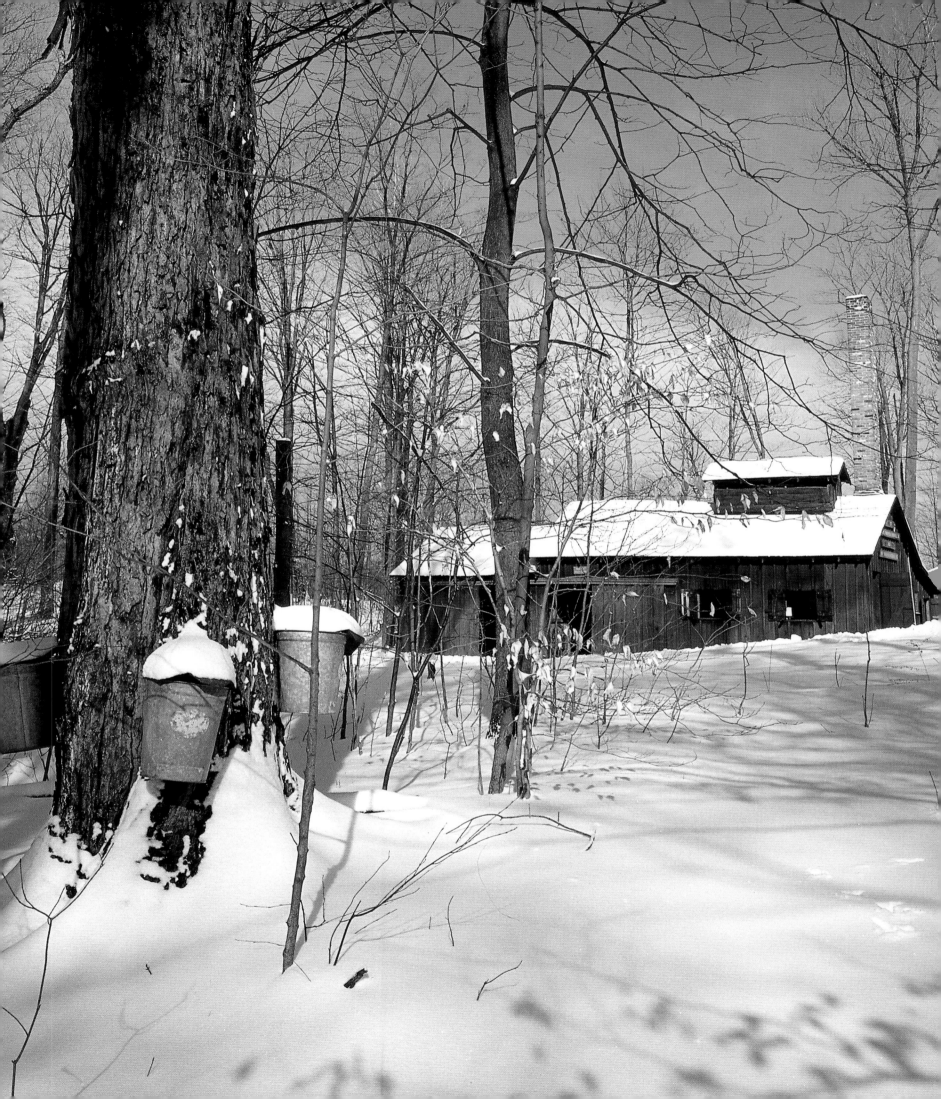

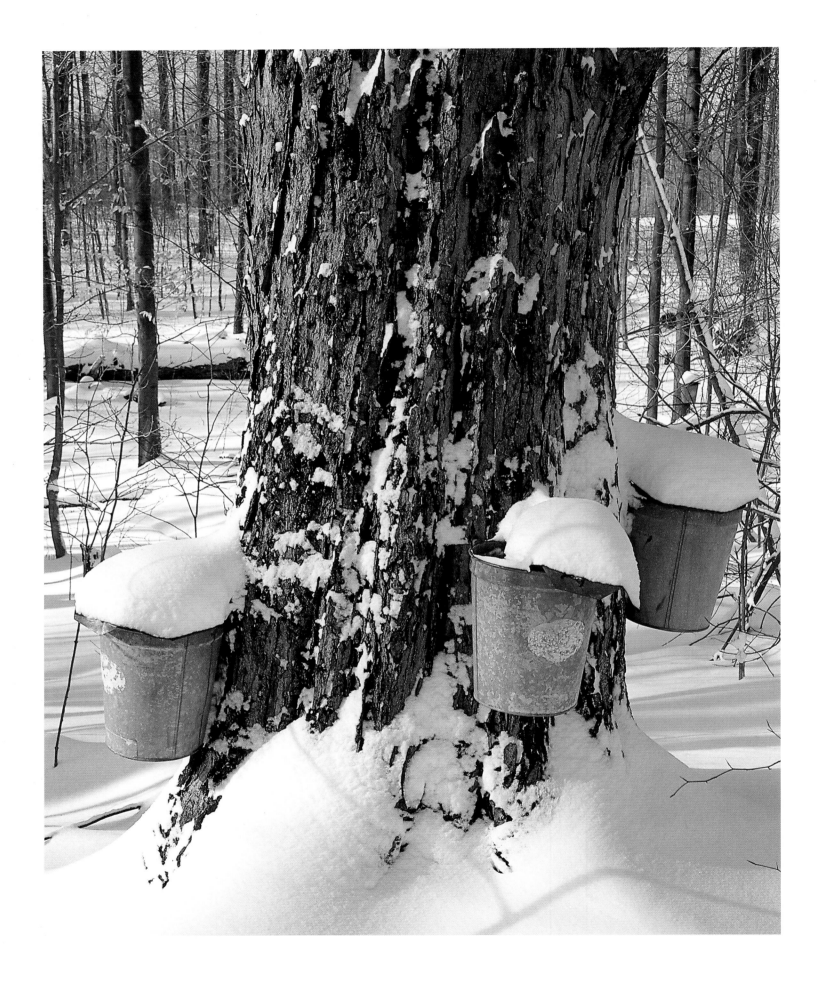

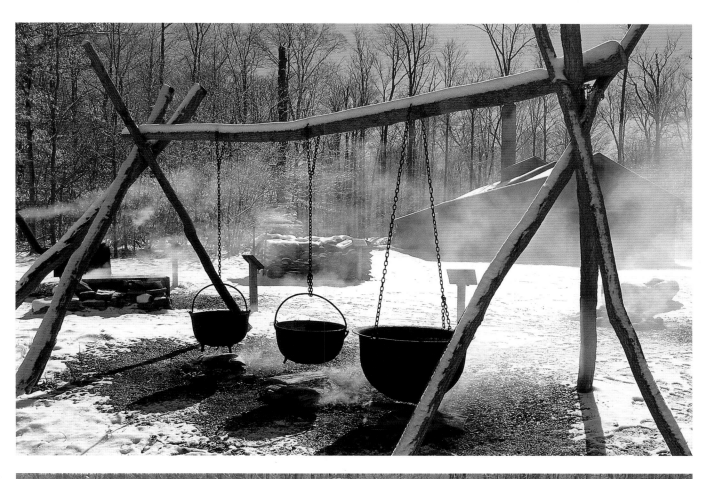

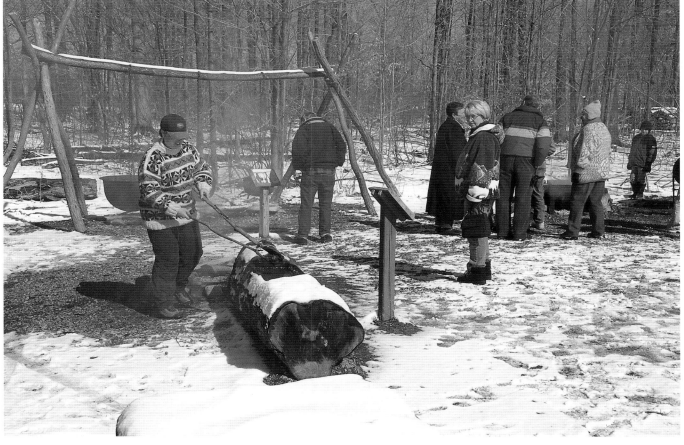

Facing page: Maple Sugaring Buckets, Bicknell Sugarbush

Boiling Maple Sap at Bicknell Sugarbush

Visitors at Bicknell Sugarbush

Pancake Breakfast,
Warren G. Corning
Visitor Center

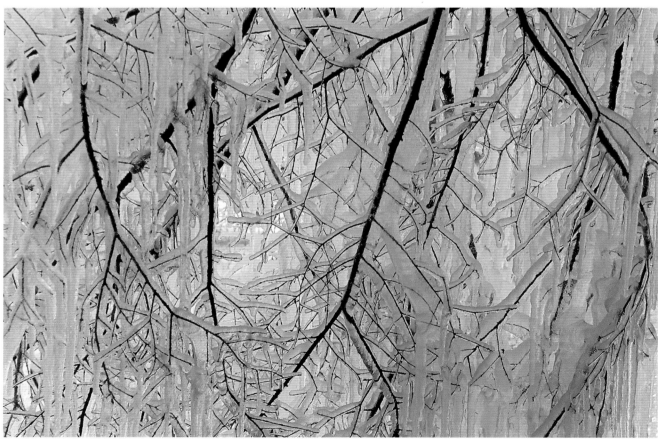

Ice Formation in
Stebbins Gulch

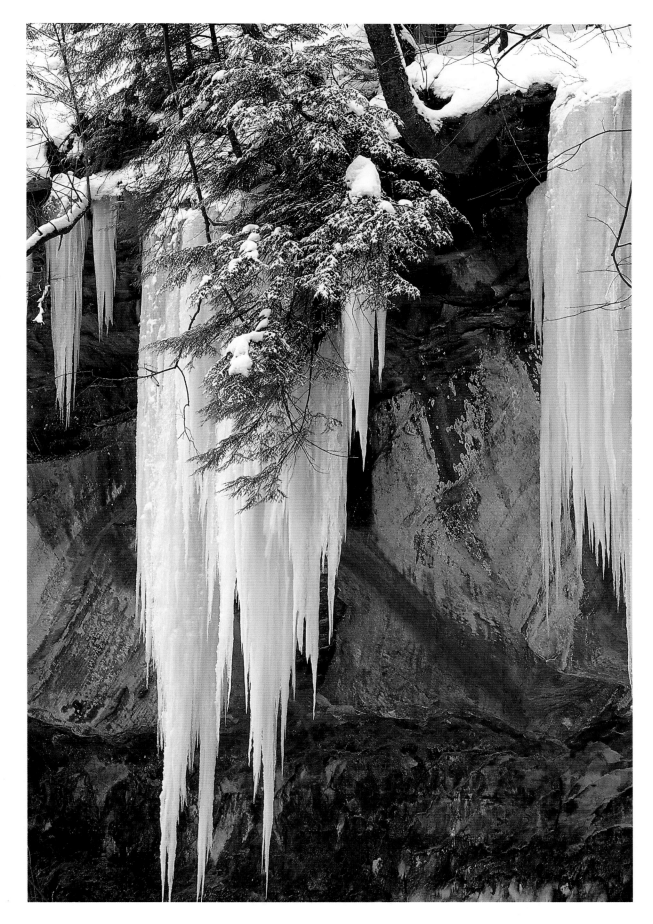

Icicles, Stebbins Gulch

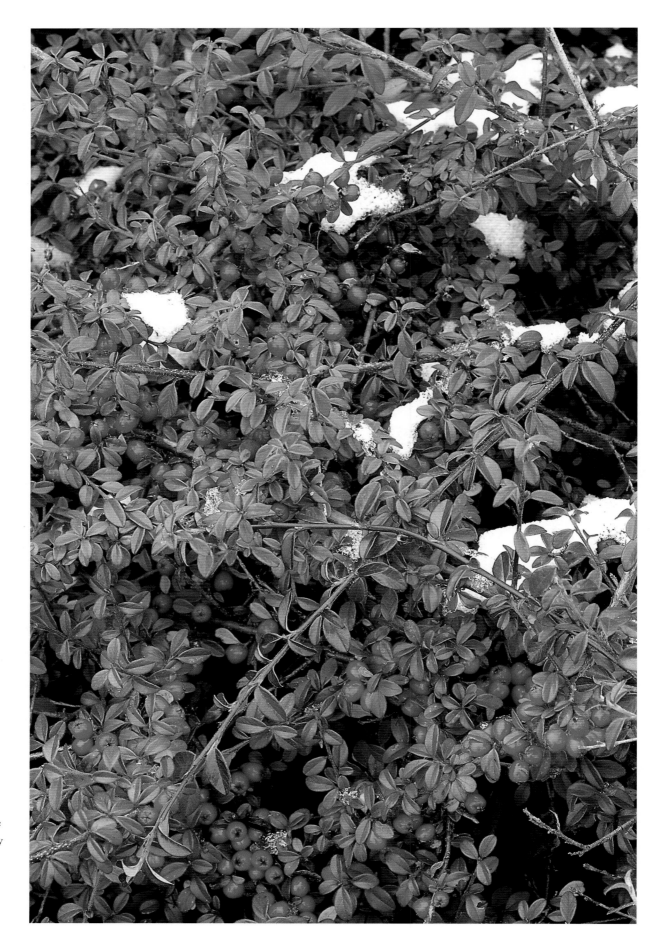

Cranberry Coton-
easter, Display
Gardens

Facing page: In a
Rare Appearance,
Townsend's Solitaire
in Winterberry, Holly
Collection

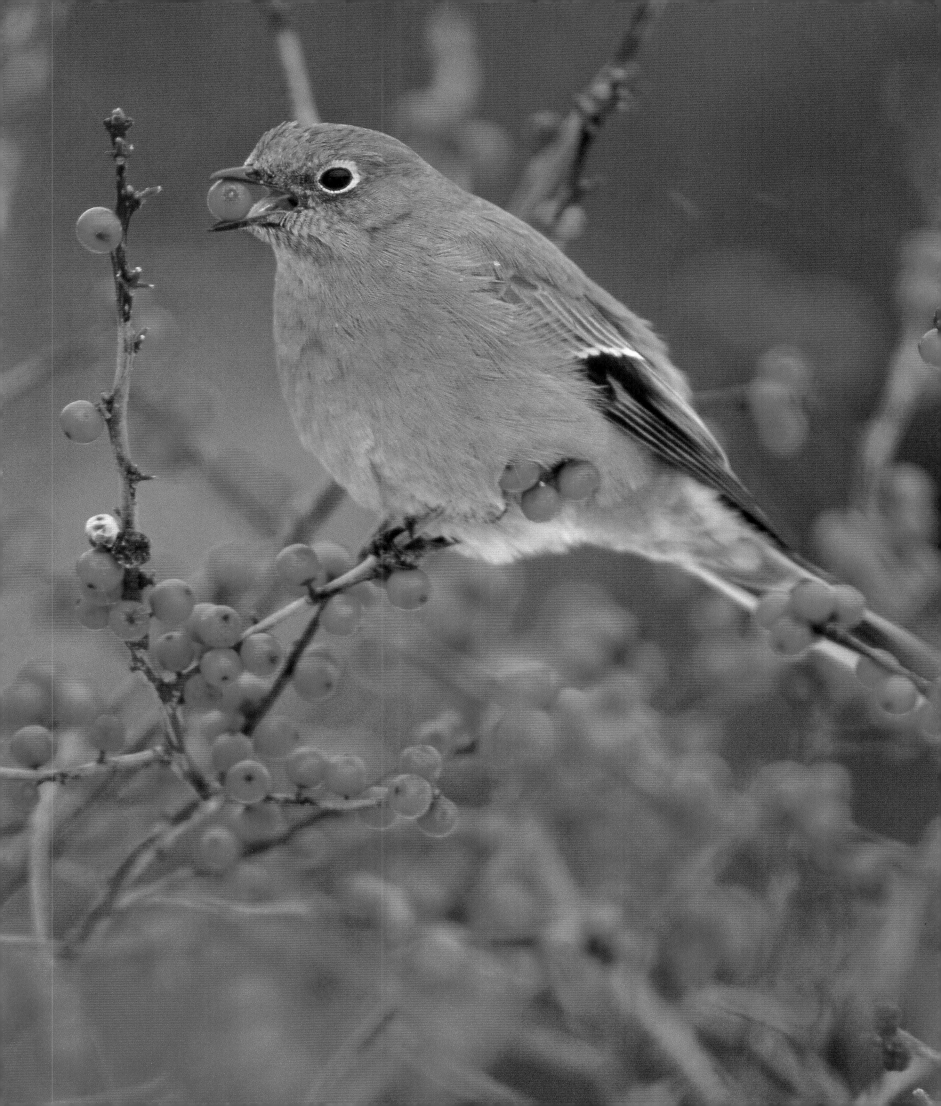

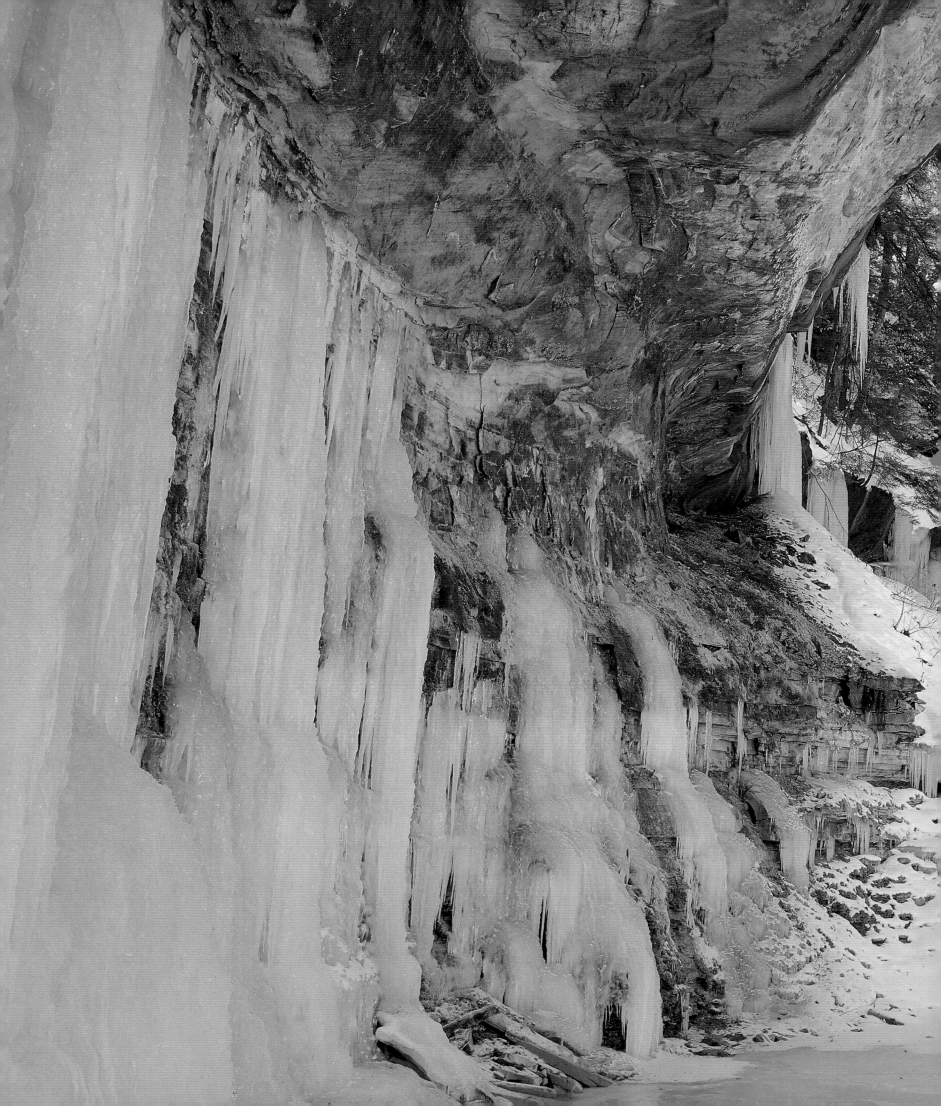

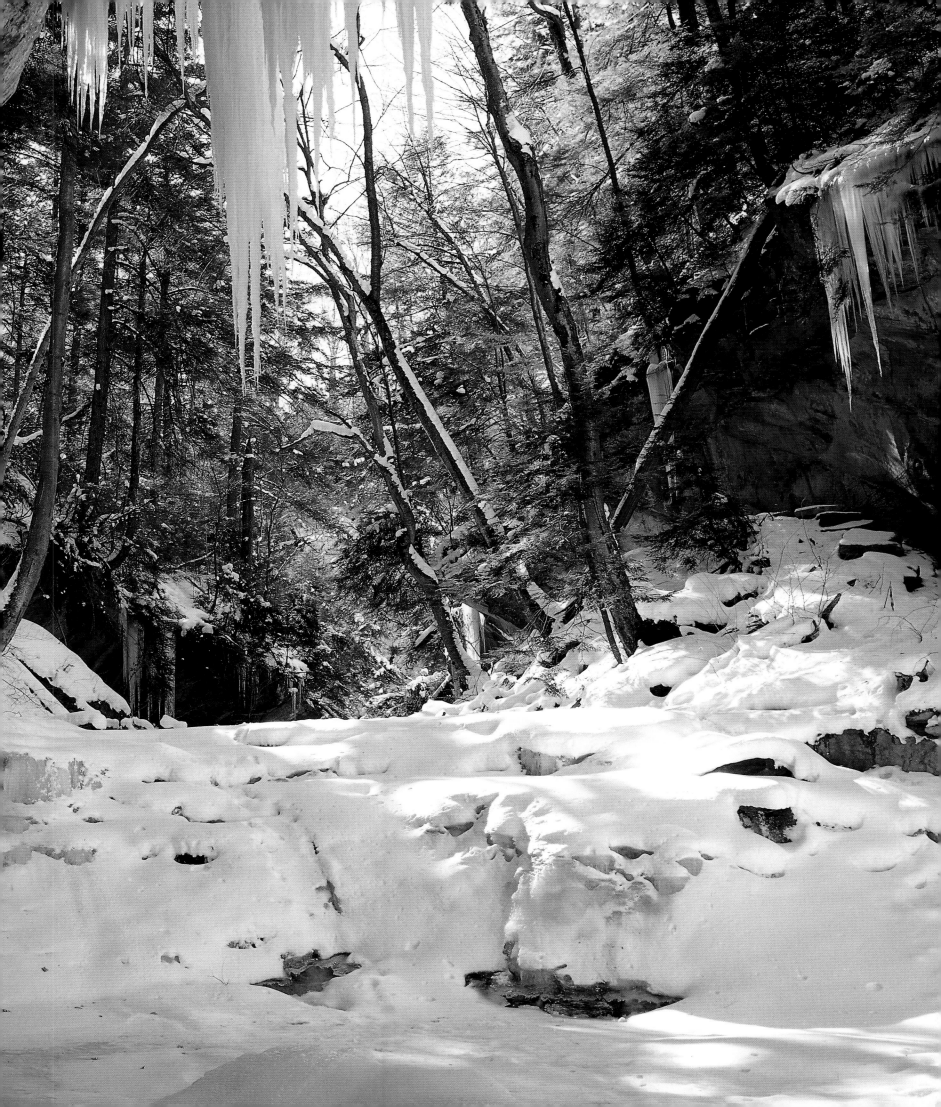

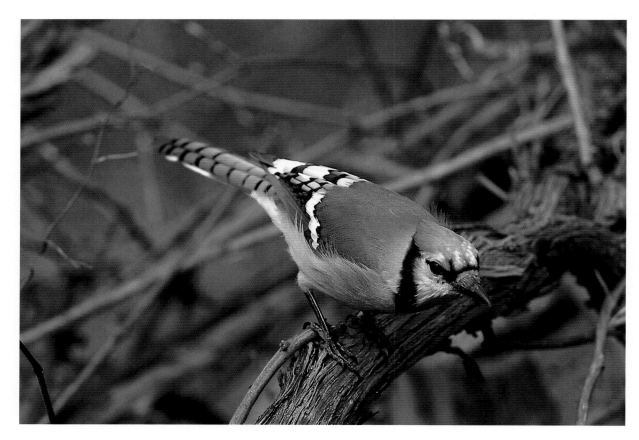

Previous pages:
Icicles, Stebbins Gulch

Blue Jay

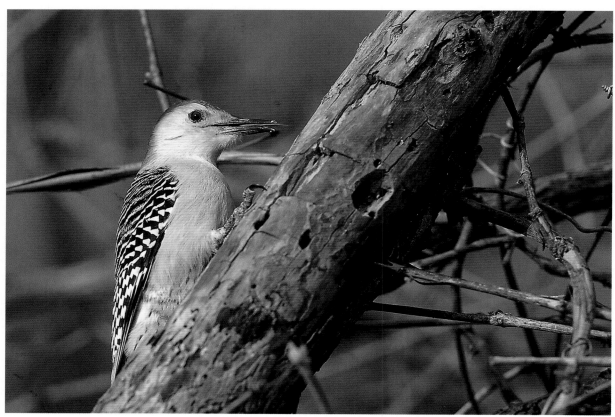

Red-Bellied Wood-
pecker

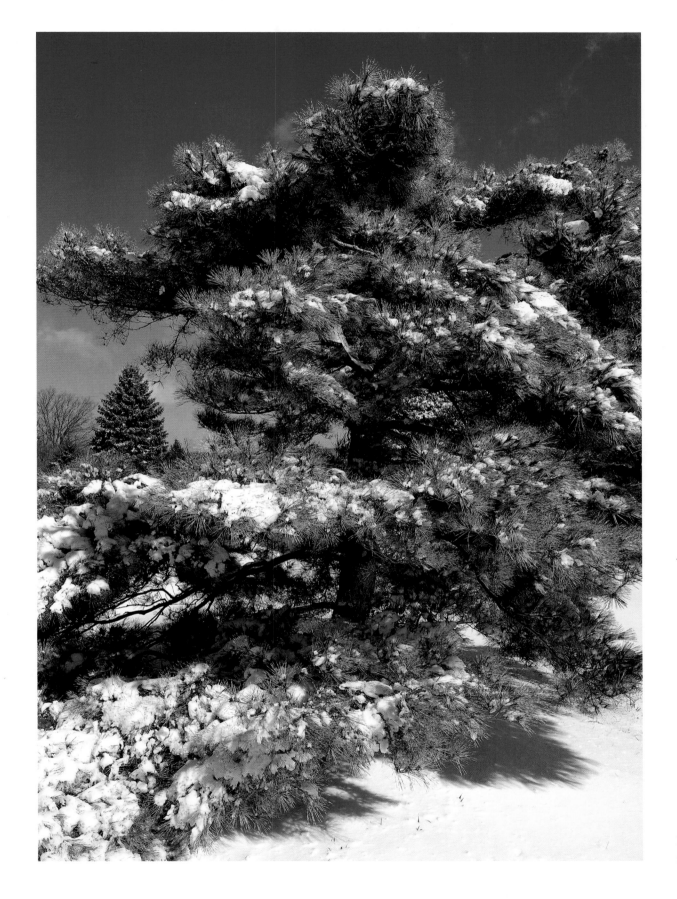

Dragon's-Eye Pine
near Sperry Road

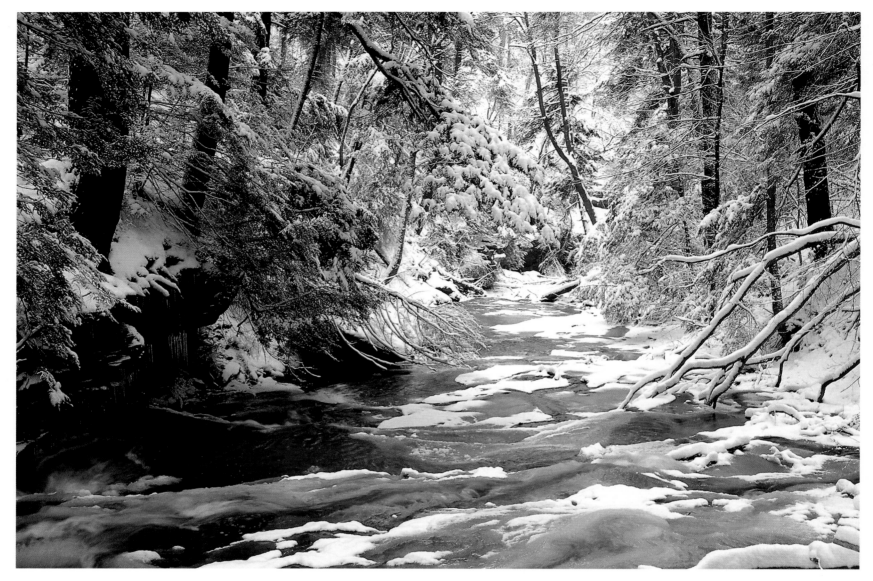

Stebbins Gulch

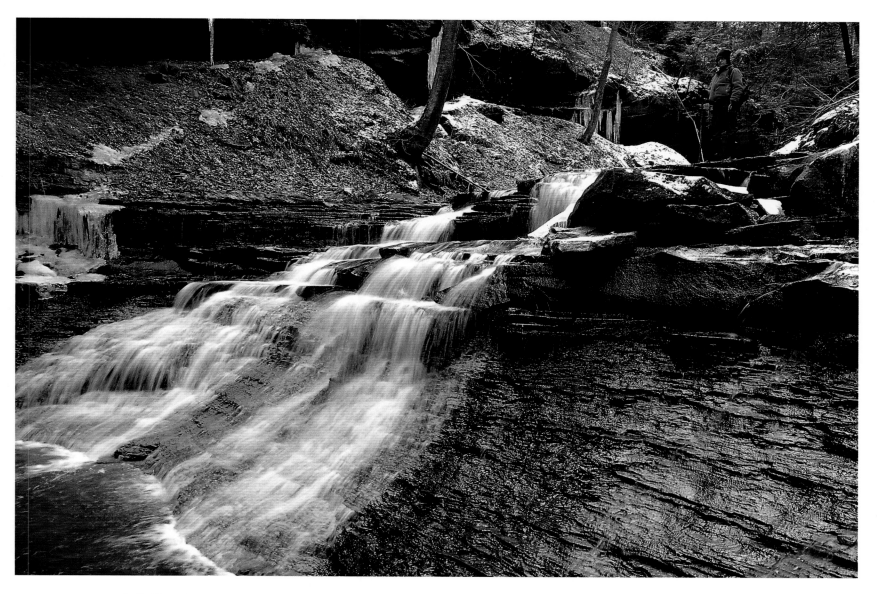

Judie Gause in
Stebbins Gulch

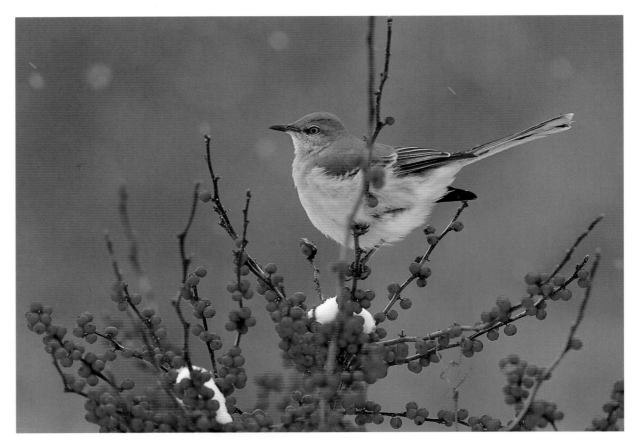

Northern Mockingbird
in Winterberry, Holly
Collection

American Holly, Holly
Collection

Sources
Photo Credits
Photo Index

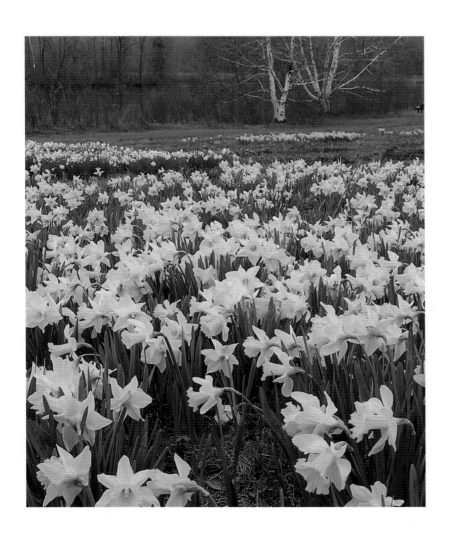

Sources

The History of the Holden Arboretum

Michael Hodder and W. David Bowers, *The Norweb Collection: An American Legacy* (Wolfeboro, N.H.: Bowers and Merena Galleries, Inc., 1987).

Emery May Holden Norweb, Holden Arboretum 50th Anniversary tapes, Holden Arboretum Corning Library, 1981.

Emery May Norweb letter to R. Henry Norweb Jr., Holden Arboretum Corning Library, 12 October 1966.

Emery May Norweb letter to grandchildren, Holden Arboretum Corning Library, 8 April 1971.

Emery May Norweb, "Some Recollections of Albert Fairchild Holden," Holden Arboretum Corning Library, undated.

"Society's Grande Dame," *Cleveland Plain Dealer, Sunday Plain Dealer Magazine,* Cleveland, Ohio, 22 February 1976.

Edward T. Bartlett II, "Katharine Holden Thayer," *Arboretum Leaves* (Kirtland, Ohio), vol. 27, no. 3 (Winter 1986), p. 9.

Roberta Bole letter to Francis F. Prentiss, Holden Arboretum Corning Library, 13 December 1927.

Florence Mustric, "Roberta Holden Bole: The Woman Who Made the Holden Arboretum a Reality," *Arboretum Leaves,* vol. 42, no. 2 (Fall 2000), pp. 6–9.

"Roberta Holden Bole: 1878–1950," biographical material by unknown author, Holden Arboretum Corning Library, undated.

Gordon C. Cooper, "Memorandum on the Location of an Arboretum in the Cleveland Regional Area," Holden Arboretum Corning Library, 4 May 1929.

"The Holden Arboretum: Revised List of Preliminary Requirements," Holden Arboretum Corning Library, 30 April 1932.

"Preliminary Statement of Scope and Objectives," Holden Arboretum Corning Library, undated (circa 1932–1940).

Dean Halliday, "Significance of The Holden Arboretum," *Popular Publications of the Cleveland Museum of Natural History* (Cleveland, Ohio), vol. 1, no. 2, January 1931.

Harold T. Clark, "Background of The Holden Arboretum," Cleveland Museum of Natural History Archives, Cleveland, Ohio, 15 August 1949.

George Ford, "The Holden Arboretum 1912–1967," unpublished manuscript, Holden Arboretum Corning Library, undated.

Arthur L. Dougan and David W. Swetland, *Annals of the Holden Arboretum 1913–1988* (Cleveland, Ohio: published by David W. Swetland; printed by Stone Printing, 1998).

Emery May Norweb diary, Holden Arboretum Corning Library, 8 April 1971.

Warren H. Corning, "The Development of The Holden Arboretum," Holden Arboretum Corning Library, undated.

Molly M. Offutt, "Maud Eells Corning (1909–1991)," *Arboretum Leaves,* vol. 33, no. 3 (Winter 1992), p. 11.

Alison "Sunny" Corning Jones, interview by Steve Love, Kirtland, Ohio, 18 November 2000.

R. Henry Norweb Jr., Holden Arboretum 50th Anniversary tapes, Holden Arboretum Corning Library, 1981.

Marty Martin, et al., "Staff tributes to Henry Norweb," *Arboretum Leaves,* vol. 37, no. 2 (Fall 1995), pp. 14–15.

C. W. Eliot Paine, interview by Steve Love, Kirtland, Ohio, 11 November 2000.

C. W. Eliot Paine, "Director's Notes," *Arboretum Leaves,* vol. 28, no. 4 (Spring 1987), p. 3.

Florence Mustric, "Eliot Paine: Seeing the Forest and the Trees," *Arboretum Leaves,* vol. 36, no. 4 (Summer 1995), pp. 3–6.

C. W. Eliot Paine, "Holden Will Rebuild, Reroute Sperry Road" and "Director's Notes," *Arboretum Leaves,* vol. 31, no. 2 (Fall 1989), pp. 7–8, 2.

C. W. Eliot Paine, "New Sperry Road Begins to Wend Its Way" and "Director's Notes," *Arboretum Leaves,* vol. 33, no. 1 (Summer 1991), pp. 2–3.

"Celebrate New Sperry Road with Us!" *Arboretum Leaves,* vol. 33, no. 2 (Fall 1991), pp. 3–5.

Elaine Price, interviews by Steve Love, Kirtland, Ohio, and Cleveland, Ohio, 3 July 2001 and 24 August 2001.

"Arboretum's New Director Mixing Skills and Hobby," *Cleveland Plain Dealer,* 28 May 2001.

Florence Mustric, "Elaine Price Brings Unique Skills, Perspective," *Arboretum Leaves,* vol. 43, no. 1 (Summer 2001), pp. 1–2.

C. W. Eliot Paine, "Arboretum Receives Holden Trust Funds," *Arboretum Leaves,* vol. 30, no. 3 (Winter 1989), pp. 3–6.

Ted Yocom, interviews by Steve Love, Kirtland, Ohio, 17 June 2000, 14 October 2000, 20 January 2001.

Florence Mustric, "Learning All the Way," *Arboretum Leaves,* vol. 39. no. 1 (Summer 1997), p. 15.

"Collection and Trail Map," Holden Arboretum brochure, 1998.

"Crabapple Collection," Holden Arboretum brochure, 1990.

Brian Parsons, interviews by Steve Love, Kirtland, Ohio, 14 July 2000 and 3 July 2001.

Florence Mustric, "Defender of Natural Areas: Brian Parsons," *Arboretum Leaves,* vol. 39, no. 2 (Fall 1997), pp. 9–11.

Ellen Corning Long, Holden Arboretum 50th Anniversary tapes, Holden Arboretum Corning Library, 1981.

Molly M. Offutt, "Ellen Corning Long: September 21, 1940–July 3, 1989," *Arboretum Leaves,* vol. 31, no. 2 (Fall 1989), p. 5.

Dixon Long, telephone interview from San Anselmo, California, by Steve Love, 16 December 2000.

Harold L. Madison, "Holden Arboretum Annual Report 1937," Cleveland Museum of Natural History Archives.

Benjamin Patterson Bole Jr., chairman, Holden Arboretum Board, "Holden Arboretum Annual Report 1939," Cleveland Museum of Natural History Archives.

Benjamin Patterson Bole Jr., chairman, Holden Arboretum Board, "Holden Arboretum Annual Report 1940," Cleveland Museum of Natural History Archives.

Benjamin Patterson Bole Jr., chairman, Holden Arboretum Board, "Holden Arboretum Annual Report 1941," Cleveland Museum of Natural History Archives.

Arthur B. Fuller, chairman, Holden Arboretum Board, "Holden Arboretum Annual Report 1944," Cleveland Museum of Natural History Archives.

Connie Norweb Abbey, interview by Steve Love, Kirtland, Ohio, 11 November 2000.

Molly M. Offutt, "New Trustee (Constance Abbey)," *Arboretum Leaves,* vol. 37, no. 2 (Fall 1995), p. 12.

Elizabeth Norweb, Holden Arboretum 50th Anniversary tapes, Holden Arboretum Corning Library, 1981, and interview by Steve Love, Kirtland, Ohio, 11 November 2000.

Paul Spector, interview by Steve Love, Kirtland, Ohio, 13 July 2000.

Jim Mack, interview by Steve Love, Kirtland, Ohio, 11 July 2000.

Peter Bristol, interview by Steve Love, Kirtland, Ohio, 11 July 2000.

Charles Tubesing, interviews by Steve Love, Kirtland, Ohio, 11 July 2000 and 20 January 2001.

David W. Swetland, "The Legacy of Lewis Lipp," *Arboretum Leaves,* vol. 35, no. 4 (Spring 1994), pp. 4–5.

"Director's Notes," *Arboretum Leaves,* vol. 35, no. 4 (Spring 1994).

Ethan Johnson, "A Cornucopia of Conifers," *Arboretum Leaves,* vol. 35, no. 3 (Winter 1994), pp. 7–9.

Tom Yates, interviews by Steve Love, Kirtland, Ohio, 11 July 2000 and 14 October 2000.

Florence Mustric, "Yates Fan Club Quarter-Century Report," *Arboretum Leaves,* vol. 36, no. 3 (Spring 1995), pp. 9–12.

Richard Munson, interview by Steve Love, Kirtland, Ohio, 12 July 2000.

Stanley H. Johnston Jr., interview by Steve Love, Kirtland, Ohio, 12 July 2000.

Nadia Aufderheide, interview by Steve Love, Kirtland, Ohio, 13 July 2000.

Florence Mustric, "Something for Everyone in Library's Resources," *Arboretum Leaves,* vol. 32, no. 2 (Fall 1990), p. 14.

Judie Gause, interviews by Steve Love, Kirtland, Ohio, 13 July 2000 and 11 December 2000.

Ethan Johnson, interview by Steve Love, Kirtland, Ohio, 13 July 2000.

Robert Marquard, interview by Steve Love, Kirtland, Ohio, 14 July 2000.

Roger Gettig, interviews by Steve Love, Kirtland, Ohio, 14 July 2000 and 12 December 2000.

Molly M. Offutt, "Conservation Easements Help Preserve Natural Areas," *Arboretum Leaves,* vol. 38, no. 4 (Spring 1997), p. 16.

Roger Gettig, "A Better Place to Live: Conservation Subdivisions," *Arboretum Leaves,* vol. 39, no. 4 (Spring 1998), pp. 3–7.

Karen Kennedy, interview by Steve Love, Kirtland, Ohio, 11 December 2000.

Karen Smith, "Plant Activities Help Children Heal," *Arboretum Leaves,* vol. 33, no. 1 (Summer 1991), p. 15.

Karen Haas, "Horticultural Therapy Extends Joy and Skill of Gardening," *Arboretum Leaves,* vol. 34, no. 1 (Summer 1992), p. 11.

Merle Moore, "Beginnings of Horticulture Therapy at The Holden Arboretum," Holden Arboretum Corning Library, August 1973.

Bill Isner, interview by Steve Love, Kirtland, Ohio, 9 September 2000.

Stephen Krebs, interview by Steve Love, Madison, Ohio, 20 May 2001.

Edward Bartlett III, Holden Arboretum 50th Anniversary tapes, Holden Arboretum Corning Library, 1981.

Jonathan Bole, Holden Arboretum 50th Anniversary tapes, Holden Arboretum Corning Library, 1981.

Clifton "Tip" Volans, Holden Arboretum 50th Anniversary tapes, Holden Arboretum Corning Library, 1981.

Florence Mustric, "In Memory . . . Clifton 'Tip' Volans," *Arboretum Leaves,* vol. 29, no. 3 (Winter 1988), p. 7.

"The Boardwalk with a View: The Flora of Pierson Creek Valley," Holden Arboretum brochure, 1997.

Marian B. Williams and Margaret Kister Hahn, "A Woodland Trail Journal: Exploring Change," The Holden Arboretum, 1998.

Charlotte M. Frieze, *The Zone Garden 3-4-5* (New York: Simon & Schuster, 1997).

Marc D. Abrams, Martin F. Quigley, "Natural Areas Assessment and Research Opportunities at The Holden Arboretum," Kirtland, Ohio, 1999.

Guy L. Denny, comp., "Natural Areas Assessment and Management Recommendations Report of the Management Advisory Focus Group," Holden Arboretum, 16–17 September 1999.

Brian Parsons, "Changes in the Web," *Arboretum Leaves,* vol. 34, no. 2 (Fall 1992), pp. 15–19.

Marian Williams, "The Fields within the Field," *Arboretum Leaves,* vol. 32, no. 1 (Summer 1990), pp. 12–13.

Molly M. Offutt, "New Gardens Say, 'Happy Birthday, Sally!'" *Arboretum Leaves,* vol. 37, no. 2 (Fall 1995), p. 9.

Florence Mustric, "New Trustees (Sally Gries, Mimi Gale)," *Arboretum Leaves,* vol. 40, no. 1 (Summer 1998), p. 6.

Florence Mustric, "Sally Gries Is Elected President," *Arboretum Leaves,* vol. 43, no. 1 (Summer 2001), p. 7.

Susan E. Murray, interview by Steve Love, Kirtland, Ohio, 11 December 2000.

"Leonard and Jean Skeggs Give Conservation Easement," *Arboretum Leaves,* vol. 39, no. 4 (Spring 1998).

Miriam N. "Mimi" Gale, interview by Steve Love, Kirtland, Ohio, 13 December 2000.

Florence Mustric, "Camp Ties," *Arboretum Leaves,* vol. 36, no. 1 (Summer 1994), p. 7.

Spring

Bill Isner, interview by Steve Love, Kirtland, Ohio, 9 September 2000.

Florence Mustric, "Right Man, Right Place: Bill Isner, Rhododendron Garden," *Arboretum Leaves,* vol. 39, no. 1 (Summer 1997), pp. 4–5.

Bill Isner, "Spring Is Not the Only Season in the Rhododendron Garden," *Arboretum Leaves,* vol. 32, no. 3 (Fall 1990), pp. 3–6.

Stephen Krebs, interview by Steve Love, Madison, Ohio, 20 May 2001.

Florence Mustric, "David Leach: Superior to All in the Field," *Arboretum Leaves,* vol. 33, no. 4 (Spring 1992), pp. 11–14.

Florence Mustric, "Staff Notes," *Arboretum Leaves,* vol. 34, no. 3 (Winter 1993), p. 13.

Dixon Long, telephone interview from San Anselmo, California, by Steve Love, 16 December 2000.

"The Holden Arboretum Helen S. Layer Rhododendron Garden: A History," Holden Arboretum brochure, 2000.

Clifton "Tip" Volans, Holden Arboretum 50th Anniversary tapes, Holden Arboretum Corning Library, 1981.

R. Henry Norweb Jr., Holden Arboretum 50th Anniversary tapes, Holden Arboretum Corning Library, 1981.

Summer

Brian Parsons, interviews by Steve Love, Kirtland, Ohio, 14 July 2000 and 3 July 2001.

Judie Gause, interviews by Steve Love, Kirtland, Ohio, 13 July 2000 and 11 December 2000.

"Myrtle S. Holden Wildflower Garden," Holden Arboretum brochure, 1997.

Jennifer Sparks, "Awesome Waves of Prairie Grass," *Arboretum Leaves,* vol. 38, no. 1 (Summer 1996), pp. 3–6.

Brian Parsons, "Flights of Fancy," *Arboretum Leaves,* vol. 36, no. 3 (Spring 1995), pp. 16–18.

Miriam Williams, "Watchable Wildlife . . . ," *Arboretum Leaves,* vol. 40, no. 3 (Winter 1999), pp. 8–11.

"Spring Events," *Arboretum Leaves,* vol. 33, no. 1 (Summer 1991).

Brian Parsons, "Landscape Design on Crystal and Reflecting Ponds," *Arboretum Leaves,* vol. 35, no. 4 (Spring 1994), pp. 6–8.

Florence Mustric, "A Visit with Art Holden," *Arboretum Leaves,* vol. 43, no. 1 (Summer 2001), p. 14.

Charlotte M. Frieze, *The Zone Garden 3-4-5* (New York: Simon & Schuster, 1997).

"The Eastern Bluebird," Holden Arboretum brochure, 2000.

Florence Mustric, "Bluebirds Come Back," *Arboretum Leaves,* vol. 38, no. 2 (Fall 1996), pp. 13–17.

"Can't Get Enough of Those Arboretum Blues," *Cleveland Plain Dealer, The Plain Dealer Sunday Magazine,* 4 March 2001.

Lantern Court

Tom Yates, interviews by Steve Love, Kirtland, Ohio, 11 July 2000 and 14 October 2000.

Florence Mustric, "Yates Fan Club Quarter-Century Report," *Arboretum Leaves,* vol. 36, no. 3 (Spring 1995), pp. 9–12.

Tom Yates, "Great Delight in Tiny Spaces: Lantern Court's Rock Gardens," *Arboretum Leaves,* vol. 36, no. 2 (Fall 1994), pp. 8–11.

Florence Mustric, "John Cross: Welding a Sturdy Career," *Arboretum Leaves,* vol. 40, no. 1 (Summer 1998), pp. 14–15.

Florence Mustric, "A Seamless Web: George Rosskamp," *Arboretum Leaves,* vol. 38, no. 3 (Spring 1997), p. 18.

Alison "Sunny" Corning Jones, interview by Steve Love, Kirtland, Ohio, 18 November 2000.

"Lantern Court at The Holden Arboretum," Holden Arboretum brochure, 2000.

"The Rose Garden at Lantern Court," Holden Arboretum brochure, 2000.

Fall

Jonathan Bole, Holden Arboretum 50th Anniversary tapes, Holden Arboretum, Corning Library, 1981.

Dixon Long, telephone interview from San Anselmo, California, by Steve Love, 16 December 2000.

Emery May Norweb, Holden Arboretum 50th Anniversary tapes, Holden Arboretum Corning Library, 1981.

Tom Yates, fall walk leader and interview by Steve Love, Kirtland, Ohio, 14 October 2000.

C. W. Eliot Paine, interview by Steve Love, Kirtland, Ohio, 11 November 2000.

Arthur L. Dougan and David W. Swetland, *Annals of the Holden Arboretum 1913–1988* (Cleveland, Ohio: published by David W. Swetland; printed by Stone Printing, 1998).

Connie Norweb Abbey, interview by Steve Love, Kirtland, Ohio, 11 November 2000.

Richard H. Munson, interview by Steve Love, Kirtland, Ohio, 12 July 2000.

Ted Yocom, fall walk leader and interview by Steve Love, Kirtland, Ohio, 14 October 2000.

Joe Cluts, fall walk leader whose conversations with Steve Love added to this essay, Kirtland, Ohio, 14 October 2000.

Winter

Ted Yocom, interviews by Steve Love, Kirtland, Ohio, 17 June 2000, 20 January 2001.

Tom Yates and Brian Parsons, "Stebbins Gulch," Holden Arboretum brochure, Kirtland, Ohio, 2000.

Ted Yocom, "Stebbins Gulch," informational material, Kirtland, Ohio, December 1991.

Bob Downing, "Stopped by Woods—on a Snowy Day: Stebbins Gulch Is a Road not Taken by Many for Frosty Hike," *Akron Beacon Journal,* 7 January 2001.

Joe Cluts, Stebbins Gulch winter walk leader whose conversations with Steve Love added to this essay, Kirtland, Ohio, 20 January 2001.

Charles Tubesing, interviews by Steve Love, Kirtland, Ohio, 11 July 2000 and 20 January 2001.

Florence Mustric, "Between a Tree and a Slippery Place," *Arboretum Leaves,* vol. 38, no. 2 (Fall 1996), p. 3.

Tom Yates, "Treasure of Time: Stebbins Gulch," *Arboretum Leaves,* vol. 35, no. 1 (Summer 1993), p. 12.

Little Mountain

Ted Yocom, interviews by Steve Love, Kirtland, Ohio, 17 June 2000, 14 October 2000, 20 January 2001.

Brian Parsons, interviews by Steve Love, Kirtland, Ohio, 14 July 2000 and 3 July 2001.

Roger Gettig, interviews by Steve Love, Kirtland, Ohio, 14 July 2000 and 12 December 2000.

Molly M. Offutt, "Conservation Easements Help Preserve Natural Areas," *Arboretum Leaves,* vol. 38, no. 4 (Spring 1997), p. 16.

Roger Gettig, "A Better Place to Live: Conservation Subdivisions," *Arboretum Leaves,* vol. 39, no. 4 (Spring 1998), pp. 3–7.

Tom Yates and Brian Parsons, *A Journey through Time on Little Mountain,* Holden Arboretum publication with contributions from the Lake County Historical Society, Kirtland, Ohio, 1992.

"Little Mountain," Holden Arboretum brochure, 2000.

Judith Moore, "Little Mountain: Forest Characteristics and Management Recommendations," report to The Holden Arboretum, 1 September 1989.

"Battling Dangers Old and New on Little Mountain," *Arboretum Leaves,* vol. 31, no. 1 (Summer 1989).

Frances Heller, "An Afternoon on Little Mountain," *Arboretum Leaves,* vol. 29, no. 3 (Winter 1988).

Marc D. Abrams, Martin F. Quigley, "Natural Areas Assessment and Research Opportunities at The Holden Arboretum," Kirtland, Ohio, 1999.

Guy L. Denny, comp., "Natural Areas Assessment and Management Recommendations Report of the Management Advisory Focus Group," Holden Arboretum, 16–17 September 1999.

Warren Bicknell Jr. Sugarbush

Paul Spector, interview by Steve Love, Kirtland, Ohio, 13 July 2000.

Eli Miller, interview by Steve Love, Kirtland, Ohio, 17 March 2001.

"Sugarbush Trail Guide," Holden Arboretum brochure, 2000.

Richard H. Munson, "Director's Notes," *Arboretum Leaves,* vol. 40, no. 3 (Winter 1999), p. 2.

Brian Parsons "Supersweet Sugar Maples—An Update," *Arboretum Leaves,* vol. 28, no. 4 (Spring 1987), pp. 6–7.